IN YOUR OWN
STYLE

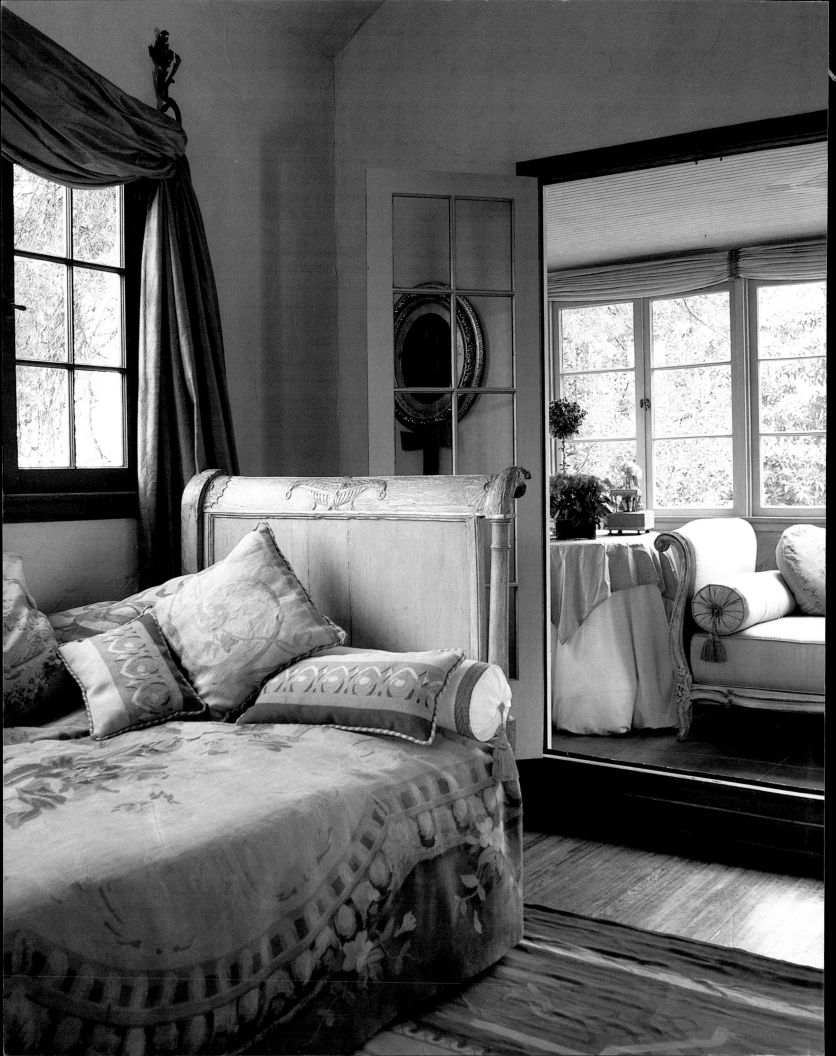

THE ART OF CREATING
WONDERFUL ROOMS

IN YOUR OWN
STYLE

BY LINDA CHASE
AND LAURA CERWINSKE

PHOTOGRAPHS BY
DAVID PHELPS

Thames & Hudson

First published in the United States in hardcover in 1994 by Thames & Hudson Inc., 500 Fifth Avenue, New York, New York 10110

First published in the United Kingdom in 1994 by Thames & Hudson Ltd, 181A High Holborn, London WC1V 7QX

First paperback edition 1999

Library of Congress Catalog Card Number 94-60035

British Library Cataloguing-in-Publication Data

A catalogue record for this book is available from the British Library

ISBN 0–500–28164–5

In Your Own Style was produced by
Laura Cerwinske Editorial Production

Book Design by Gates Sisters Studio

Printed and bound in China

ACKNOWLEDGEMENTS

We would like to offer our foremost acknowledgment to David Phelps for his professional and personal dedication to this book. He lent not only his wonderful eye and great intelligence but also his heart to this long and demanding project.

Our gratitude to Heidi Rode and Christina Glafkides of Carlson Chase Associates, Inc. who gave their diligence and devotion.

We would also like to acknowledge the designers, suppliers, and show-room personnel who went out of their way to help us with photography.

Our thanks to Peter Warner of Thames & Hudson for his patience and encouragement; and to the Gates Sisters Studio for giving this complex body of material its refined presentation.

OPPOSITE

A detail of a room by Richard Neas reveals the designer's imaginative use of brilliant green wall color to dramatize a collection of blue-and-white porcelain and antique accessories.

PAGE 1

Carolyn Quartermaine pays homage to Braque in her collages on fabric. Photograph by Steve Dalton, courtesy of "Vogue Entertaining."

PAGE 2

In a bungalow designed by Linda Chase, two classical daybeds are juxtaposed to create an atmosphere of lyrical and relaxed formality.

PAGE 6

The New York apartment of designer John Saladino. Photograph by Lizzie Himmel.

PAGES 8-9

Linda Chase combined colors, textures, and antique furniture and decorative objects in a highly individual setting where Renaissance-style torchères flank an eighteenth-century French canapé upholstered in simple cotton piqué and decorated with pillows made of Aubusson remnants.

DEDICATION

To my husband, Peter Carlson
LINDA CHASE

For Jona, who has always been and continues
to be a wondrous embodiment of
individual style.
LAURA CERWINSKE

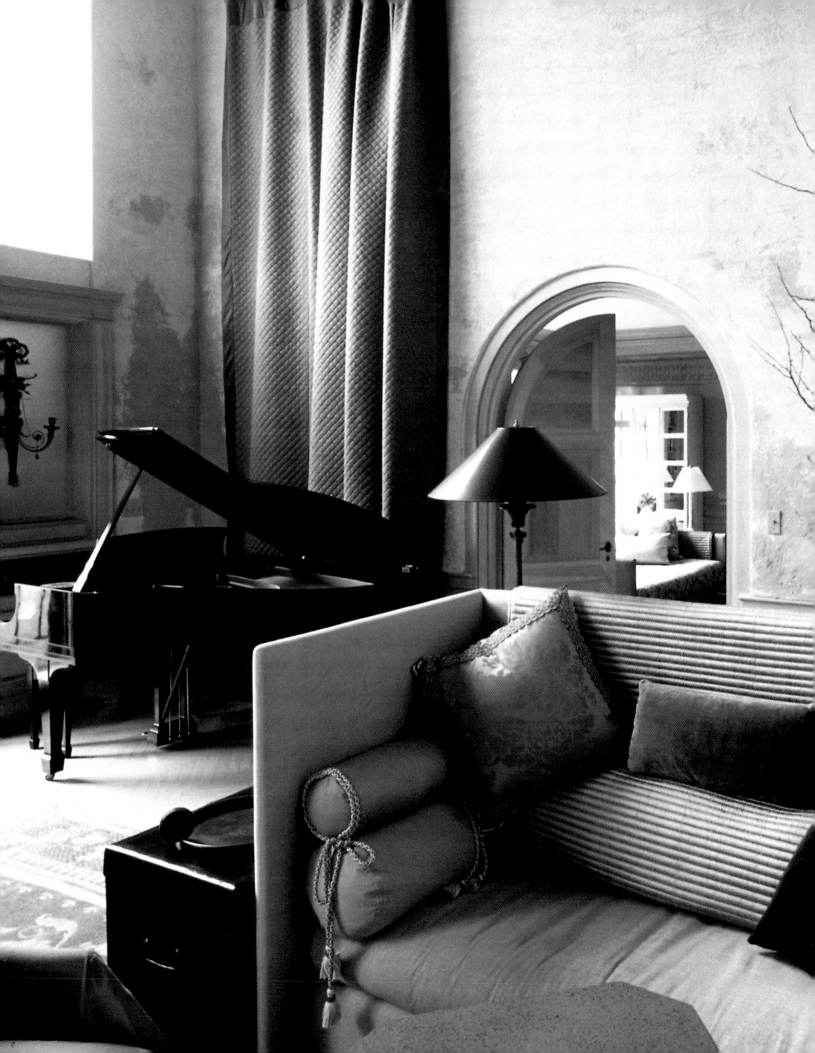

CONTENTS

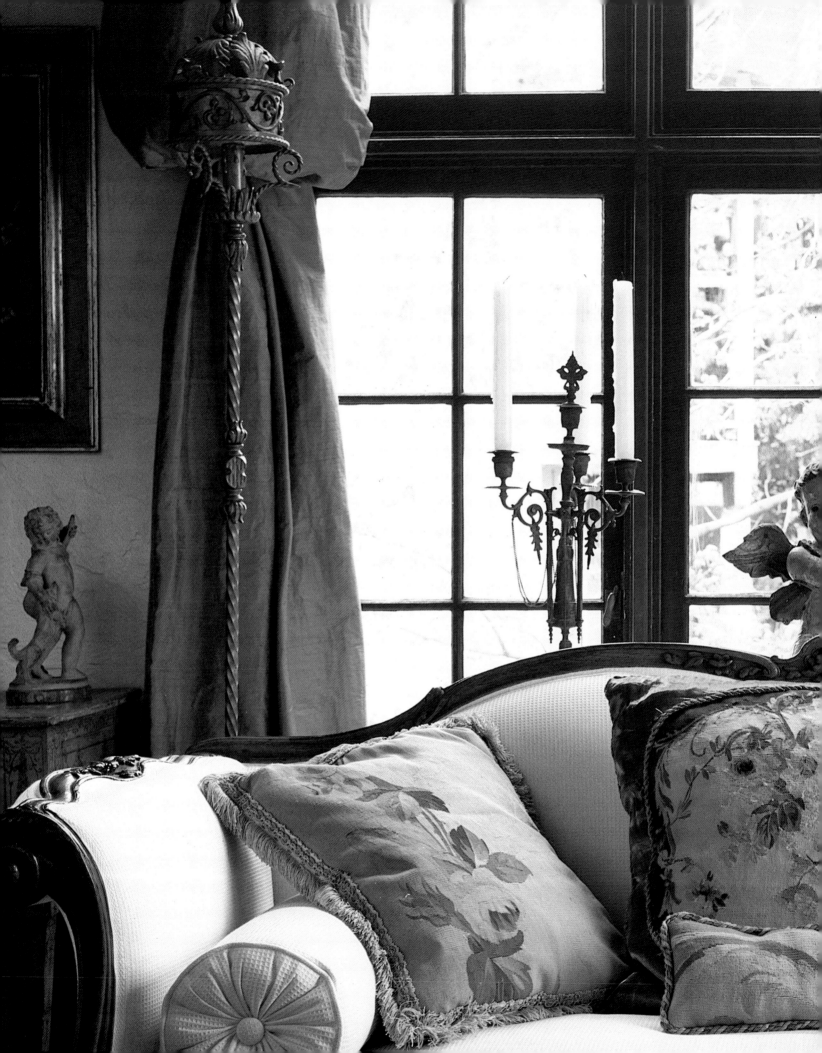

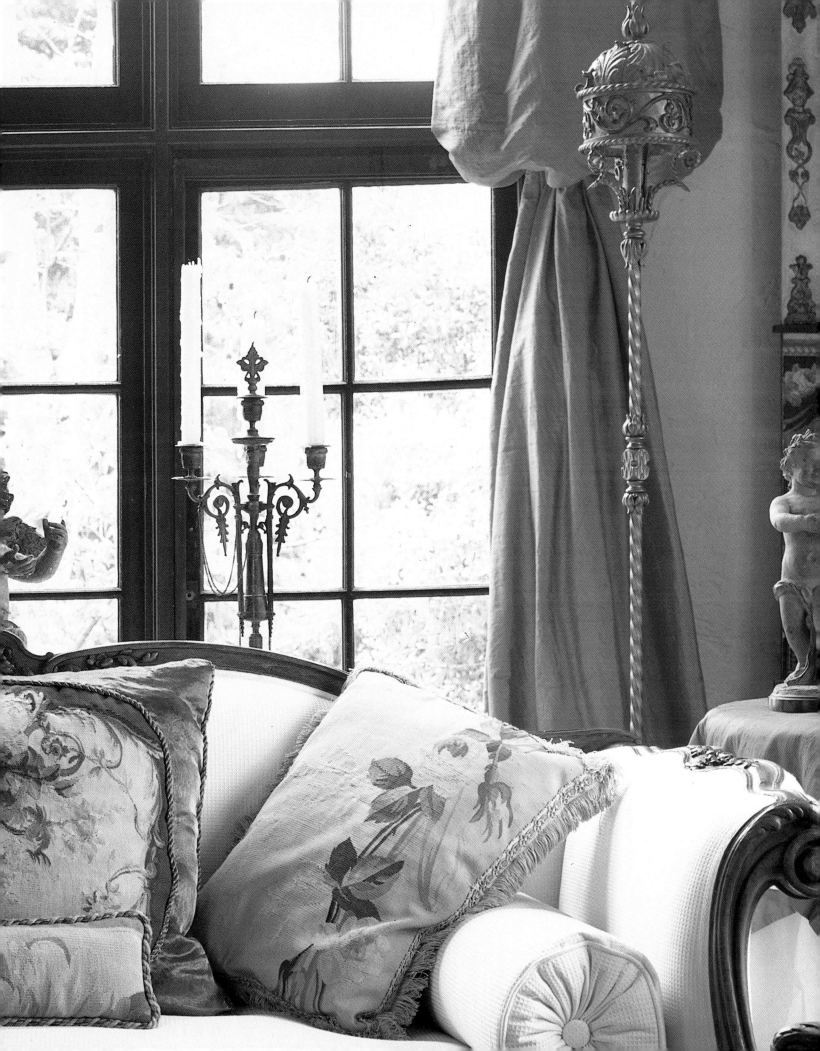

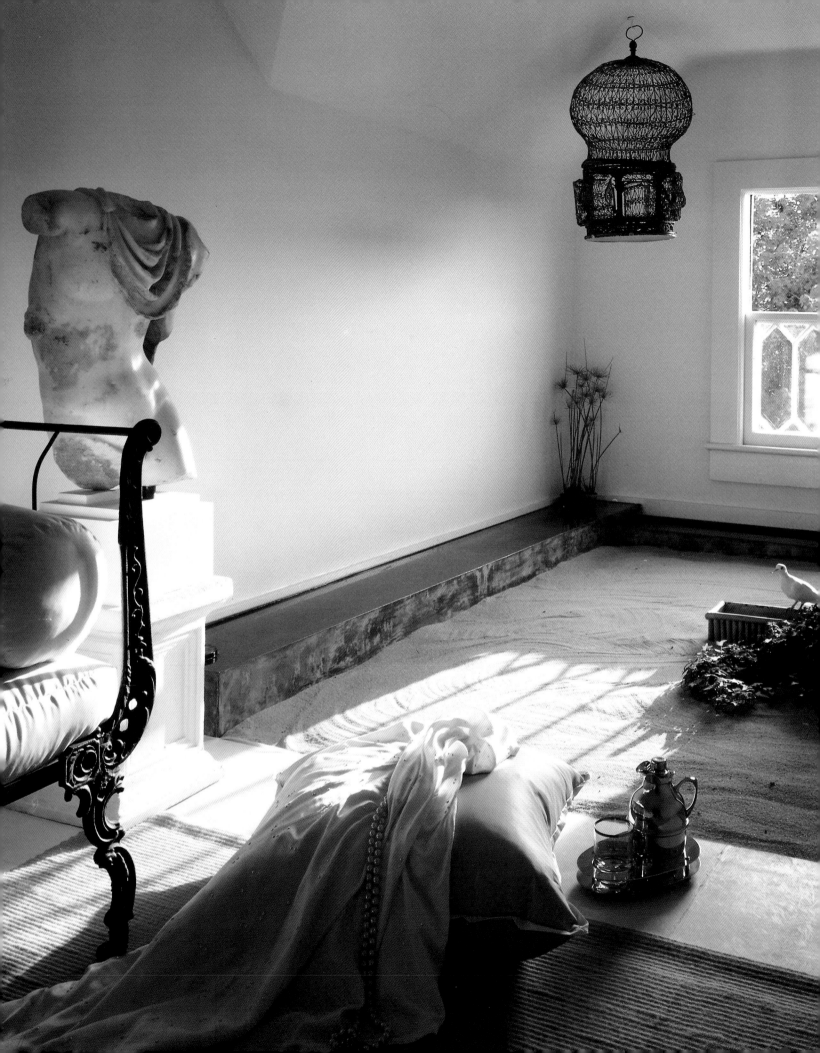

When I was first approached about writing the foreword to this book, I must admit I was apprehensive. After all, Linda Chase and Laura Cerwinske had previously collaborated on a beautiful book for Thames and Hudson, *In the Romantic Style*. There is more to my reluctance, however, since between the time Linda Chase contacted me regarding this task and the present, we became business partners and then husband and wife.

Preparation of *In Your Own Style* has therefore been a constant in our life together. The search for images and the discussions of how best to relate the information the book offers have been a vigorous and emotional endeavor. It has been a consistent source of anxiety and delight.

Style changes and evolves, an excellent indication that it is a vital thing, buffeted by opinion and the latest news report. What is intended here is a snapshot, a guideline, to assist you in realizing your own dreams.

Within these pages you will find the extraordinary visions of some of the most talented disciples of the art of interior design as well as uncomplicated practical information to help you in creating your own style.

Linda and I are presently anticipating the birth of our first child. I cannot help but feel that this is auspicious and apt. A book is born and assumes a life of its own. Travel, wander in the unexpected visions within.

P E T E R C A R L S O N
Los Angeles, December, 1993

In an homage to Mexican architect Luis Barragan, Peter Carlson gave great character to a room with little architectural distinction by employing sand and water. Photograph by Peter Bosch.

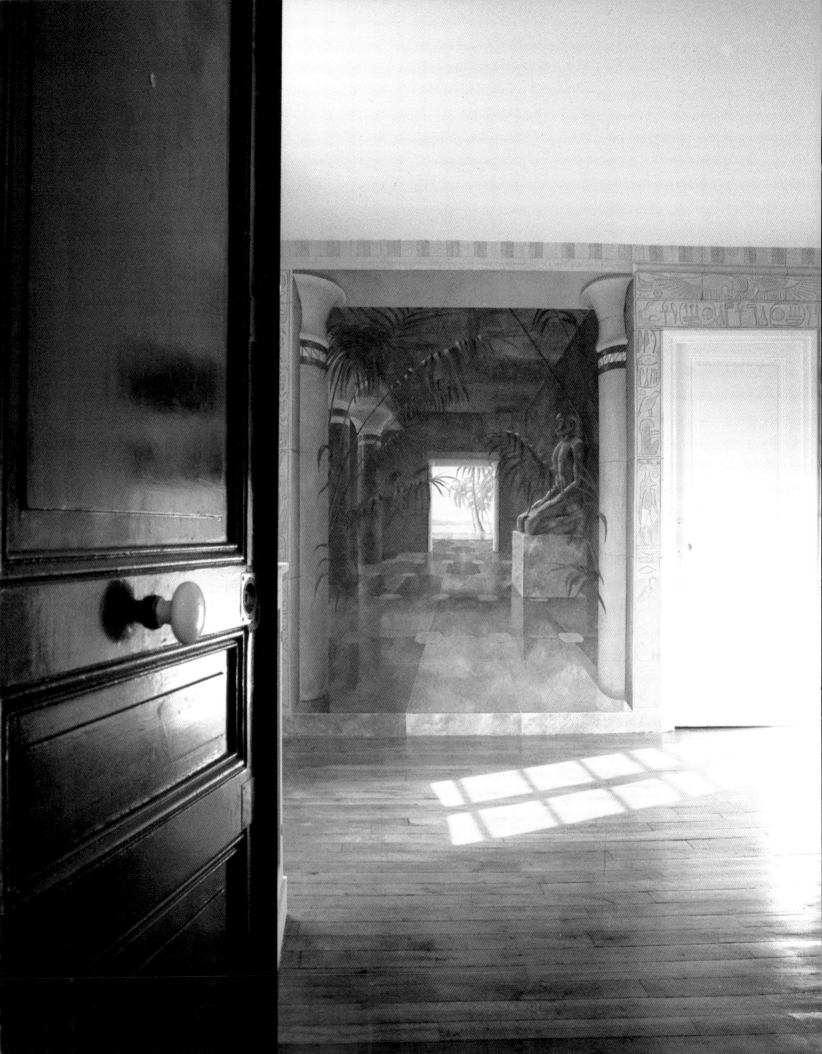

The room is the beginning of architecture. You do not say the same thing in one room

as you say in another, that's how sensitive a room is. A room is a marvelous thing, a world

within a world. It's yours and offers a measure of yourself.

L O U I S K A H N

During the course of writing this book, Linda Chase and I both moved into new houses. Even though we had collaborated on a previous interior design book and are both professionals in the field—Linda is an interior designer and I am a design writer and editor—the experience of creating interiors for our own new houses sharpened our recognition of our readers' needs.

Linda and her husband, interior designer Peter Carlson, bought a 1920s Hollywood Hills bungalow filled with the details typical of that locale and period. They chose the house because, unlike many Los Angeles hillside homes of its era, it was still true to its original design and had little imprint of previous owners.

I remember the first time I visited the house. Even though I had known Linda's apartment in New York and am familiar with her work, nothing prepared me for the exquisite simplicity of her rooms. She

A door opens into an atmosphere of mystery and drama with an Egyptian-inspired mural created by trompe l'oeil artist Christian Granvelle. The mural also serves to give the room an illusion of greater depth.

and Peter had combined their individual collections of antique furniture, drawings, books, and personal mementos to create an effect of quiet elegance that was uniquely their own. Their impeccable visual style extended to their hospitality. Sitting at table with them was a visual and gastronomic delight. Linda and Peter make beautiful living look effortless.

Unlike Linda and Peter's house, mine was a most uncharacteristic choice. Presented with a city—Miami—that offered Mediterranean Revival houses that reminded me of my years in Italy, Art Deco fantasies about which I had written, stucco mission bungalows of early Miami settlers, clapboard cottages seemingly transported from the New England coast, and sleek examples of tropical modernism, I purchased a quirky ranch house with a cottage in a secluded wood.

From the moment I moved in, *In Your Own Style* became more than a book I was in the middle

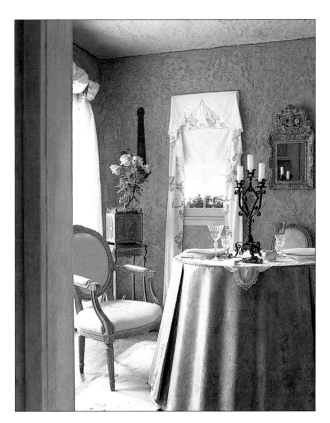

of writing. I was living out its message: To create wonderful, truly individual rooms you must define your own style and understand the process required to realize it.

Linda and I conceived *In Your Own Style* as a source of inspiration and instruction for people who want to tailor interiors to their own taste, personality, and way of life. As a professional designer, Linda wished to convey the quality necessary to give a "look" integrity as well as to illustrate the relationship between the look and the design process. As a writer and critic of art, architecture, and design, I wanted to enhance the appreciation of the art of interior design by describing the historical context from which it has evolved. We both sought to provide a rich gallery of

The provincial charm of a room designed by Linda Chase is achieved by juxtaposing inexpensive objects, such as the wrought iron candelabrum and lace panels, with fine antiques such as the Aubusson rug. The crude texture of the painted plaster walls contrasts with the delicate carving of the antique chairs and a period French mirror.

ideas and a firm command of the basics, enabling our readers to embark on a project with confidence.

We organized *In Your Own Style* in an easily followed step-by-step fashion: from initial concept to the development of a general plan to the final execution of the design. We include specific recommendations, offer traditional and unusual design alternatives, and reveal secrets of the trade. We present the fundamentals of design not as rules to be strictly adhered to, but as a foundation for expressing individuality. We also indicate when professional guidance is best sought.

In renovating and decorating their house, Linda and Peter used the same process that she outlines in this book. Their renovation was a total success; however, even pro-

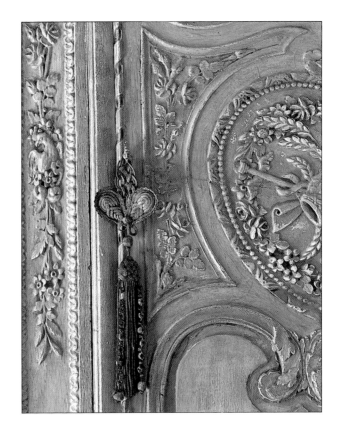

fessional designers encounter the unexpected and learn what they would do differently if they had the opportunity to go about it again. For example, they painted their floors in stages to avoid moving out during the process and realized how, in the future, they would strongly encourage anyone who possibly can to avoid living in a house during renovation. "At one point, our paint schedule was rearranged and we found ourselves without access to a bathroom."

My house had elicited trepidation from previous potential buyers who prudently looked elsewhere. I viewed it as a "before" filled with possibilities. In one moment, I saw my discovery as an Italian villa and the cottage as its renovated stables; in another, it seemed to me a Russian dacha reminiscent of those I'd visited outside St. Petersburg. In my mind the woods and grounds became rambling English gardens in a sensual tropical setting.

The carved design found on an antique Italian armoire can be a source of inspiration for a room motif. The motif could be stenciled on wood floors, handpainted on plaster walls, or even embroidered on fabric.

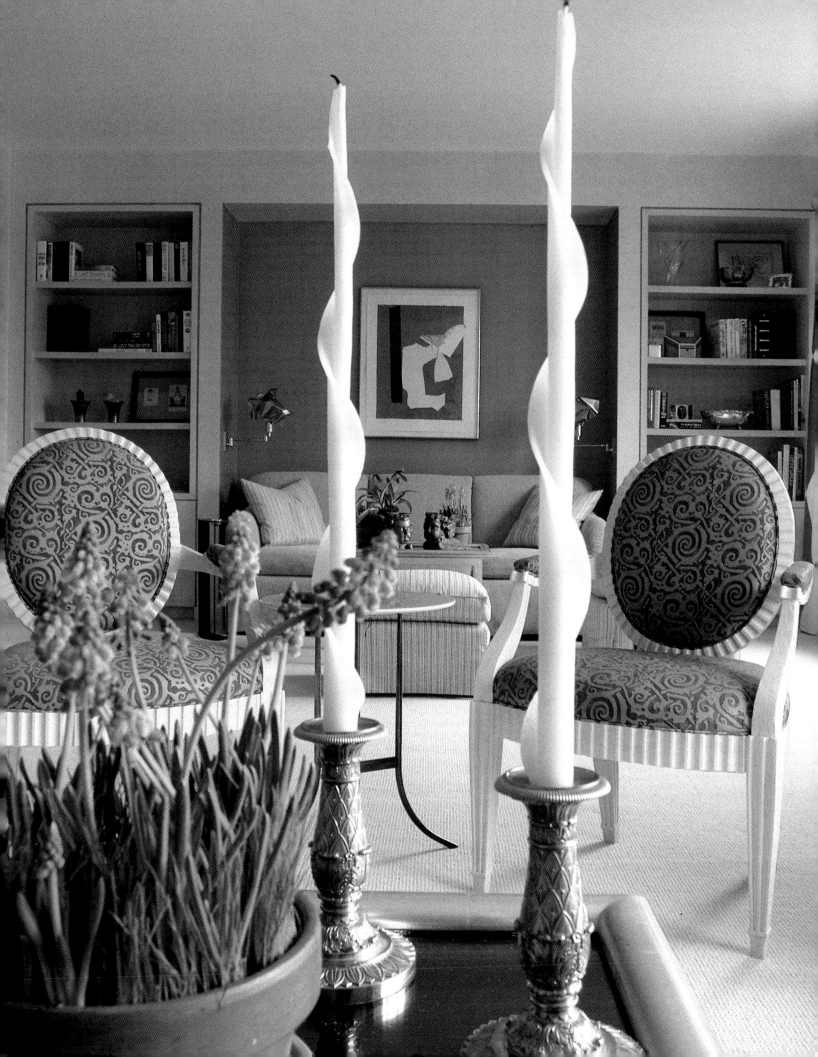

What I actually bought was three or four years of work. The renovations and decoration continue as of this writing, and my fantasy has been tempered by the practical needs of a teenage son and a nineties budget. It is the universal process of applying practical requirements, budget constraints, zoning regulations, and time allotments to dreams.

I began by installing air-conditioning and removing what seemed to be a hundred mirrors from walls and ceilings. Linda and Peter began by removing linoleum and installing hardwood floors. We both needed additional storage space, room for our libraries and modern electronic equipment, and updated kitchens and bathrooms. Emotionally and aesthetically, we both required that the practical be tempered with beauty. Fortunately, we both began work on our houses with the prerequisite that cannot be provided in any book: good health and a sense of humor.

Design, like all areas of creative endeavor, is the art of making choices. It includes the frustration of the search, the joy of discovery, the risks of decision, and the experience that comes with the compromises every project requires.

My garden grows. Oak trees now cradle bromeliads, the dog chases squirrels and lizards through the ferns, and I marvel at the speed with which grass grows and needs mowing. My paintings begin to crowd walls, and my friends happily gather on floors not yet tiled in rooms not yet fully furnished.

Will my house resemble my lifetime of dreams? Probably not.

Linda and Peter's master plan will likely change too. But the evolution of both houses will be firmly rooted in our knowledge of design and be set free by our trust in our artistic instincts. We hope this book encourages the same for you.

LAURA CERWINSKE

Comfort and a look of tailored chic are smartly integrated in a room designed by Peter Carlson where several furniture groupings allow for easy conversation and relaxation. Photograph by Lizzie Himmel.

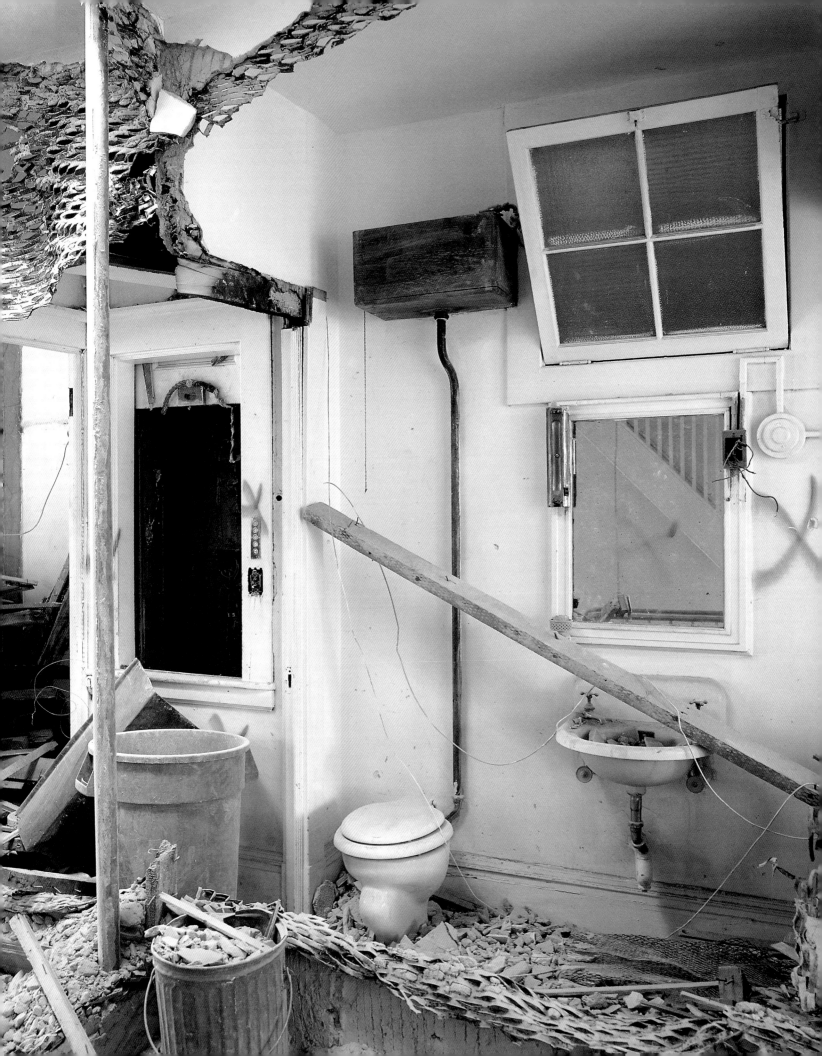

DEVELOPING

A

PLAN

A plan calls for the most active imagination. It calls

for the most severe discipline also. The plan is what determines

everything; it is the decisive moment.

L E C O R B U S I E R

It is critical to examine a room in its earliest stages in order to assess its merits and flaws. Once you have completed any necessary demolition, you are well advised to keep your job site as free from debris as possible. This makes the area safer and enables workers to function more efficiently.

OPPOSITE

You can often preserve the integrity of a structure and save time and money by restoring existing architectural elements rather than replacing them. In this house the staircase should be checked for structural soundness and repainted or restained. Treads and risers should be checked for wear. Architectural moldings can be sanded and repainted, and the tile can be cleaned and regrouted.

PAGE 18

Renovation can involve more than meets the eye. During the process of demolition you may encounter hidden problems, and thus their resulting unexpected costs. It is rare for projects to come in under budget, and in an extensive renovation, expenses can easily exceed what you anticipated.

PAGE 19

You can save time, money, and misunderstandings by preparing a budget and securing necessary permits, documents, and agreements before beginning your project. Shown are a variety of agreements, budgets, bids, and project schedules.

EMPLOYING PROFESSIONALS

Whether you employ an architect, interior designer, or interior decorator or act as your own designer, the same procedures for planning and implementing a successful design project must be followed. One of the first steps is to identify the scope of work to be done. This means asking the right questions—those that lead you to define exactly what you want to achieve. The next step is to decide whether or not to employ a professional who will assist you in determining the budget, organizing the construction and furnishings schedules, investigating materials and suitable applications, and supervising the work through completion.

If you are unable or do not wish to hire a professional, this book will help you to organize and approach your project just as an architect, interior designer, or interior decorator would.

The role of an architect is to design and build new structures or to redesign existing ones. In addition, the architect's expertise is necessary to assemble a team of consultants as required for property siting, installing all mechanical systems such as heat venting and air-conditioning systems, and all electrical systems. Architects also prepare the necessary drawings and documents required by local building departments and the project contractor.

Interior designers "create new interior architecture and form, whether in the conversion of an old building or in a completely new structure," explains David Hicks, one of Britain's foremost interior designers. "This may involve deciding the position and size of doors, windows and other openings, moving walls and staircases, improving the flow of circulation, or changing levels and scale."

Decorators, on the other hand, concentrate on "recovering, recoloring, repainting, relighting, and rearranging an existing room....In practice, many jobs involve aspects of both decoration and design.... Very few interior decorators are interior designers, but many designers also decorate."

There are several ways of selecting a designer. The best method combines observation, referral, and investigation. You may want to contact the local chapter of the American Institute of Architects or American Society of Interior Designers for a list of pro-

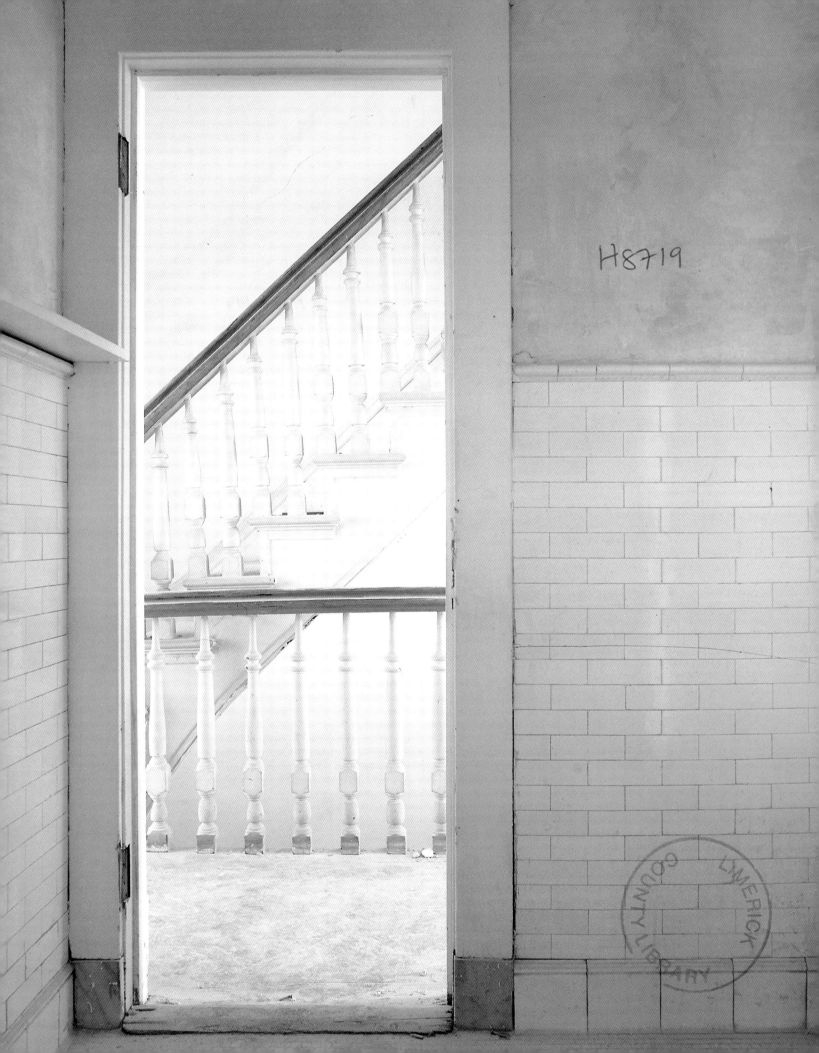

H8719

In some cases, changing only one element in a room will achieve a desired look. Removing the vintage pedestal sink might be all that is needed to update this bathroom.

fessionals in your area. In Britain, membership in the Royal Institute of British Architects indicates professional standing in the field. However, keep in mind that it in no way guarantees finding the right one for you. In fact, many excellent designers are members of no organization. Word of mouth is probably the best way to go.

Once you have a particular designer in mind, arrange for an interview to discuss the project and to review the designer's portfolio of work. Ask to visit a completed project. Professionals acknowledge that clients often have excellent ideas of their own, and they will make it their business to understand your objectives as early on as possible. The designer's expertise and trained eye can guide you to a realistic view of what will be needed to achieve your ultimate goals.

Often one professional will lead you to another. For example, you might be referred to an interior designer who, in turn, tells you of an architect he or she has worked with. Frequently architects, designers, engineers, contractors, and other craftspeople work together as teams, and finding the right team can be as important as finding the right single professional. It is wise to seek out those who work on projects of your size and with similar budget concerns. Working with a firm, however renowned, that is accustomed to projects of a larger scope or bigger budget could create major problems later on.

In determining a fee structure, you will discover that there is no one standard within the design industry. Some professionals charge an initial consultation fee and, if the client wishes to proceed, a full conceptual design fee plus a percentage calculated on the cost of all furnishings and miscellaneous materials purchased. Others, including consultants and architects, may charge on an hourly basis in combination with a percentage of the entire construction budget.

Whatever the fee structure and payment schedule, you can anticipate that a professional will require a contract and a retainer before getting started.

DETERMINING THE BUDGET

Most of the decisions you are about to make will be dependent upon your budget, and the first step, obviously, is to determine how much money you have to spend. If you are working with a designer, be candid—it will prevent misconceptions, misunderstandings, even unnecessary expense later on. After all, developing an interior scheme for a modest budget can take a designer as much time and effort as a more expensive one, and having to scale back a project adds to the designer's work. On the other hand, if you feel pressured to spend more money than you have available, or if you feel intimidated by a designer's manner or plans, he or she is probably not the right one for you.

Once you have firmly defined the scope of your project, the designer will allocate certain percentages of the overall budget to each particular phase. Examine this schedule of costs, and do your best to be realistic. Remember, most projects usually cost more and take longer than you expect.

Sometimes renovating an existing house will take longer than building a new one. Before embarking on any renovation, you will want to determine whether the effort is worth the cost. An architect or designer is probably in a better position to evaluate this for you. If you are contemplating a renovation of an older building, be certain to assess the historical value of the property. You wouldn't want to diminish its value by altering or removing original architectural elements or details. A good design professional generally will be able to assist you in assessing the particular merits of your building.

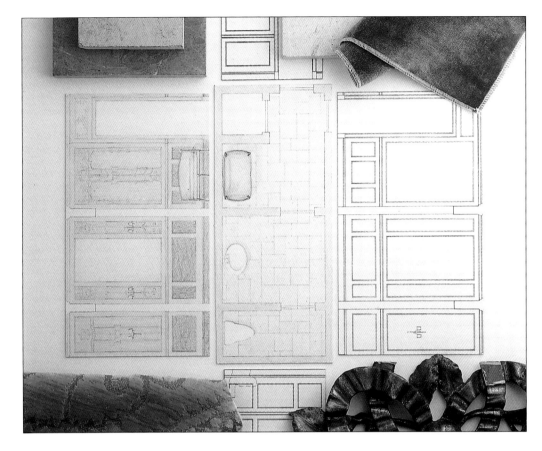

Your plans can be executed as simply as a quick sketch or as elaborately as the powder room maquette with samples shown here. By taking the time to lay out all your materials in advance, you gain a clearer sense of the relationship of the elements within a space.

Since some professionals are particularly sensitive to noticing and preserving historical details and others are less knowledgeable or concerned, you need to select your designer carefully if you are renovating a historical property. With expertise, changes can be made to accommodate your needs while still preserving the integrity of the house.

Often salvaging parts can help in cutting costs and avoiding unnecessary work. For instance, in a Federal townhouse where the mantelpiece is missing, you would have two choices: The preferable one is to find a fireplace of the correct size and period in a salvage yard; or you could research Federal designs and select one you want carved from stone to your specifications. Generally, finding a piece in a salvage yard is less expensive than fabricating a custom piece. The exception, of course, would be if the mantel is particularly fine and rare.

Even if your primary objective is simply cosmetic, or if you are interested only in adding space, revising the floor plan, or giving the house a face-lift, it is unwise to retain obsolete electrical wiring, plumbing, and heating and cooling systems. If you are unable to do everything at one time, set aside a certain amount of money and carry out the building or remodeling project in stages. For example, if the wall sconces you want cannot be purchased for a year, it might be practical and, in the long run, less expensive, to install the wiring for them during construction; or to install the wiring for a chandelier you eventually will inherit before replastering a ceiling full of cracks. A tightly restricted budget may require the space to remain essentially in its present condition. Some minimal changes in surface treatments, a few important new furniture pieces, and the addition of new curtains will often be enough to transform a room sufficently until the budget allows for the next stage.

CONSTRUCTION

One of the advantages of working with professionals is access to their team of related professionals. Architects and designers have lists of contractors they use and can guide you to those workmen who are most suitable for your project. If you choose to work without a professional, you should explore the option of hiring a general contractor before hiring any other workmen. Since they give a volume of repeat work to subcontractors, general contractors may get more economical rates than you can with a one-time project, and therefore end up saving you money and aggravation.

Doing your own contracting is seldom advisable. However, if you are making one or two small changes, a general contractor may not be appropriate. In these cases you will need to:

1. Be sure the workmen are licensed and insured.

2. Check their backgrounds with the Better Business Bureau or a local consumer affairs office (even the state attorney general's office to be sure there are no civil suits pending).

3. Visit other projects they have completed to inspect the quality of their work, and ask the clients whether the work was completed on schedule and within budget.

4. Request references and check them thoroughly.

5. Get at least three different bids in writing.

6. Make sure that all work is completed in compliance with your local building code and that all necessary permits are secured. You will need to call your local building department to learn the specific requirements in your location. Be advised that what appears to be a satisfactory job may not necessarily comply with the local building code; too often, this becomes known only after a building is completed and fails to pass inspection.

When drawing up contracts be very specific about what work is to be done and how it is to be completed. If the contractor is to relocate doors, make sure before work begins that new hinges are included in his bid. If installing a new floor, determine which party will cover the costs of a new subfloor if one is necessary. In a major renovation, it does not take long to accumulate tens, even hundreds, of thousands of dollars in additional costs if the contracts are not clear and carefully thought through.

A perfect illustration of such a case is the story told by Frederic Galacar of Galacar & Co. about his friend Roger, who lives in a circa 1795 Federal house and is the luckless owner of one of the world's most expensive front doors. "Three thousand dollars max," said the contractor, smiling broadly with reassurance. Unfortunately, every time the workmen pried off a board they found something unpleasant that needed fixing, such as rotted sills and nests of carpenter ants. Roger ultimately paid $35,000 for the new door, new sill for the foundation, and new flooring for the porch.

DEVISING A SCHEME

The first step in determining your approach to an interior is to take inventory of the existing features. What strong architectural elements prevail: a spiral staircase, French doors, fireplace, vaulted ceilings? Which of these most commands attention, and how do you intend to show it to its best advantage?

The architectural style dictates to a large degree the direction of the interior design. However, adhering to the architectural style does not compel you to produce a predictable

ABOVE

If your budget and schedule allow, custom furniture can be designed for your project. Here, drawings of scaled furniture designed by Peter Carlson, a bronze frieze, and a prototype of a bronze and steel settee are being checked for any modifications.

OPPOSITE

For a client presentation, a professional designer will usually work out a scaled furniture plan and key in each of the individual components. Coordinating as many samples as possible, such as those shown here—fabrics, wood veneers, metal finishes, stone samples, as well as furniture and lighting designs—helps the client to better visualize the completed space.

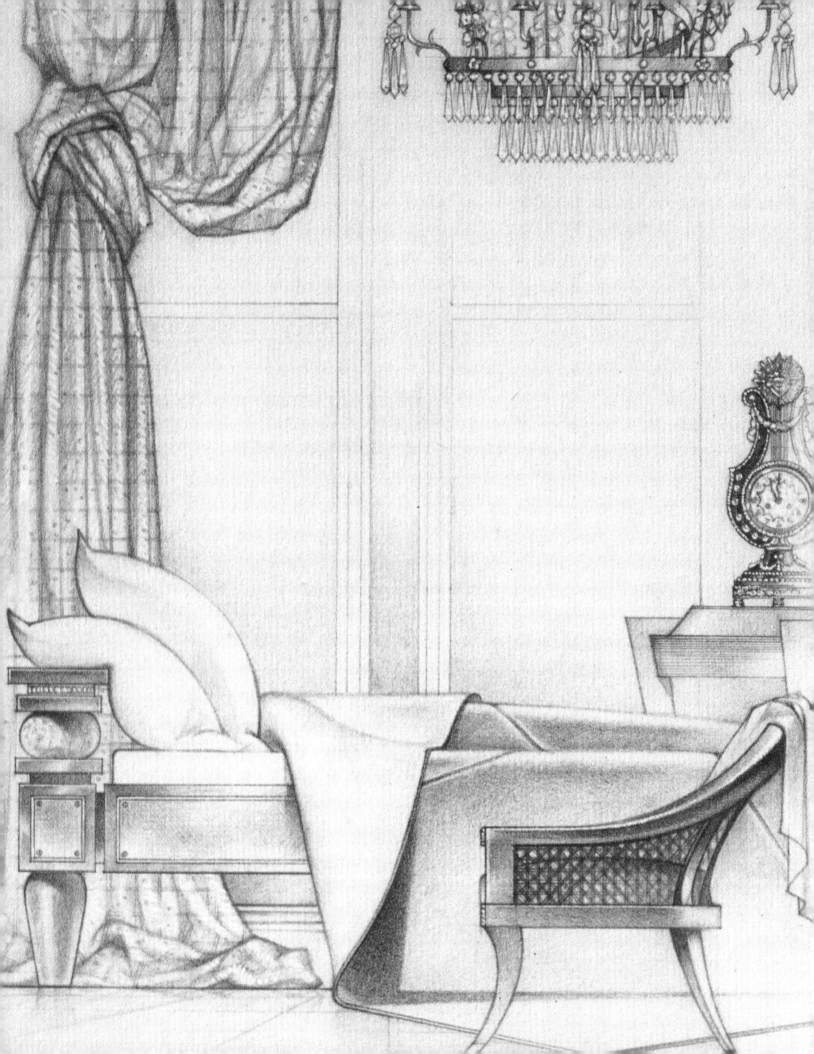

interior. A house with Palladian influences, for example, does not necessarily call for a strict Palladian interior, though it should be strong and linear and reiterate the principles of the Neoclassical style.

Once the room's major features have been clearly established, don't detract from them by drawing attention to too many other elements. One of the most common mistakes in design is placing equal importance on too many elements, thereby distinguishing none and depriving a single feature of any focal dominance. The best rooms employ a limited number of distinctive features and successfully relate them to one another. (This tenet holds true for furnishings as well as architectural elements.)

The overall proportions of a room also need to be considered at the onset of design. A generously proportioned room usually offers more options than a small one. The ideal for someone with classical tastes might be the "double cube" room with ornate moldings and high ceilings, two fireplaces opposite each other, and beautifully proportioned, symmetrically positioned windows and doors. A low-ceilinged room broken up by an irregular placement of windows and doors needs more ingenuity and patience. The key is to not try to make it look like the double-cube room. It is better to conform to existing architecture and achieve something tasteful than to attempt to redefine a space with inadequate architectural elements. There is nothing wrong with adding properly proportioned crown moldings to twelve-foot ceilings, but to add the same moldings to eight-foot ceilings would be proportionally clumsy and visually disastrous. Rather, maximize whatever redeeming qualities the room does have.

In an apartment with eight-foot ceilings, the walls, ceiling, and floor will require greater visual continuity to integrate the surface planes. A sharp distinction between ceiling, wall, and floor is less desirable and would only serve to emphasize the poor proportions and choppy layout. This does not mean that the ceiling, walls, and floor of a difficult room should be painted the same value of the same color, but it would be wise to limit their range. Conversely, in the classicist's ideal room, you might want to paint the walls in a definite color and articulate the ceiling in a shade of white to dramatize the volume.

Equally important in the evolution of a room are the existing surface materials and selection of companion materials. In fact, this is where your options really begin unless you are willing to undergo structural or architectural changes to perfect a room. With the exception, perhaps, of historical restorations, these are not questions of what is correct or incorrect, but of defining your own inclinations and needs. From this point on, every decision you make furthers your commitment to the character of the room and determines its personality.

Textural subtlety, often overlooked, can be as important as the more obvious color and form. A variety of looks can be achieved by subtly manipulating and integrating textures. In fact, materials often define a particular designer's look, and may even typecast his or her work. Chintz, for instance, immediately brings to mind a Rose Cumming or Mario Buatta interior. Imagine a monochromatic, generously proportioned room and you think of what Syrie Maugham did best.

Many of the most exciting interiors not only illustrate these principles, they incorporate an element of whimsy or the unexpected as well. However, unless you engage the help of a professional, or have a trained eye and a great deal of self-assurance, you are best advised to adhere to more conventional ideas.

One of the easiest ways for a designer to convey the true feeling of a room is through an artist's rendering, such as this one of a Kip's Bay showhouse room designed by Peter Carlson. The actual room is shown on page 132. Illustrator: George Stavrinos

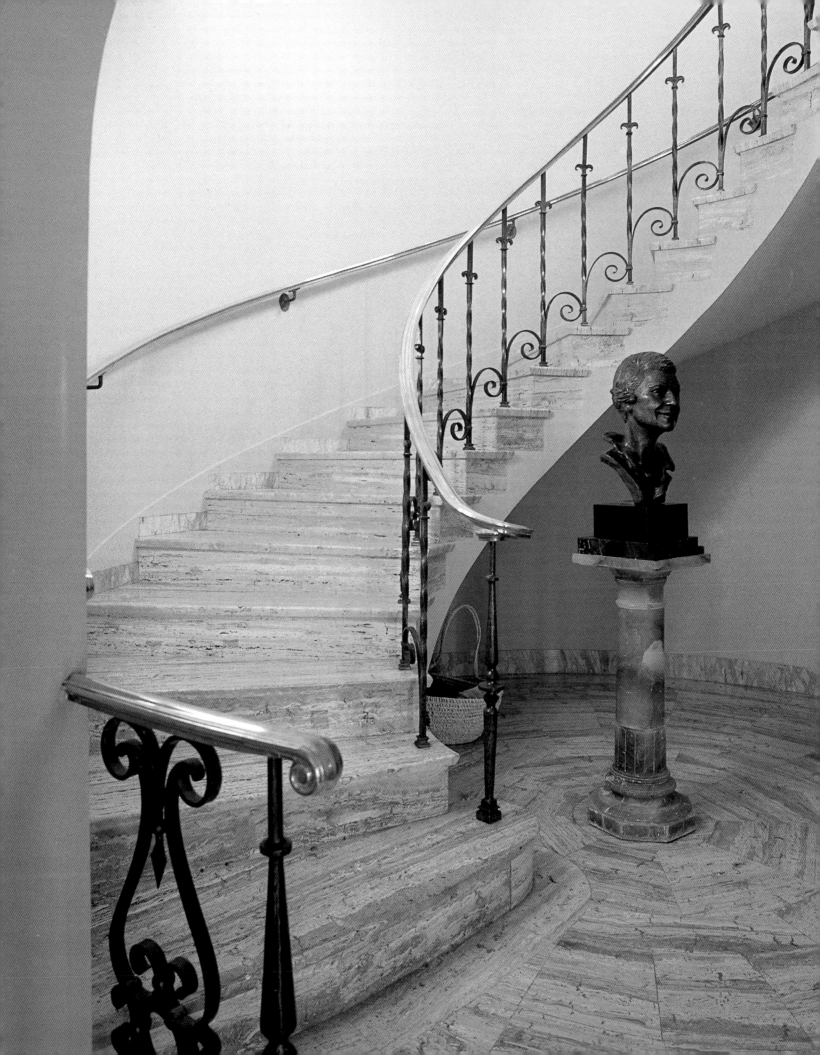

ARCHITECTURAL
ELEMENTS

Addressing the architectural elements at the outset simplifies

the remaining work of designing an interior and affords greater

latitude in executing the decorative scheme.

P E T E R C A R L S O N

The fundamental character of a house is derived from the style of its architectural elements—staircases, fireplaces, doors, windows, and moldings—and their materials and proportions. Great imposing houses with a wealth of beautiful architectural elements traditionally have spacious rooms with high ceilings to accommodate these elements; smaller rooms must have a careful selection of fewer and simpler elements.

Carefully examine the existing architectural elements in your rooms—and their materials and proportions—to determine if they are compatible with the style you desire. Thorough research of the period and style will provide you with a knowledge of the exact proportions and details that will give your look integrity and set the foundation for all that follows in composing the interior.

If you decide that one or more of the existing architectural elements are unsuitable or in poor condition, you will have to consider the extent of alteration necessary to modify, remove, and/or replace them. Major modifications may require the expertise of an architect, interior designer, and a skilled contractor.

STAIRCASES

A staircase need not be simply a passageway from one level of the house to another, but can offer a wonderful opportunity to establish the character of the interior. It can be designed as straightforwardly as a simple series of steps, as dramatically as a monumental sculpture, or as discreetly as a slender spiral. It can be constructed in obvious adherence to the laws of gravity or it can offer the illusion of being suspended in space. Materials can range from stone and wood to metal and even glass.

The staircase comprises elements that together compose its architectural style. The *banister* is also known as the handrail. The *newel post* is the column at the top or bottom terminus of the banister. The *balusters* are the series of turned or plain columns that connect the banister to the stair. The rhythm of the staircase is determined by the height of the riser (the vertical distance between each step or tread) and the distance between landings. The tread depth, or depth of the step, also contributes to the character of the structure.

If you are installing or replacing a staircase, keep in mind the amount of available

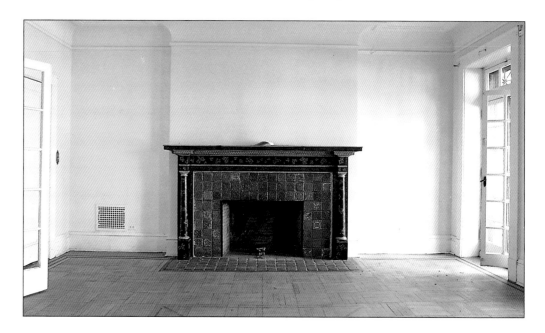

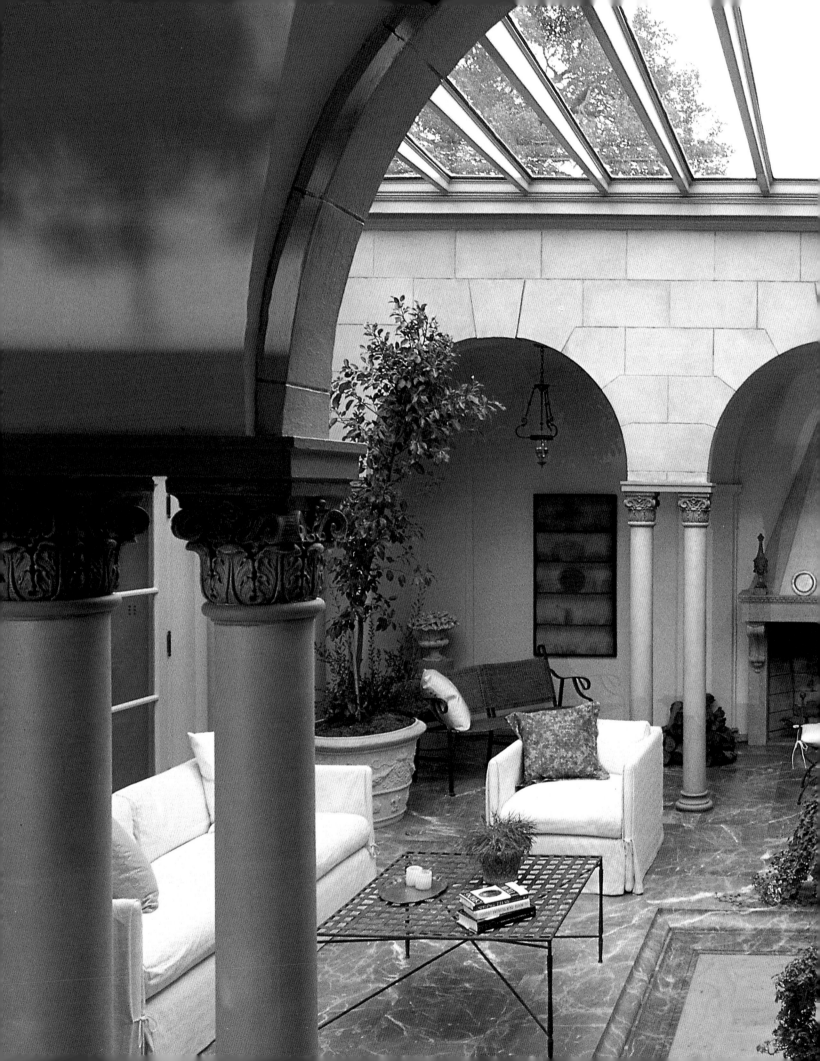

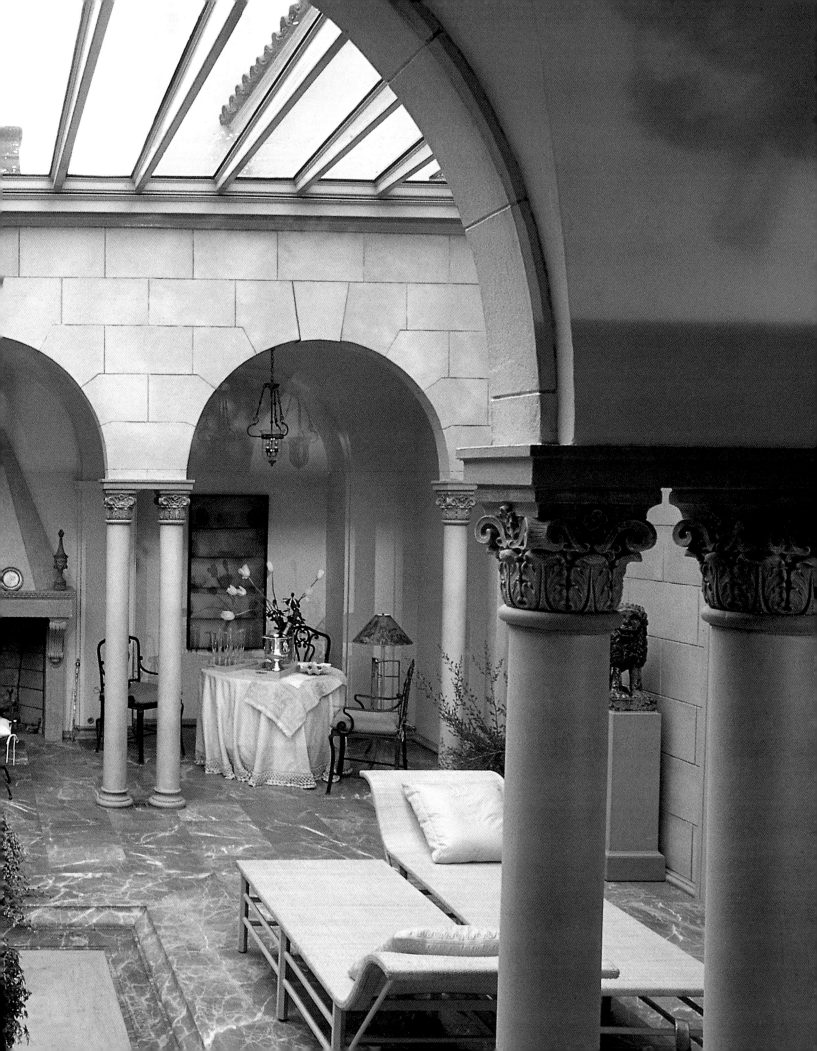

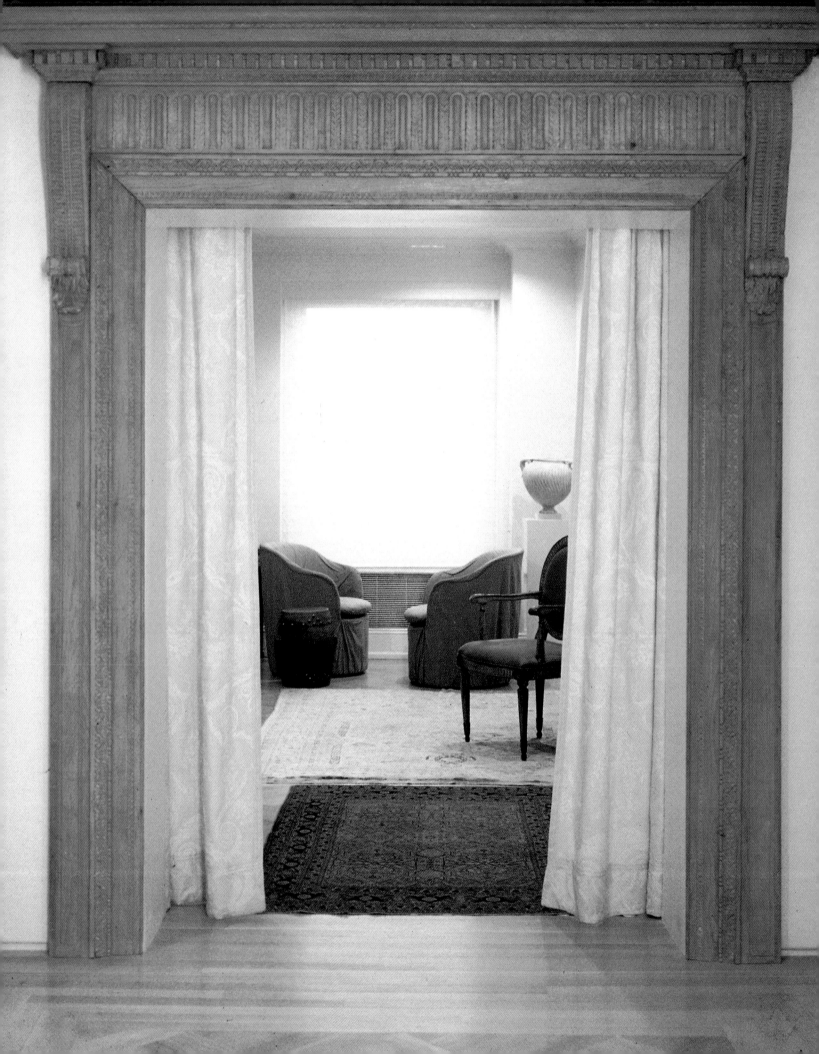

space it will require: A curving stair needs more room than a straight flight, and spiral stairs require an area at least six feet square to allow for wide enough treads. If you are unable to replace or undertake a major renovation of a staircase, you can still modify its character by replacing one or more of its components, such as the banister or newel post, by painting or staining uncarpeted wood, or by removing existing or installing new carpet.

FIREPLACES

A fireplace can be one of a room's most inviting assets and its most compelling architectural feature. It provides a focal point as well as an aura of elegance, comfort, or domesticity. Even nonfunctioning fireplaces can be used successfully as a room's focus.

The fireplace is composed of three principal elements:

The *mantelpiece,* usually made of wood or stone, is the shelf above the fireplace opening. The *hearth,* usually made of stone or brick, is the floor of the fireplace and extends a short distance from the foot of the fireplace into the room.

The *surround,* the border around the fireplace opening, is typically treated decoratively and is often completely integrated with the mantelpiece.

While all these details should be treated in a manner sympathetic to the other architectural elements, greater flexibility is permissible in the selection of the fireplace surround because its character can be more furniture-like. In a strictly period setting, such as Federal, Regency, or Louis XV, you must exercise great care to ensure that all elements produce a logical, harmonious whole. In a more avant garde setting, you can take greater liberty in your choices.

DOORS

The selection of a door style should be made in keeping with the architectural style of the house. In houses of ornate architectural styles, a less decorative version of the same style can be used for upper floors or rooms of lesser importance. In an apartment or in houses that require simpler doors, the style of door should remain consistent throughout.

TYPES OF DOORS

Flush doors have perfectly flat surfaces and are commonly used to maintain a contemporary look.

Folding doors or *accordion doors* combine swinging and sliding operations. When open, they do not project as far outward as a swinging door.

French doors are actually a pair of casement windows divided by glass panes. They typically reach to the floor and are hinged to open in the middle.

Louvered doors have a series of narrow horizontal openings framed at the top with overlapping slats to promote ventilation.

Paneled doors have decorative panels of almost any configuration that can be applied symmetrically or asymmetrically.

Pocket doors require an opening in an adjoining wall into which the door can slide.

Sliding doors operate on tracks and require no pocket. A pair or pairs of sliding doors traverse one another in different planes.

Swinging doors are hinged so they can open in one or both directions.

If your existing doors are acceptable in style but in poor condition, determine whether they can be salvaged and refinished. Decide also if there are enough doors in the room and if they are positioned pleasingly. Can the doors be relocated to allow for a better furniture layout? How does the direction in which they open and close affect

ABOVE

In a restored Federal residence in New London, Connecticut, a wallpaper border provides more graphic decoration than the crown molding. Composition medallions embellish the corners of the door frame.

OPPOSITE

A living room door surround, whose design derives from Greek temple architecture, frames the vista of an adjoining salon designed by John Saladino. Photograph by Peter Vitale.

PAGES 32-33

Repeated arches, paired columns, and the triangular hooded fireplace establish the grandeur of an atrium designed by John Saladino in a room inspired by a classical Pompeiian house. Photograph by Langdon Clay.

movement? If there is constant or even occasional congestion in the comings and goings through a doorway, you may want to widen it or add another door to the room, depending on the room's size. The help of a professional will be necessary to determine where to position the new opening, to examine the structural nature of the wall, and to decide exactly what will be required. The new opening will then have to be designed according to the scale and architectural and decorative style of the room.

If the room has sufficient doorways and they all are adequately positioned, your next consideration will be the style, material, and finish of the existing doors. Do they need to be painted, stained, and/or sealed? In a two-hundred-year-old country house, heavy wooden doors simply stained and embellished with forged iron hardware would enhance the interior's rustic appeal. A modern city apartment, on the other hand, would likely call for doors painted with a high-gloss enamel or other clean, sleek finish. In a beach house, unpainted louvered doors are appropriate to the casual, breezy atmosphere.

Door frames have traditionally been treated with a variety of applications. The *entablature,* which derived from classical temple architecture, includes a triangular form known as the *pediment,* which rests on a horizontal beam called the *architrave,* which can

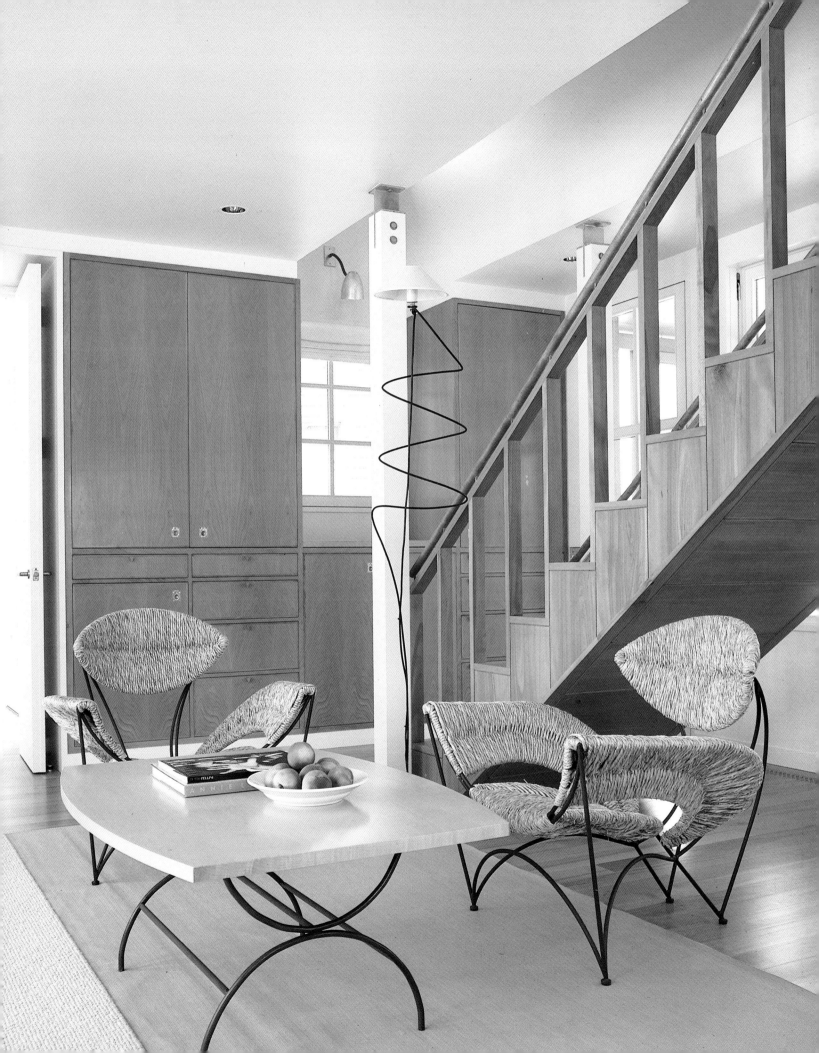

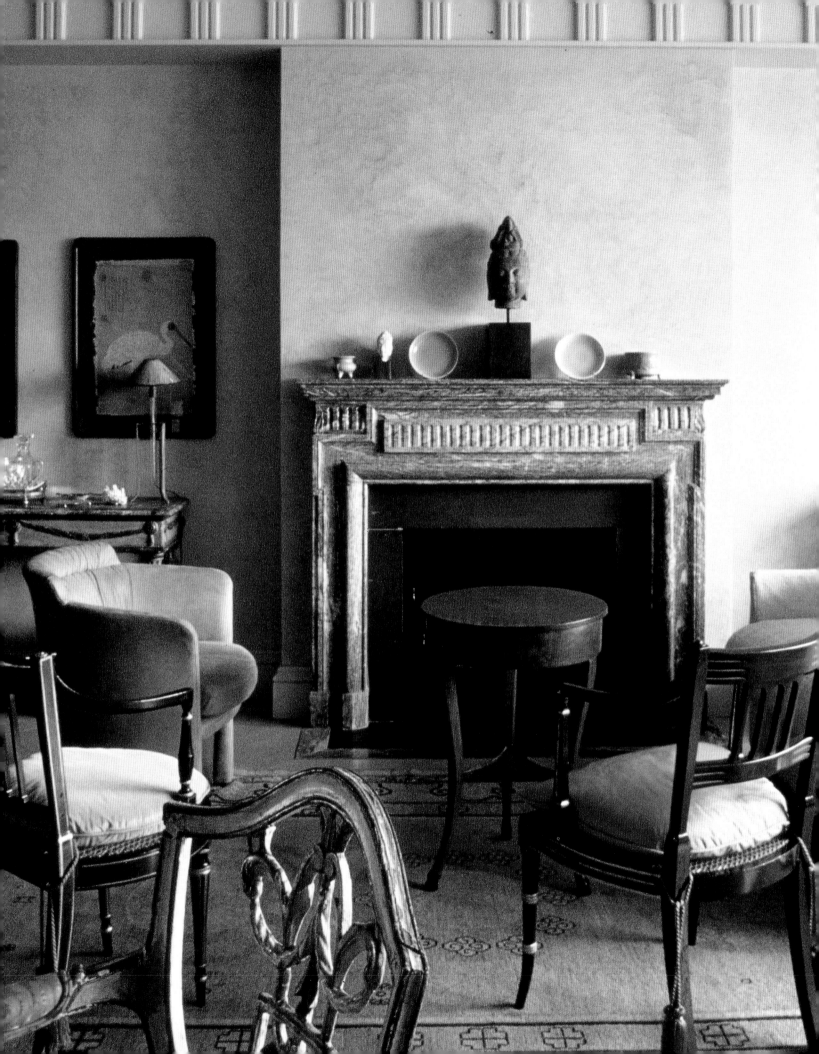

have decoration applied. *Pilasters* are flat or fluted column shapes applied to the door frame. *Rosettes* are carved or molded ornaments in the form of a flat, stylized rose that are generally applied to the upper corners of a door frame where the horizontal and vertical moldings meet. Today, the doors of most houses built in contemporary styles are framed with flat moldings.

Acoustics and privacy are other factors to be considered in the selection of doors. Solid-core wood doors filter out more sound than lighter hollow-core doors.

WINDOWS

Similar preliminary questions apply to windows as to doors. Are there enough to allow for sufficient light and ventilation or to accommodate important views? Are the windows pleasingly proportioned and are they placed appropriately in terms of the style of the room? Is the style of the windows in keeping with the architecture of the house? Chapter Nine, *Windows and Window Dressings,* describes in detail the different types of windows, their functions, and the effects various window treatments achieve.

By preserving the architectural integrity in your window selection, you will be protecting the appearance of your exterior facade. As with the alteration of other architectural elements, you should seek the expertise of an architect or interior designer when structurally modifying windows.

Do not overlook the decorative potential of the window itself. The frames and surrounds can be either stripped or embellished; extra molding can be added to make windows appear more substantial.

MOLDINGS

Moldings, which were originally devised to disguise joints, today serve a number of functional and decorative purposes. They provide protection for the base of the plaster work, physical and visual transition between the various planes of the room, and a neat, finished look to the interior. Their designs generally derive from the wood construction of the earliest Greek temples, later copied in stone, and from the architectural ornamentation of medieval churches. Today, most are manufactured in simply cut or elaborately carved wood, or are molded in plaster or synthetics.

The *base molding* marks the joining of the wall and the floor while serving to protect the wall from scrape marks.

The *chair rail,* a molding devised to prevent the backs of chairs from scraping or denting plaster or damaging the wallcovering, can be used to visually separate colors or decorative treatments on a wall. Usually applied around the perimeter of the room approximately thirty inches from the ground, or two-thirds of the distance from the ceiling to the floor, chair rails require a room of substantial height to look proportionally pleasing.

The *crown molding,* named for its position at the top of the room, moves the eye gracefully from the vertical plane of the wall to the horizontal plane of the ceiling.

Picture rails were developed during the Victorian era to act as suspension devices for pictures. Today, they add a beautiful finishing touch to rooms with high ceilings. It is usually a mistake to use them in rooms of less than ample proportions, where they would only serve to emphasize the lack of ceiling height.

Examine your existing moldings to determine if they are original and if they are in keeping with the style of your interior. If they have been replaced with something unacceptable, you may want to duplicate the original from the great range of reproduction moldings available today. In a sleek interior, you may even prefer to eliminate the moldings altogether.

OPPOSITE

The Greek Revival crown molding of triglyphs and dentils is echoed in the classical detailing of the fireplace in a room designed by John Saladino. Photograph by Lizzie Himmel.

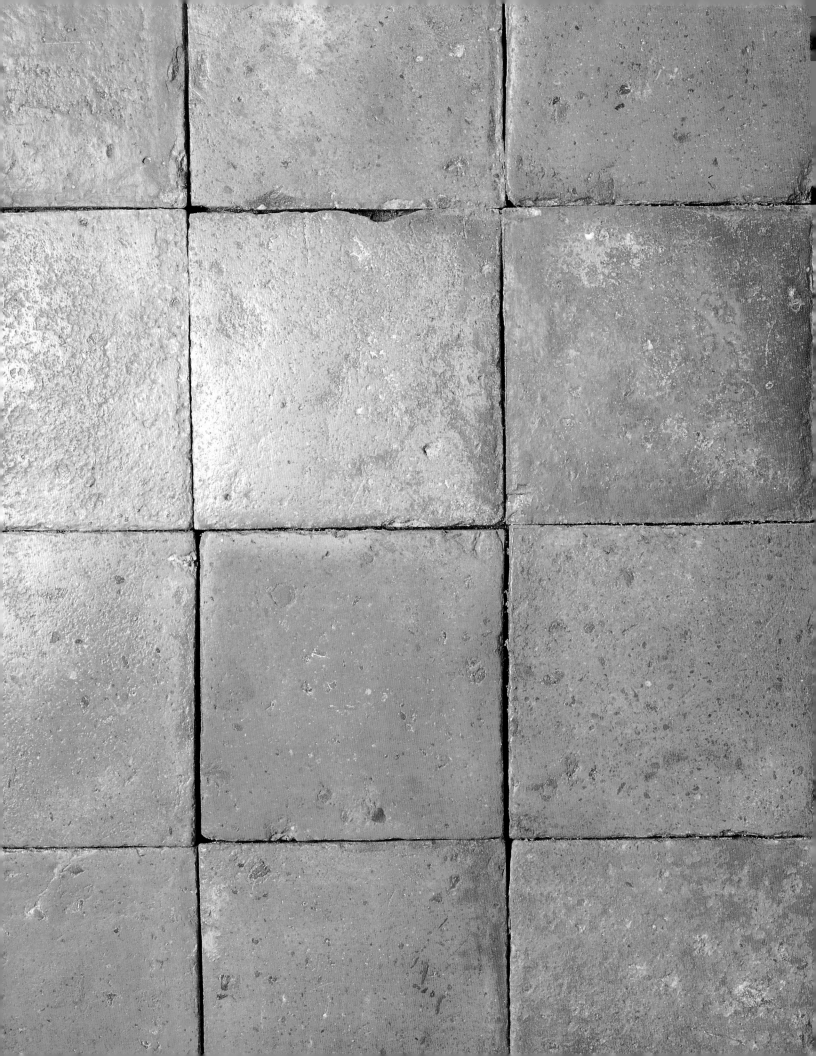

FLOORS

AND

FLOOR

COVERINGS

Infinite possibilities lie underfoot.

MARK HAMPTON

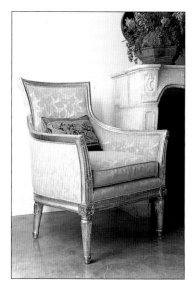

A B O V E

The mottled concrete floor is a striking counterpoint to the formality of the gilt bergère and limestone mantelpiece. Photographed in the showroom of Gregarius/Pineo, Los Angeles.

O P P O S I T E

Honed marble tiles were selected by Caroline Sidnam and Linda Chase to give a sleek, continuous look to this New York penthouse and to provide an elegantly subdued monochrome backdrop for the Jean Michel Frank furniture not yet installed.

P A G E 4 0

Simple square antique pavers with a waxed finish from La France, Los Angeles.

P A G E 4 1

A floor finished in silver leaf adds glamour to an elegant bed chamber. Photograph by Peter Bosch.

The floor is the foundation of the room on which everything else will ultimately rest. Since it is an architectural component as well as a decorative feature, it is usually wise to decide on the type and design of the floor early on. Its color, texture, and design will not only determine the floor's character, but also contribute to the overall personality of the room. The floor can become either a considered background for furnishings or a bolder element upon which all other decisions will be based. For example, a neutral floor such as stained hardwood, plain carpet, or sisal will allow for much greater latitude in the selection of fabrics than an elaborate marquetry inlaid floor or a richly patterned and brilliantly colored rug.

Wonderful floors can be one of the more costly elements in the design of a room, yet with resourcefulness and imagination, many have been realized at moderate cost. They can be fabricated from concrete, wood, or stone, and can be treated with paint, stains or washes, and polished or waxed. Whatever the specific material and treatment, the flooring must be appropriate to the function of the room. Since every room of the house has different practical requirements, floors and floor coverings will likely need to vary. You will need to examine your overall layout and determine which areas will receive the most traffic and which will have furniture groupings that might receive a rug as a focal point.

It is important to remember that a continuous look is almost always preferable to a variety of different materials that start and stop. For practical purposes, however, materials may have to change in areas that will receive greater wear, such as the entry, kitchen, and bathroom.

Just as different materials offer varied effects, the floor's pattern or lack thereof adds to the room's distinction. Your desired "look" will determine your direction toward a bold or subtle, formal or informal, serious or whimsical design. If what you are looking for is a subtle backdrop to accentuate your furnishings, your choices might include simple hardwood flooring, a discreetly patterned carpet, or a handsome sisal. If, on the other hand, the floor is to be a feature of the room, you might favor a boldly patterned floor or an elaborate carpet.

Before selecting from among the wide range of available natural and synthetic materials, it is advisable to first examine the condition of a room's existing floor. A new floor will have a much better appearance and remain in good condition if it is laid over a sound, level subfloor or the appropriate underlay. If the existing subfloor is unacceptable, a new one may need to be installed and the advice of an expert called for. Even when existing floors are compatible with a new plan, they may still require minimal work, such as sanding, polishing, or staining, to obtain the desired look.

COMMON MISTAKES

Regardless of the type of new flooring, you must start with a clean, level surface. When applying a new material over an existing floor, it is important to make sure the new flooring materials will not resist the existing flooring material. If you have any questions, contact the manufacturer of the material you are installing.

A professional installation is imperative to ensure the long life and beauty of your floor. (Unless you are an expert, a do-it-yourself job will most likely look just that.) Often, great care is taken to select a flooring material but without regard as to who will install it and the method of installation. The best materials procured at great cost can be ruined in the wrong hands. Always be sure to budget enough money for an optimum installation.

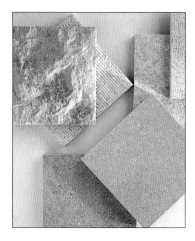

ABOVE

A variety of stone finishes includes polished, honed, ribbed, split-faced, flamed, and bush hammered.

BELOW

By adding a stylized decorative border, you can dress up an otherwise plain terrazzo floor. Photograph by Cookie Kinkead.

FLOORING MATERIALS

STONE

Stone floors can lend drama, elegance, old-world charm, or a rustic quality to a room. While they may not appeal to everyone, they can be appreciated for their strong character and beauty. Stone floors are especially appropriate for highly trafficked areas such as entries and kitchens.

The sophistication of limestone, with its subtle colorations and finely grained texture, often conveys a look of gentle grandeur. Colors vary greatly from off-whites through creams, taupes, tans, and beiges. Limestone can be very soft or as hard as marble. Some highly patterned limestones are formed almost entirely of fossils—corals and shellfish. These can work handsomely with contrasting bands of plainer stone.

Marble, a form of limestone crystallized through heat, pressure, and the percolation of subterranean water, offers the greatest variety of pattern and color. It is admired for the elegance of its dramatic colorations and its range of subtle to vivid markings. Like other stones, marble can be finished in a variety of ways that produce dramatically different looks. Used alone, it is handsome and makes a strong statement. Combining marble with more porous limestone softens its look.

Granite, equally as dramatic as marble, works especially well in contemporary interiors where a sleek look is desired. Denser and therefore harder than marble, it also can be more expensive.

Slate varies in color from the light grays and midnight blues of Spanish quarries to the purples of northern Wales, the greens of the English Lake District, and the reds of Africa. Easily riven into thin sheets, it has a smooth and gently uneven texture. While slate is usually associated with exterior use, it can be a handsome alternative for interior flooring.

A sleek flooring material used widely in the 1940s and 50s, *terrazzo* is currently enjoying a revival in popularity. An admixture of cement and marble chips, it is available in almost any color combination. Terrazzo floors are crafted on site: the materials are combined, poured, leveled, left to dry, and then polished. Though it can stain and some deeper colors may fade in harsh sunlight, terrazzo is relatively easy to maintain.

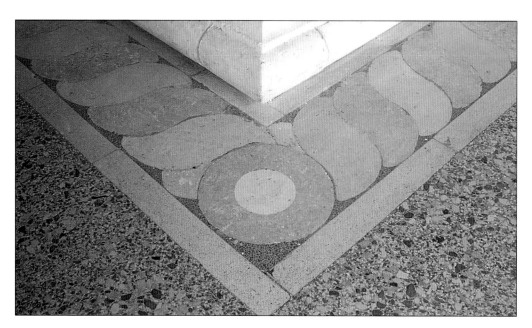

Concrete, a dominant material in the construction industry, is, surprisingly, an ancient synthetic building material. It can be used inventively in residential settings. Made from a mixture of water and cement—an aggregate of sand and stones—concrete requires a sturdy subfloor or a solid floor at ground level for support. While it is primarily valued as a structural material, its raw industrial aesthetic can be a dramatic departure from a more traditional material. When tinted, scored, waxed, or polished, it takes on an unexpected elegance. Imagine a fabulous French *fauteuil* (beautifully refined armless side chair) sitting on a polished concrete floor. Interesting effects can be achieved by grinding tinted concrete and installing it as if it were terrazzo. The design possibilities are endless.

STONE FINISHES

The processing of the exposed surface greatly affects its final coloring and look. Smoothing diminishes the intensity of color, while polishing heightens it with its resulting gloss. Bush-hammering gives a stone surface a rough slablike quality. Scorching, an intensive heat process also known as flamed or flamme, imparts a slightly rough or velvety finish. Honing leaves stone with a smooth matte surface.

All of the processes are performed after the slab is cut. Polishing and honing are typically performed on a 3/4-inch-thick slab; scorching and hammering require a minimum of 1¼ to 1½ inches in thickness. The finish a stone will receive can be as much a design aspect as the stone selection itself, and unexpected finishes can add wonderful texture to a room, as designer Albert Hadley's interiors often illustrate. He is fond of stenciling and incising floors in all kinds of patterns, as well as sanding and varnishing dark colors to a mirrorlike gloss.

BRICK

Brick floors, usually found in older houses, add warmth and impart a rustic ambience. Brick is molded from clay and then fired. Its color has traditionally reflected the locale from which the clay came, varying from deep browns to warm reds and pinks. Today white, cream, and soft pink bricks are made from an aggregate, and more strident colors can be produced with pigments. They can be installed in a variety of patterns, from running band to multidirectional basketweaves and herringbones. Brick floors can be cleaned with a weak solution of muriatic acid and water.

TILE

The earliest ceramic tiles were made nearly six thousand years ago in Egypt—slabs of clay that were molded in wooden boxes, dried, and fired in a kiln. Except for the substitution of mechanical presses for hand

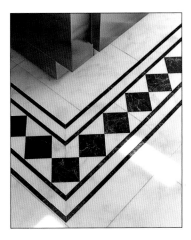

Inset squares of black marble create a starkly graphic diamond-patterned border on a highly contemporary kitchen floor.

molding, the process remains much the same today for tiles such as terra cotta, which provide simple, durable floors and a beautiful patina as they age.

For sleek interiors, uniform and evenly finished machine-made tiles are more suitable than handcrafted, irregular tiles with their variations in shape, texture, and color. Patterns created by tiles of different size, shape, and texture can enhance a sense of depth, make the walls of a small room seem to recede, or make the floor appear wider and longer. Patterns of tile can also create historical effects by replicating motifs of a specific period.

While there are no hard-and-fast rules about choices of tile for specific rooms, it is generally true that modest-sized rooms benefit more from the use of large tiles because they do not break up the space visually like small tiles. Mixing tile sizes is an option for those who have a sure sense of design and proportion. In a room where tiles are to be applied to both walls and floors, it may actually be smarter to use different tile sizes for each surface, since the settling of the foundation will make it nearly impossible for the two tile planes to align. Keep in mind, however, that wall and floor tiles are seldom interchangeable because they are fired at different temperatures to accommodate different uses, and because most interior wall tiles do not have the wear or impact resistance necessary to withstand foot traffic.

The decorative art of mosaic has embellished floors since the time of the ancient Romans. Mosaics found in the ruins of Pompeii and Herculaneum inspired a long tradition of composing geometric and pictorial designs with small marble, ceramic, and glass tesserae (the individual tile pieces that compose the mosaic image). Today, mosaics are most commonly found in hallways, courtyards, and bathrooms. Different materials produce different decorative and textural effects: Marble, with its subtle variations of color, shading, and pattern, produces an elegant look; ceramic, with its more consistent pigmentation, can have either a matte or lustrous appearance; glass is brighter, even jewel-like. These materials can either be set directly into wet mortar or pasted down on a full-size cartoon of a design and then inverted and set into wet mortar and later grouted.

Regardless of type or method of installation, all tiles require a level floor to insure against buckling. This is especially true of handcrafted tiles, which are irregular to begin with. Once installed, almost all tiles need to be sealed to protect against spills and scuffing. Of the many sealants available, oil, beeswax, and polyurethane are the most commonly used. As with stone, it is always wise to contact the manufacturer or supplier about the different visual effects of various sealants and for specific application instructions.

Exotic floor treatments such as leather tile and vinyl tiles that have been metal-leafed impart an unusual quality to a room. Leather tiles bring an increasing look of warmth to an interior as they darken with age. Leafed floors give a room a patina unique to metal.

RECOMMENDATION
WITHIN THE DESIGN INDUSTRY, A GENERAL GUIDELINE IS TO CALCULATE 10 PERCENT OVERAGE TO COVER ANY BREAKAGE IN SHIPPING OR COMPLICATIONS THAT MAY ARISE DURING INSTALLATION. METALLICS NEED EXTRA CARE IN ORDER TO AVOID DAMAGE TO THE FINISH. AGAIN, EXPERT INSTALLATION IS A MUST. WE'VE ALL SEEN BATHROOMS WITH TILES INCORRECTLY MATCHED AND IMPROPERLY JOINED. ❧

WOOD

The hardness, grain, color, and cut of different woods determine their suitability for various

rooms and types of floors. Woods such as beech, ash, maple, white pine, and white oak are lighter in color than those such as mahogany, cherry, and teak. Such woods as maple, which have little grain, are more visually uniform than others—ash for example—which have considerable grain. Hardwoods, such as oak, beech, ash, and walnut, while more expensive, are preferable for flooring where the appearance of grain is desired. Softwoods, such as pine, spruce, and other evergreens are more suitable for floors that are to be painted. Teak, mahogany, and ebony can make up beautifully either as an entire floor or as a border detail. However, because of increasing environmental awareness, we may be seeing less extravagant use of these more exotic woods.

The method in which lumber is milled determines much of its character and produces different effects. When sawed in slices, the process called "through and through," yields the maximum amount of usable, though not necessarily the highest-quality, timber. Logs sawed in quarter sections, termed "quarter sawn," produce a symmetrical grain that is highly desirable in appearance, but more costly because of the waste the method generates.

Simple tongue-and-groove strip flooring is produced by the joining of two boards by means of a projecting member along the length of one board that fits into a corresponding groove in the other. The strips are generally less than three inches wide and 3/4-inch thick. Tongue-and-groove flooring is the most popular and one of the most durable of all wood floors. For visual effect, it is best installed on the long axis of a room, especially when bordered with patterns of contrasting woods.

Parquet flooring is the result of a long tradition of laying wooden blocks or strips in various geometric patterns whose effect is to integrate architecture and decoration. The most famous and enduring parquet pattern is known as *parquet de Versailles,* a flooring pattern used continuously since the seventeenth century in all manner of buildings. Its wood panels are set on the diagonal and framed by additional bands. A square or diamond inner pattern is made up of shorter strips of wood arranged in an interlocking design. It is still possible today to acquire an authentic antique parquet removed from an old château or villa. While very expensive, it will bring a feeling of history and the beauty of aged materials to a new interior. While reproductions of these floors are widely available today, they cannot compare with authentic parquet flooring.

Wide, *handsawn planks,* the earliest form of wood flooring, were once so highly valued that they were often installed without nails so they could be moved from one location to another. Reproductions with surface irregularities that reveal the handcrafted quality of those early boards are available today. These wider plank floors are more susceptible to warping than narrower strip flooring and are considerably more expensive because a much greater thickness of wood is necessary to combat warping.

WOOD TREATMENTS AND FINISHES

For centuries, artists have been adding decorative patterns and creating trompe l'oeil effects by painting and stenciling simple wood floors. *Painted floors* are a departure from the commonplace, for even the simplest paint application can transform a room's sense of space and mood. Scandinavian interiors are superb examples of the timeless elegance that can be achieved with paint. Whether a one-color application or a complex design, each type of handpainted floor imparts its own unique charm. In addition, the gradual wear and tear of the painted

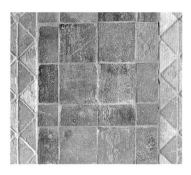

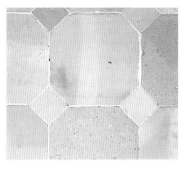

TOP

Antique pavers from La France, Los Angeles are laid in a pattern typically used in prestigious homes of the Renaissance.

CENTER

Antique terra cotta pavers are combined with reclaimed flooring and bordered on either side with new marble that has been highly distressed to give an impression of wear. Stone courtesy of Ann Sacks, Los Angeles.

ABOVE

Antique pavers from Bordeaux in octagon shape with clipped corners. Available through La France, Los Angeles.

floor's finish can be considered an aesthetic extension of the painted look.

A more subtle approach to painted floors is *color washing*. This process involves the application of thin color washes of diluted paint to achieve a less opaque look. Like wood stains, color washes enhance the wood grain. With a wash, however, the range of color is unlimited. The creative application of successive layers of color washes can produce a wide variety of effects.

The process commonly referred to as *pickling, liming*, or *whitewashing* is essentially a lightening of the wood achieved with washes of diluted white pigment.

Stenciling was especially prevalent in eighteenth- and nineteenth-century European houses. Increasingly popular today, it is one of the least intensive means of adding decoration to a surface. Stencils can range from simple motifs to complex, elaborate designs. A handpainted touch over a stencil will soften the design's hard edges. Sanding a design with sandpaper or steel wool before it is sealed can produce a muted and more old world look.

Whatever the painting technique, surface preparation and sealing of the floor are of vital importance to the design. One of the oldest materials used to seal and finish wood is *beeswax*. It can be used alone or applied over synthetic-based products such as polyurethane. Beeswax, despite requiring more maintenance than synthetic sealants, should not be overlooked. Its mellow, timeless appearance is incomparable.

CARPETS

Fine carpets are works of art. According to Larry A. Hokanson, president of Houston's Hokanson Incorporated, "The best are those that are not so overpowering in color or design that all other aspects of the room are lost. Because the overall design is interrupted by furniture, a fine carpet must be appreciated in small portions." He further explains that "color placement on a carpet is as important as the design." Like works of art, however, carpets should not be color matched to fabrics and other accessories, just as you would not match the colors in a painting to everything else in the room. (Nevertheless, there is nothing wrong with combining colors into a harmonious palette.)

Most carpets are made by the weaving of warp and weft threads. The warp is kept under even tension on the loom while the weft, which binds the warps together, is passed from side to side, as if threaded over and under. The result is a flat fabric resembling a European tapestry in weave. In cut-pile carpets, "knots" of yarn, usually wool, lie between the foundation wefts. The finest examples, which are slowly and painstakingly handwoven, come from the Orient, where the yarn tufts that give the rug its pattern and color are inserted and knotted to the warp one knot at a time. The more knots per inch, the finer the rug. In a very high quality Oriental rug there may be as many as 800 knots per square inch. The designs, typical of the Persian preoccupation with gardens and paradise, have been copied century after century. Usually there is a central field or ground surrounded by a border. Like Native American Indian rugs, which are also knotted or tied, fine Oriental rugs harmonize well in traditional and modern interiors.

The soft texture, feel, and appearance of smooth *fitted carpets* have made them one of the most popular of floor coverings. Acoustically effective in absorbing sound and easy to clean and maintain, they are manufactured in one piece with their backing produced at the same time as the pile. Fitted carpet can be woven, as in the case of Wiltons (which are woven on a jacquard loom that allows up to five or six colors in a

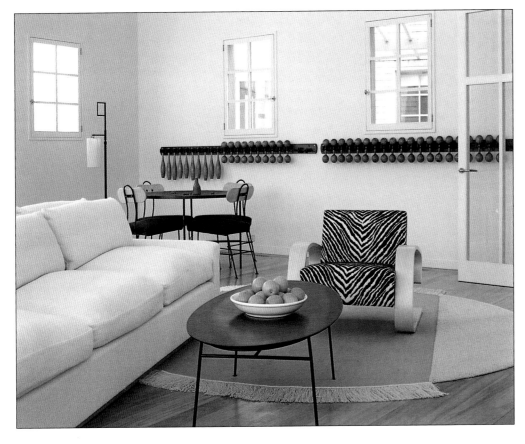

pattern design and whose pile is cut) and Axminsters (the first seamless English carpet, now one of the most popular worldwide), both of which can be woven in broadloom widths of more than six feet. The majority of patterned carpets woven in the U.S. are tufted, a process in which the yarn is pushed up through a backing to form tuft loops that may be cut or left uncut. The density of the yarn and the height of the pile affect its appearance and durability.

Fitted carpets are produced from a variety of fibers in different amounts and combinations. Wool—durable, flame-resistant, and the most buoyant—which is among the most expensive, combines well with other fibers, including synthetics (which have low resistance to flame and more readily show wear).

Industrial carpet has a tight, clean, streamlined, continuous look. It is an excellent choice for tight budgets and for rooms that must cope with children and high traffic because it offers a great look and long wear for less money than other carpets. Though most industrial carpets are manufactured in more architectural or subdued tones, they, like sisal, can add textural interest to a room.

Sisal can bring a casual touch to a formally furnished room and a tailored or sleek note to a more flamboyant one. It is available in a wide variety of woven patterns and a great range of colors. A recent fashion for hand-painting on sisal has broadened its decorative possibilities. Sisal comes from the leaves of the agave plant and ranges in color from honey to russet or dark brown; it can also be dyed. Because of its durability, it works especially well in hallways and other hard-wearing areas. Although sisal can look handsome on staircases, be advised that the material can be slick.

Sea grass and rush matting, which are moderately priced, are available in richly textured

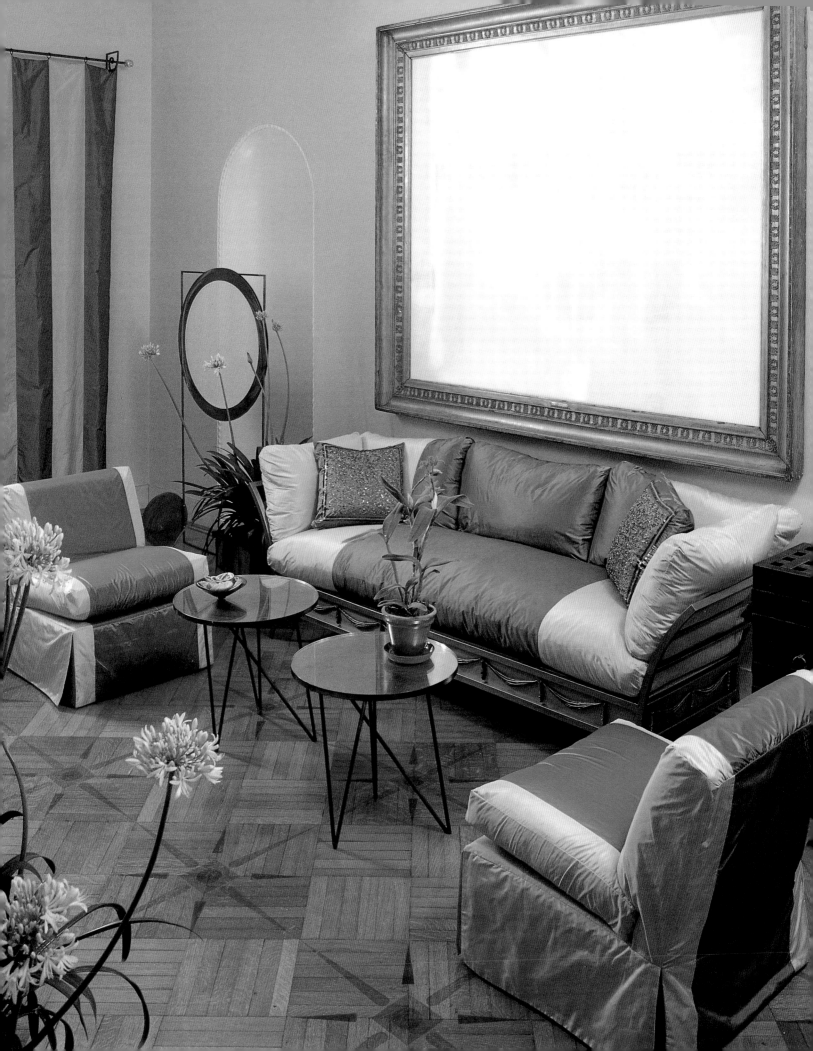

weaves and patterns. They can be installed over concrete and other hard floors. Keep in mind that because they are a natural fiber, they may stretch over time and have to be refitted periodically.

THE CARPET PAD

Whatever your choice of carpet, it is important to invest in a quality underlay, known as a carpet pad. A carpet pad enhances the look and comfort of a carpet and adds years to the its life. It also helps even out imperfections in the floorboards, enabling the carpet to lie smoothly. A carpet pad should be used with an area rug as well as with a fitted carpet. There is a variety of nonskid pads made specifically for use with area rugs.

RECOMMENDATION

IN A ROOM WITH AWKWARD SPACES AND IRREGULAR STOPS AND STARTS, IT IS NOT ADVISABLE TO USE A FITTED CARPET WITH A BORDER. THE BORDER WOULD ONLY SERVE TO ACCENTUATE THE IRREGULARITIES OF THE ROOM. IN MORE IDEAL CONDITIONS, IT IS USUALLY PREFERABLE TO USE A PATTERNED CARPET WITH A BORDER RATHER THAN A FITTED CARPET DEVOID OF ANY DESIGN—DEPENDING, OF COURSE, ON YOUR SCHEME. ❦

FINE RUGS AND AREA RUGS

Immensely decorative and easy to place, rugs provide visual relief to an uninterrupted expanse of floor and define furniture groupings within a specific space. You can use a number of patterned rugs within a spacious room, if a look of dense patterning is what you desire. Be advised that it requires great expertise to ensure the success of this look. For the less experienced it is usually wiser to use one large rug rather than many smaller ones, particularly if you are trying to unify your space.

Oriental rugs come easily to mind when thinking of fine area rugs. The term "Oriental rug" actually refers to one that is hand-knotted or handwoven. No rug made by machine, even in an Oriental pattern or in China, India, Turkey, Iran, or the Caucasus, is a genuine Oriental rug if it is made by any method, including hand-punching, hand-gluing, or hand-sewing, other than hand-knotting or hand-weaving. Because of the labor intensiveness of these processes, the soaring costs of materials, and the political instability in many of the countries that produce Oriental rugs, they continue to increase in both expense and value.

The distinctive beauty of antique Oriental rugs derives from their unusual shades and tints of color and their fine texture, luster, and quality of workmanship. Designs in Oriental rugs are formed by the arrangement of different-colored knotted yarns. The type of knot can indicate the origin of the rug. A Turkish knot, for example, is the easiest and coarsest knot to tie. It is made from a strand of wool that encircles two warp threads, with the loose ends drawn tightly between the two warps; a Persian knot is a strand of wool that encircles one warp thread and winds loosely around the other.

The coloration of Oriental rugs derives from the type of dye used: natural vegetable and animal dyes, made from such sources as henna leaves, oak bark, and crushed insects; aniline dyes, which are synthetics that fade easily and cause the fabric to wear rapidly; and chrome dyes, colorfast, nonfading synthetics that do not weaken fabric fibers.

The two main parts of the design of an Oriental rug are the field or ground and the border. The field is typically dominated either by one central or several medallions, a motif repeated in multiple rows, or in an allover pattern with very little repetition. Many patterns illustrate religious or philo-

In a room designed by Peter Carlson, Pierre Finkelstein of Grand Illusions, New York applied three different stain colors to simulate an intricate inlay on a simple parquet floor. Photograph by Antoine Bootz.

sophical beliefs with images of dragons, cranes, lotus flowers, vases, and the phoenix.

The number of borders used in a design vary from rug to rug, depending on size, origin, and the design. Most Oriental rugs have a single main border flanked by three to seven borders. In addition to field and border designs, dates are occasionally woven into the rug.

Caucasian rugs are brilliantly colored, have highly stylized figurative, geometric, and animal motifs and a woolen foundation. While each village in the Caucasus weaves designs unique to its area, there is a great exchange of designs. Dates based on the Moslem or Christian calendars are woven into the rugs, depending on the region.

Persian rugs are almost always woven in wool or silk and are rectangular or elongated in shape. They are richly colored and often have a central field of crimson or indigo on which motifs in warm browns, greens, and yellows are patterned. The so-called "garden" rugs and carpets are laid out in the form of a garden with paths, flowerbeds, pools, and streams. Figurative and geometric designs are used occasionally, especially in the "vase" carpets that show vases holding flowers or plants.

Turkish rugs, which come from the Anatolia region of Turkey, are often red and blue in coloring, except for the prayer rugs that are woven in green, a sacred color. Because of Islamic prohibition, few have figurative depictions, showing instead a pointed prayer arch sometimes flanked by pillars of wisdom and embellished with Arabic script. The finest Turkish rugs are woven in silk. Today, mercerized cotton is sometimes woven into the rug and represented to unsuspecting buyers as silk. The best way to know is to wet a small portion of the rug: wet mercerized cotton will feel like ordinary cotton, whereas wet silk will retain its natural silky feel.

The ubiquitous reds and greens of Turkish rugs are almost unknown in *Chinese* rugs and carpets, where more subtle blues, yellows, peaches, and apricots appear. Often carved and sculptured, many are woven with a soft, lustrous woolen pile and others with a silk or cotton foundation. The designs are based on Buddhist and Taoist symbols that include animals, dragons, and flowers such as the peony, lotus, daffodil, and pomegranate. Chinese rugs are more crisply defined and not as elaborate as those from other weaving centers. They are especially well known for the masterful use of graduated shades. Some rugs may have as many as ten different shades of the same color.

Kelims, or *dhurries* as they are also known, are pileless carpets handwoven on looms. They are the oldest and most widespread form of handmade carpet.

Rugs woven in the West were not used to cover floors until the eighteenth century when they became fashionable in the grand houses of the wealthy. Among the finest and most prestigious were the French rugs made at the command of kings: Aubusson and Savonnerie.

Aubusson weaving comes from the French town of the same name which has been an acclaimed tapestry-making center since the fourteenth century. During the mid-1700s, just when the desire for comfort was established in aristocratic circles, the sources for Turkish and Persian carpets diminished, and Aubusson's manufacturers began producing flat woven rugs. Known for the exquisite complexity of their patterns, the beauty of their colors, and their meticulous workmanship, Aubusson tapestries and carpets eventually became highly prized, like many other examples of decorative art. (Napoleon spent three million francs at Aubusson in the year 1806 alone.) Aubusson carpets are still extremely popular.

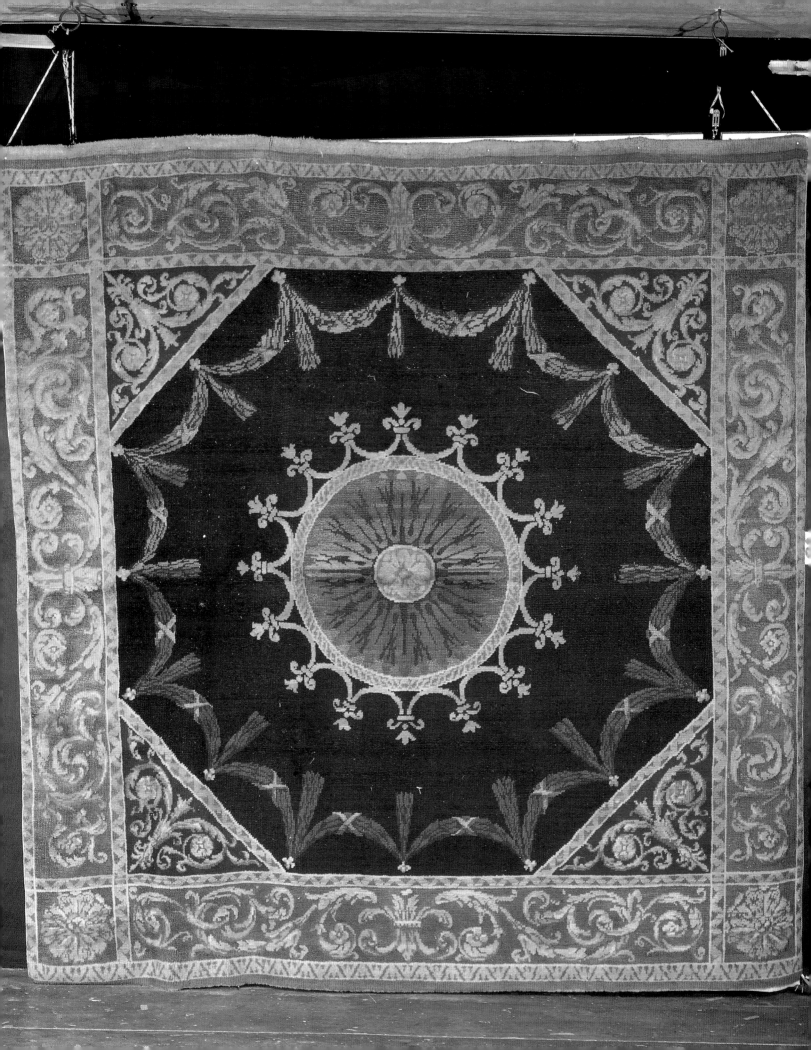

V'soske uses numerous weaving techniques and materials to produce luxurious, one-of-a-kind floor coverings. This photograph shows a variety of samples incorporating silk, wool, and linen.

Savonnerie rugs, woven by hand into a deep, rich pile, are among the most formal and sumptuous floor coverings in the world. Originally, they were designed to reflect the grand decorative styles of their monarchical patrons, ranging from the extravagant devices of Louis XIV to the more restrained, light, and delicate ornamentation of Louis XVI. The savonnerie weave is still produced today in several French mills.

Needlepoint rugs are stitched by hand in a form of embroidery on evenly woven cotton or linen canvas to form a highly detailed ground. The art of needlepoint became popular in the eighteenth and nineteenth centuries in both Europe and North America. Although examples of needlepoint rugs of that era can still be found, they are expensive and often too fragile to use underfoot. Reproductions in the style of original designs are more affordable and practical. Because no machine has yet been devised that can replicate the effects of needlepoint, the rugs are prized for their individuality.

American hooked rugs were likely first produced during the late Colonial period. Most early examples bear geometric designs—log cabin, patchwork, diamond or lozenge, overlapping circles, and stars, shells, and scallops. Floral, pictorial, and motto designs, surrounded by geometric borders, developed later. The hooking technique requires strips of cloth (originally home-woven linen), about 3/8 to 1/2 inch, to be pulled through a coarse foundation fabric with a small hook. The hooked-in strips are left in raised loops of even height that form the pile. The underside is kept flat. Closely hooked rugs are very durable and form a substantial fabric. When the looped pile is clipped, a soft and velvety surface forms.

RECOMMENDATION

MANY DESIGNERS FAVOR THE MUTED LOOK OF FADED RUGS BECAUSE THEY PROVIDE A RICH YET SUBTLE BACKDROP FOR FURNITURE AND WORKS OF ART. THE "ANCESTRAL" LOOK HAS BECOME SO DESIRABLE THAT MANY NEW RUGS ARE NOW GIVEN AN "ANTIQUE WASH" TO REDUCE THE BRILLIANCE OF THEIR COLOR. YOU CAN DISTINGUISH A GENUINE ANTIQUE RUG FROM ONE THAT HAS BEEN ANTIQUE WASHED BY SPLITTING THE PILE AND EXAMINING ITS BASE: IN A WASHED RUG, THE COLOR OF THE TOP OF THE PILE WILL BE DRABBER AND MORE MUTED THAN THAT AT THE BASE. FRINGES WILL ALSO HAVE A BROWNISH, "TEA-STAINED" CAST. ❧

BUYING RUGS

Rug prices vary widely from source to source. Compare prices to determine if the cost of the rug you are interested in seems fair. After determining the quality, evaluate the design according to whether the pattern is well executed and the colors are pleasing. Then examine the rug thoroughly for any flaws such as tears, moth damage, stains, and unevenness. Look for wrinkles or ridges that will not come out because of improper warp tension or creases from folding. Some irregularities are to be expected and are even desirable. Those that are undesirable can sometimes be corrected. If the cost of the rug is considerable, you should ask the dealer to make the repairs as part of your negotiation.

Usually you can take the rug out "on approval" with the understanding that you will make your decision within one or two days. It is customary to leave a check for the full price of the rug, which will be returned to you if you return the rug; be sure this is clearly understood. When purchasing an important piece, you should secure a guarantee from the seller. Some sources, such as auction houses, sell rugs "as is" and you should purchase with that understanding. If you are not absolutely certain of the condition and authenticity of the rug, consult an expert. If you are buying an antique rug, you may wish to have a certified appraiser give you a written appraisal of its value. This should include the name and address of the seller along with the size, origin, age, any identifying characteristics, and the dollar value of the rug. It will also be a necessary document for the insurance you would be advised to have.

RECOMMENDATIONS

AVOID BUSY PATTERNS ON STAIRCASES WHEN POSSIBLE. A CALM GROUND IS BETTER SUITED TO THE FUNCTION OF THE STAIRCASE, AND A STRONG BORDER WILL ARTICULATE SUCH AN IMPORTANT ARCHITECTURAL FEATURE. IN PLANNING THE INSTALLATION OF A STAIR RUNNER WITH A REPEATING PATTERN, BE CERTAIN THAT THE SAME PART OF THE REPEAT APPEARS AT THE SAME POINT ON EACH RISER. ❧

Herringbone patterns and other weaves enhance the textural richness of SisalWool™ carpeting by Karastan. Photograph courtesy of Karastan.

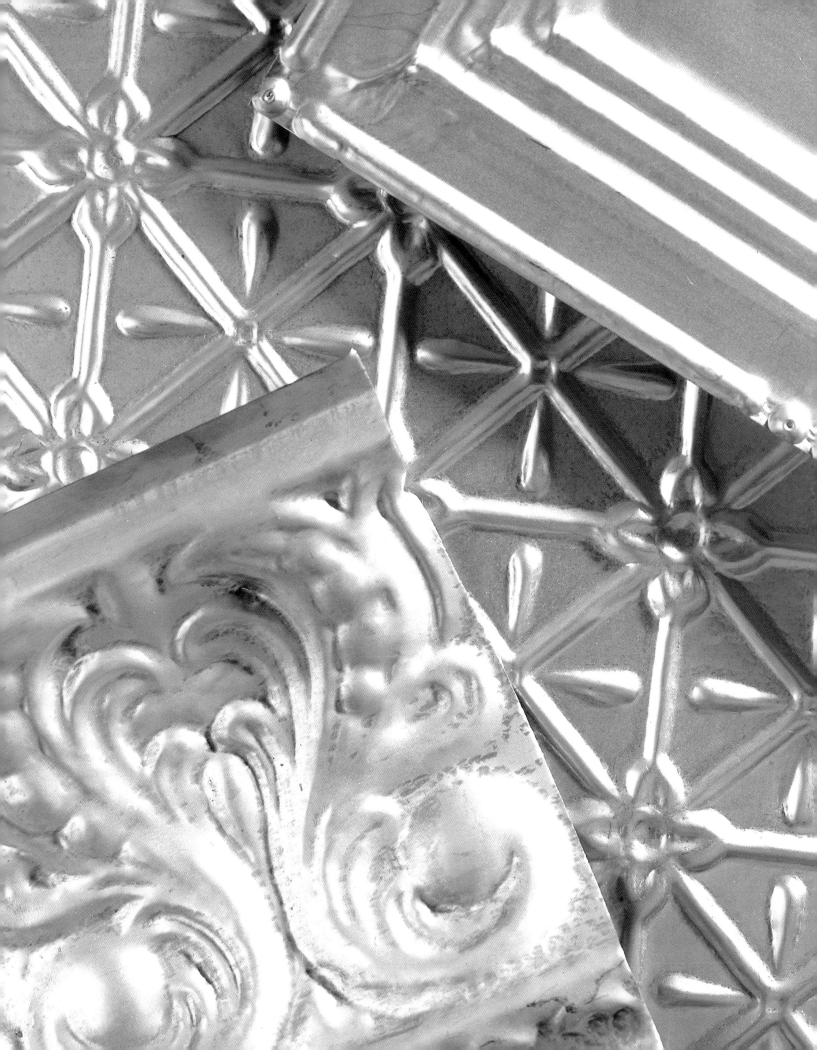

W A L L S

A N D

C E I L I N G S

Although a native of New Hampshire, I was born at the foot

of Mt. Vesuvius. There was a merry dance to the music of mandolin

and tambourine round the tomb of Virgil on my natal morn.

All this because the room in which I made my debut was

adorned with a landscape of scenic wallpaper.

K A T E S A N B O R N

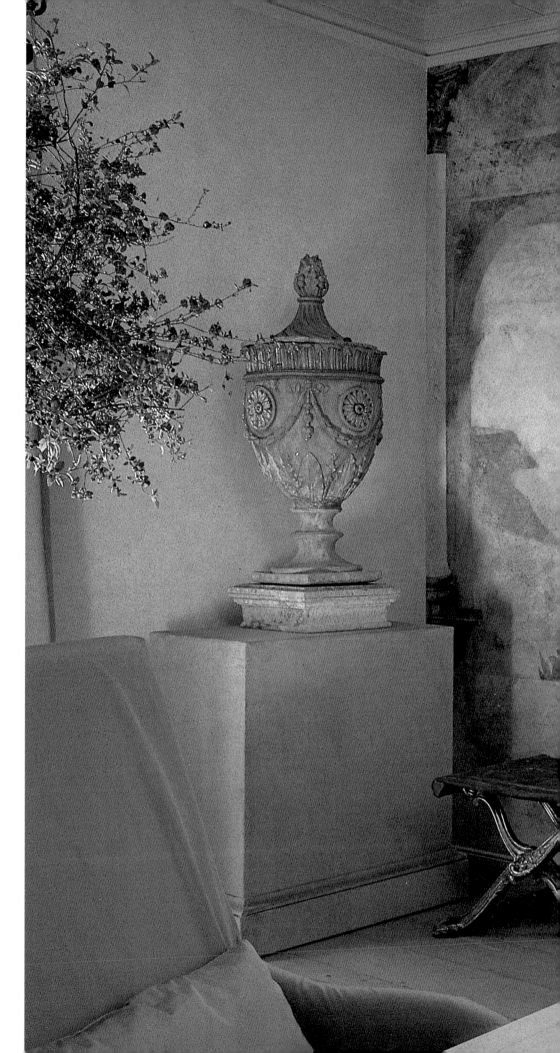

RIGHT

A trompe l'oeil mural, inspired by
a scene painted in the dining room
of a Pompeiian house, enhances
the classical character of a room
designed by John Saladino. The
mural was painted by Christian
Granvelle. Photograph by
Langdon Clay.

PAGE 58

Details of a variety of stamped-tin
ceiling panels.

PAGE 59

Minor repairs to cracks and chips,
a skim coat of plaster, and fresh
coats of paint are all that were
needed to transform the walls of
this New York penthouse renovat-
ed by Caroline Sidnam and Linda
Chase.

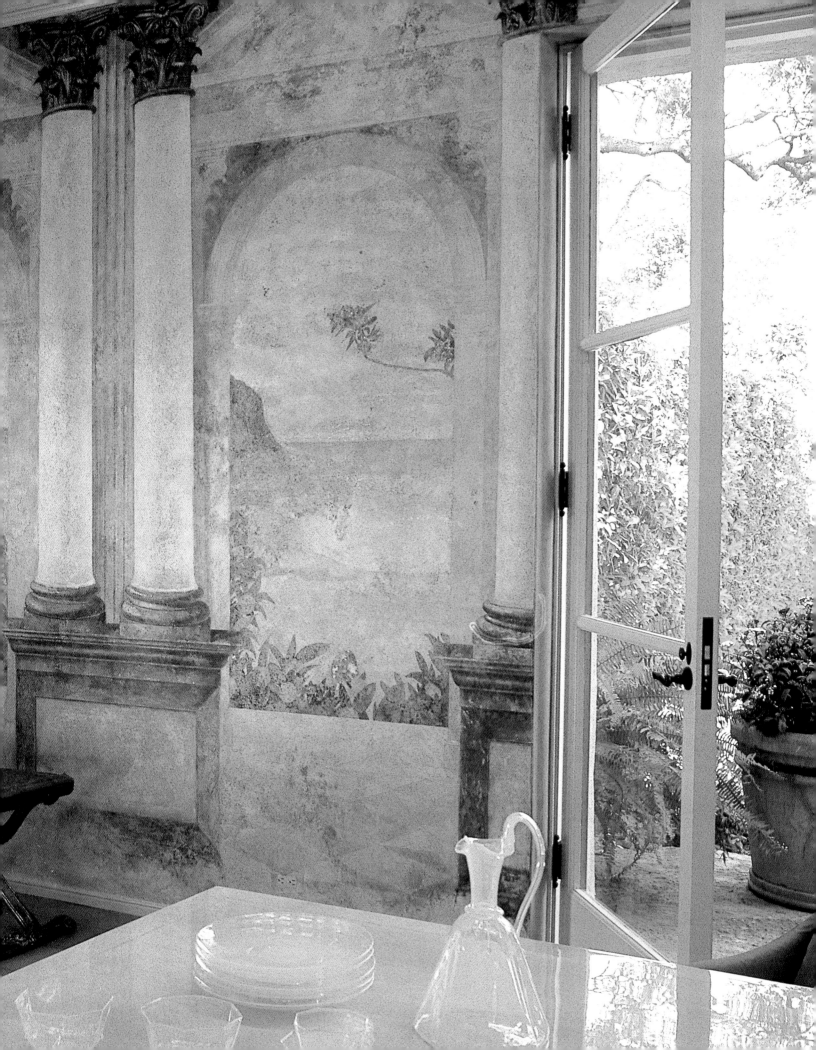

Like giant canvases, walls entice us to add the color, ornament, imagery, and texture that can elevate a room from the commonplace to the extraordinary. Their surface decoration helps to establish the tone of the room.

If your existing wall treatment is inappropriate to the look you want, or if the wall surface is in poor condition, the walls will need to be treated. They may need only a fresh coat of paint and the filling of minor cracks and picture-hardware holes, or they may require the removal of wallpaper. If existing plaster is severely damaged, walls may need to be covered with canvas to provide a smooth surface to paint over. A licensed and experienced painting contractor will be able to help you.

If you are altering the walls in only one room, it is important to maintain a sense of harmony with the other rooms in your house. Also, when selecting a material, pattern, or color for the walls, keep in mind the total look you want to achieve. How will the walls relate to the ceiling and floors? Regardless of your look, these elements must work together harmoniously.

One of the easiest and most economical ways to change a room is to paint the walls. Generally, the walls themselves should be painted with a matte-finish paint, and all the moldings and woodwork—wainscot, chair rail, dado, baseboards, crown moldings, even doors and window casements—painted in a satin or semigloss finish. Like the walls, the condition of the woodwork requires scrutiny, for the higher the sheen, the more visible any imperfections become.

HANDPAINTED DECORATIVE WALL TREATMENTS

Any treatment or finish that is achieved by hand reflects a special appreciation for quality and individuality. Like other hand finishes, handpainted decorative wall treatments require the expertise of skilled artists or artisans and more time to apply than most machine processes.

Glazing, which produces one of the most elegant of painted surfaces, requires the application of one or more coats of oil-base color to a painted surface to create a semitransparent glaze, which can be manipulated in a variety of ways to produce many effects. Most glazed surfaces are finished with a coat of clear, protective varnish, which also adds luster to the finish.

Washing has the painterly quality of watercolor. A color wash is usually applied over wood to give the surface a softer, aged appearance. A wash can also serve to modify the color of an undercoat.

Lacquering gives walls a look of depth and richness. The wall surface must first be carefully prepared—cracks and flaws filled in, rough edges sanded, an application of primer undercoat painted—and then covered with six or more coats of satin or semigloss paint. Each coat must be allowed to dry thoroughly and then rubbed with very fine steel wool. If the final finish is to be very lustrous, all coats should be of a high gloss paint with a final coat of clear varnish.

Combing, a technique in which a steel, metal, or rubber comb is dragged across a top coat of wet paint or glaze, produces a subtle pattern on walls. Once a base coat has been applied and allowed to dry, a top coat is painted over it. Linear, circular, or diagonal patterns are then combed onto the surface while the paint is still wet. A top coat of a different color from the base coat will amplify the visual effect.

Marbling, a trend that also has been enthusiastically embraced over the last decade, involves the painting of a surface to simulate the cool beauty of stone. Colors are blended

and streaked, and veins are painted with careful brushwork to resemble various types of marble. Walls can be divided with bordered, marbled panels that create an architectural look. For example, vertical panels can be marbled in a lighter color than the dado which is marbled in a deeper color. The combining of techniques, such as marbled panels with a glazed wainscot, or a marbled wainscot below trompe l'oeil, can also be quite dramatic.

Stenciling a design can add decoration to an interior devoid of architectural detailing. Although the technique is all too often associated with unsophisticated patterns, a wealth of historical and interesting designs are available. Designs can be combined and stenciling can be used with other techniques to create very sophisticated effects.

Trompe l'oeil, which has grown increasingly popular over the last decade, is a process in which a flat surface is painted to appear three-dimensional. Designs can be applied from precut stencil patterns, usually using three or more overlays, or handpainted on a wall. They can be as simple as three-dimensional borders or as elaborate as the walls of Pompeii.

A *mural* can be painted either directly on a wall or on canvas panels attached to a wall. If it is intended to be showcased as a work of art, the mural can be framed by molding. Left unframed, it becomes part of the architecture. The dining room, a room intended for leisure and conversation, is a perfect room for a mural.

WALLPAPERS

The variety of patterns in wallpaper is vast, ranging from solids, stripes, and geometrics to florals and figurative prints. One of the first considerations in selecting the most appropriate paper for a room is to decide whether the walls are to function exclusively

as a background or are to be in themselves a decorative feature.

The scale of the pattern you select will further define the overall look of the room. Small-scale patterns in small rooms are a safe, if predictable, choice; a gutsier pattern can be more dramatic.

The inspiration for the choice of wallpaper color and pattern can come from a piece of antique furniture, a favorite painting, or a personal collection of objects. Regardless of the source, the selection must be made with the scale of the patterns and the frequency of their repeat in mind.

Geometric patterns are based on repetitions of mathematically derived designs. Prevalent in Islamic, Asian, and African cultures, they have been incorporated into Western art since the Middle Ages. Geometric designs work best on expanses of wall large enough for their repeats to be legible. Because they can be manipulated to create spatial illusions, they may be used to alter the perceived height or width of a room.

Stripes are one of the most versatile of patterns. While they articulate the architecture of the room, they too can be quite effective in creating illusions of height or width.

Overall patterns such as *florals* work successfully in rooms with a "cluttered" look that cries out for effusive decoration. The designer Manuel Canovas is known for his simultaneous use of many different floral patterns with small repeating patterns, using color to unify the overall scheme.

Delicately colored *Chinese* patterns have been popular ever since they were introduced in Europe in the late seventeenth century. Decorated with scenes of flowers, birds, mountains, clouds, and village scenes, their designs were handpainted on rice paper. Many authentic Chinese designs are now available in reproduction.

Toile de Jouy designs, developed in eigh-

TOP

A niche is decorated with a "Pulcinella" figure painted by artist Carlo Marchiori in the style of an eighteenth-century Venetian fresco.

ABOVE

In his own living room, Marchiori painted a mythologized portrait of a friend Sam Jung Park and his dog Togo. Both photographs by Cookie Kinkead.

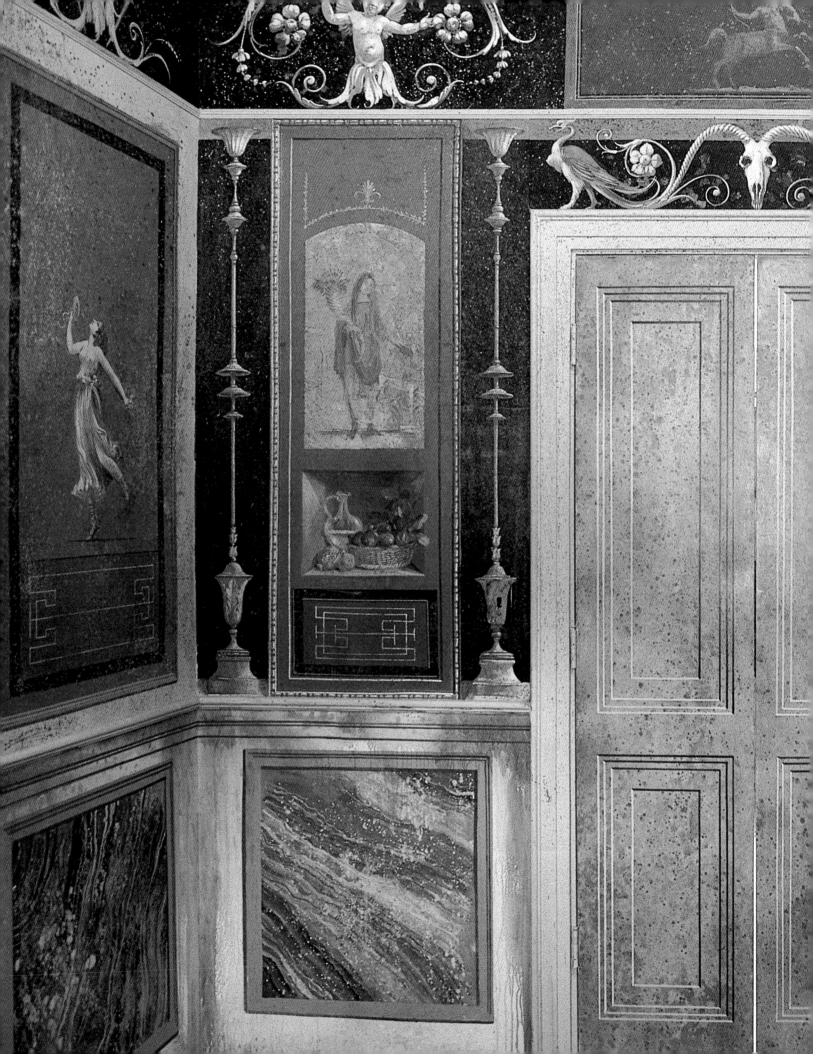

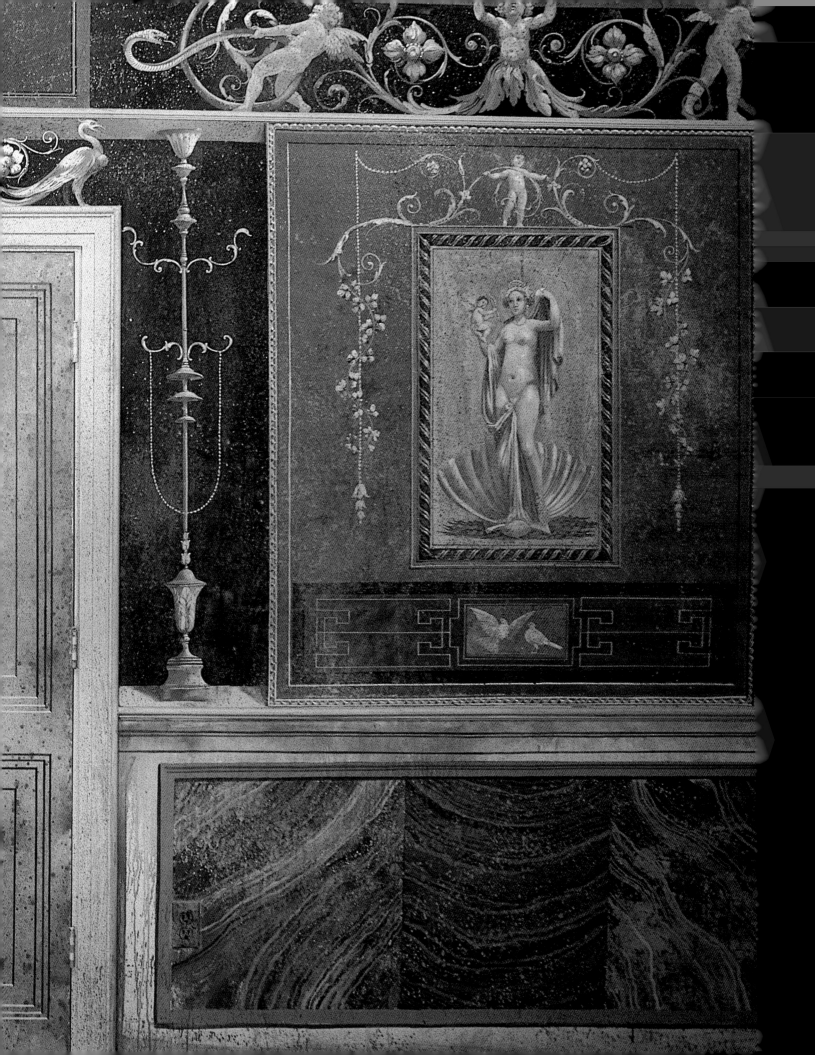

teenth-century France, are narrative depic-tions of a wide variety of pictorial subjects, including scenes from classical mythology and pastoral reveries. They are usually print-ed in monotone red, blue, brown, or magenta ink on a neutral background, mak-ing them ideal for coordinated fabric and paper schemes with a French look.

Scenic papers and *pictorial panoramas* provide a sense of narrative fantasy and spatial illu-sion. They are derived from original designs created by mural artists. The form evolved from the early-nineteenth-century practice of decorating walls with tempera paintings on large canvases in plaster frames. The artist J.-C. Suarès has visited the oldest wallpaper manufacturer in the Western world, Zuber & Cie, in Rixheim, France. "A typical panoramic scene takes a year or two to con-ceive and another seven or eight months for

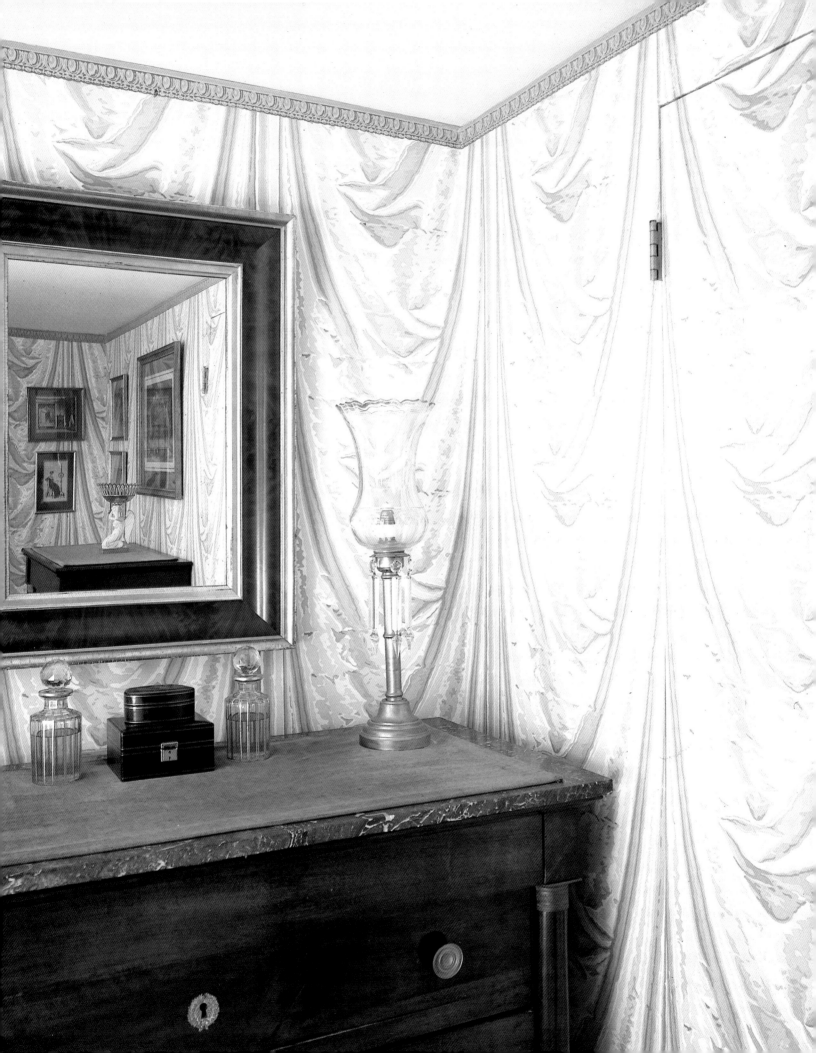

twenty men to engrave by hand. Next comes the mixing of inks and the printing of panels. To achieve the quality Zuber demands, company technicians make their own paper and devise their own inks. The yellows and oranges of the horizon are blended with the deep blues of distant skies. The transition is almost indiscernible to the naked eye, but it gently gives the room brightness and clarity." Scenic papers tend to unify a room. Because they are as compelling as a large painting, they should be used principally where the wall is to be made a dominant feature of the room. They also establish a sound guide for the choice of an accompanying color scheme.

Architectural papers represent three-dimensional architectural elements in two-dimensional, usually trompe l'oeil, form. Papers of moldings and ornamental borders, for example, can be used to enhance the architectural character of a room devoid of architectural detailing. Architectural papers can also be used as witty visual puns. As with three-dimensional elements, it is wise to use architectural papers with careful consideration of the proportions of the room.

Tea papers, which add the reflective beauty of silver and gold leaf to a wall surface, lend a quality of delicate elegance to a room.

Textured papers can add subtle dimension as well as texture to a room.

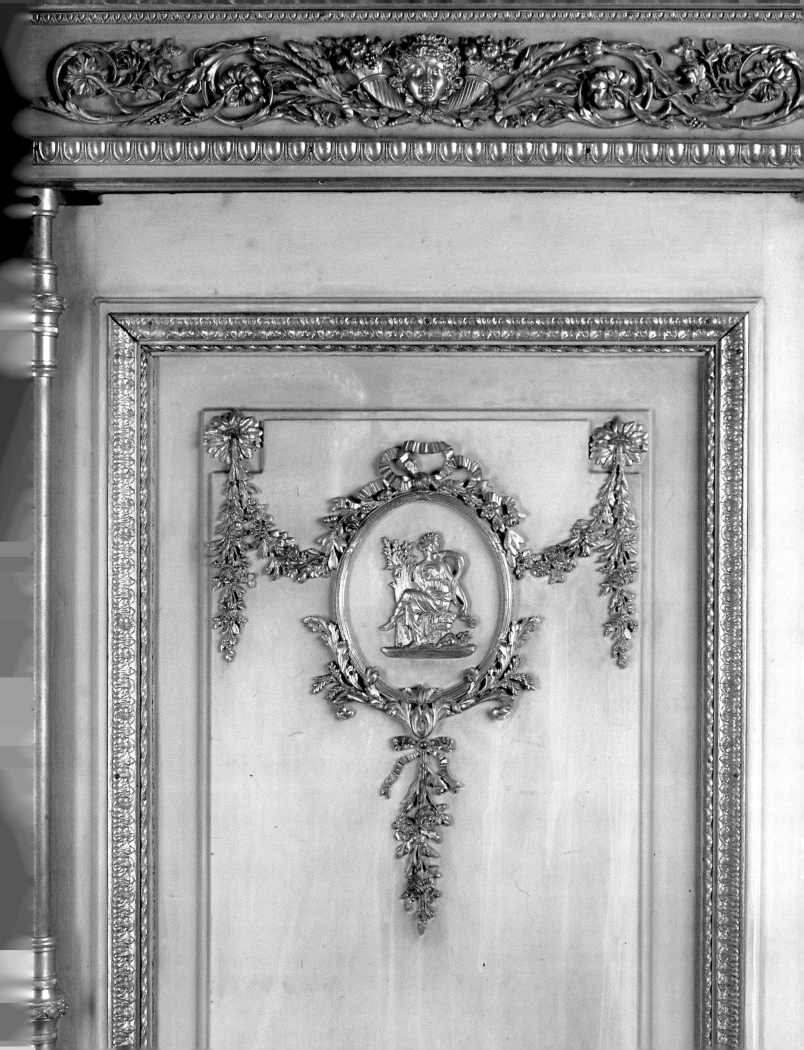

Relief papers, made of embossed cotton fibers or wood pulp, work well to conceal irregularities and faults as well as to enhance the textural quality of a room by adding pattern.

While *antique wallpapers* are extremely scarce and fragile, reproductions of historical designs printed from the original blocks are produced by such firms as Galacar and Co., Zuber et Cie, and Dufour. Though many reproductions are affordably priced, others can be, as Frederic Galacar admits, "beyond the reach of all but someone like the Emir of Kuwait or the U.S. State Department. Anyone who has actually undertaken a project of historic preservation (even something like trying to fix the plumbing in a Beacon Hill apartment) will not be surprised by spiraling and unexpected costs. Such persons, interior design professionals being among them, have experienced Murphy's Law first-hand and will nod knowingly as I stare in slack-jawed amazement at the production bills for a design. To them it will seem perfectly natural that a documentary paper originally conceived as selling for less than $100 per roll should become, seemingly of its own volition, the world's most expensive wallpaper."

Generally, however, interpretations of classic wallpaper designs are not only more affordable than genuine documents, but are also available in a wider variety of colors and often have accompanying fabrics. Some manufacturers even offer new papers that appear aged with all the inconsistencies in pattern and patina that give antique papers their richness and character.

BORDERS

Border papers are an excellent means of giving a room the illusion of architectural detail. Borders can be selected to complement an overall or repeating wallpaper design, or used alone on a painted wall to articulate moldings. In lieu of crown molding, a border can define the lines of a room. Be advised that borders will tend to magnify any architectural irregularities.

PREPARING THE WALL SURFACE and APPLYING THE COVERING

Manufacturers such as Frederic Galacar feel that hanging wallcoverings is no job for an amateur. "If you have invested in multi-screened, handprinted papers, you should trim and install them with great care on a properly treated, lined wall surface that has been tested prior to installation." He recommends using an experienced professional, preferably a Certified Paperhanger who is a member of the National Guild of Professional Paperhangers. Further good advice is to make sure the installer is familiar with and willing to follow the manufacturer's recommended application.

Estimating the number of rolls required on your own is risky; it is best to consult with your designer, installer, or knowledgeable retailer, since different types of patterns and certain materials have unique requirements.

If you are applying wallpaper yourself, be certain the wall is clean and that cracks in plaster have been filled in and smoothed. For new plasterboard or water-sensitive painted walls, a primer must be applied to seal and protect the surface. (Check with the manufacturer or supplier whether it should be acrylic or oil-base.) If a wallcovering is translucent and the underlying paint color or colors are in strong contrast to the wallpaper design, the wall may require a uniform primer coat.

Lining paper made of an off-white pulp is used by wallpaper specialists to provide additional adhesion, uniform color, and even absorption of the paste. This lining paper does *not* replace good surface preparation.

An example of the handmolded and handglazed relief tiles with multiple glazes that are available in a wide variety of Arts and Crafts School designs at Ann Sacks Tile and Stone, Los Angeles.

Just as application methods differ, wallpapers can be trimmed in a variety of ways. Complex borders must be hand cut and may sometimes require careful alterations such as reductions and/or pieced-together additions to ensure alignment. Again, a specialist's recommendation regarding the most appropriate method of trimming is advisable.

The final steps in applying wallcoverings are pasting and hanging. The type of adhesive depends on the type of paper. If the manufacturer has not provided specific directions, you can contact the company directly or consult a certified paperhanger. He or she can advise you not only about the type of paste, but also about the best method of application; the proper amount of paste to use to relax the paper and ensure proper adhesion; about allowing certain wallcoverings to absorb water, relax, and expand *prior* to hanging; and about removing excess adhesive from the wallcovering to avoid staining.

After hanging, the paper will likely need to be smoothed. Again, methods vary, and the manufacturer or a specialist can advise you about the process and about eliminating any bubbles that occur afterward.

Wallcoverings on paper grounds are *not washable* unless they have been treated with a vinyl-acrylic coating, either prior to or after installation.

RECOMMENDATION

ALWAYS UNROLL AND EXAMINE YOUR WALL-COVERING FOR DEFECTS IMMEDIATELY ON DELIVERY. MOST COMPANIES WILL NOT ACCEPT CLAIMS AFTER THIRTY DAYS FROM DATE OF SHIPMENT, AND NO COMPANY WILL ACCEPT CLAIMS FOR GOODS THAT HAVE BEEN CUT, ALTERED, OR INSTALLED, REGARDLESS OF THE DEFECT. FEW FIRMS WILL ACCEPT RETURNS ON QUANTITIES OF LESS THAN SIX ROLLS OF PAPER OR SIX YARDS OF FABRIC, OR ON CUSTOM ORDERS, LARGE ORDERS OVER $5,000, SALE-PRICED ITEMS, IMPORTED PRODUCTS, EXPORT ORDERS (INCLUDING CANADA), TREATED MATERIALS, DRY-CLEANED FABRICS, PLAIN GROUNDS, PURCHASED SAMPLES, AND SAMPLE BOOKS. ❦

FABRIC WALLS

Covering walls in fabric or *fabric panels* is an especially effective way of disguising poor surfaces and correcting the proportional defects of a room. All manner of fabrics, from fine silk to inexpensive gauze, can be draped, gathered, or shirred to create a soft effect. These voluminous treatments, which require a great deal of fabric, can be secured to the wall in a variety of ways. For a tailored look, fabric can be stretched over and stapled to wood battens much like canvas is stretched on a frame for a painting. The application may be finished with lengths of braid or other trim to conceal any seams. An upholsterer who is experienced in applying fabric wall finishes can advise you about the methods and necessary yardage.

PANELING AND ALTERNATE MATERIALS

When well executed, *wood paneling* can bring a manorial sense of formality to a room. Besides its rich appearance, its acoustical and insulating properties make it highly practical. The most important factor in the design of paneled walls is proportion. Whether you are using traditional paneling composed of solid planes or applied decorative moldings to create a paneled effect, the proportions must correspond to the room's architecture.

Boiserie, or intricately carved wood paneling, brings a room the same decorative richness as ornamental plaster work. Some of the grandest residences in history, such as Petrodvorets, the summer palace of Peter the

Great on the Gulf of Finland, have been distinguished by their elaborate, and often painted and gilded, boiserie.

Composition is a malleable synthetic material that can be squeezed into molds of ornamental motifs and carved. Composition ornament has been used for decorating walls since the 1500s. It was used extensively in the second half of the eighteenth century and was a signature of the exquisite interior decoration of the English architect Robert Adam. Today, the range of composition-ornament designs is vast. Composition can be pre-painted and applied to another color surface, or applied in combination with another ornament for an extravagant effect. Once cured, it is harder even than wood.

Mirror can be used in the same manner as wood paneling to delineate space. The combination of a wood wainscot with mirror panels produces a wonderful mix of light and solid.

Mirrored walls serve as an homage both to vanity and to the dazzling refraction of light. By day, mirror amplifies the sunlight from a window, and by night it doubles the illumination of lamps and candles. Ideal for casting light on a dark wall or into dim corners, mirror can also create a sense of greater space. Mirroring an entire wall can be especially effective in reflecting an important view. The trick in making this work is not to place the mirrors directly opposite the view, but at right angles to the window with the view. Antique mirror panels can give a room added character. If you cannot afford antique mirror, consider acquiring new mirror that has been distressed by professionals to appear old.

Tiled walls, like tile floors, provide an infinite range of colors, patterns, and decorative possibilities. They can be acoustically harsh, as sound reverberates against them. Be certain to take this factor into consideration when planning a tiled wall. Tiled mosaics can achieve effects similar to those of panoramic papers or painted murals, with the added dimension of being composed of tile, stone, or bits of glass.

CEILINGS

The ceiling, a once-resplendent canopy, could well be described as the modern interior's most abused feature. With each decade of the twentieth century, the standard wall height has diminished by inches, making it extremely rare to find high, let alone ornamented, ceilings in a modern house. All too often today the design of a room stops at the crown molding. Before the twentieth century this was not the case. In fact, until the late 1800s the ceiling was the most richly ornamented part of the room.

In sixteenth-century Europe, the ceilings of better houses were often clad with brightly colored tiles and framed by wooden beams. The tiles served both as decoration and insulation. In the seventeenth century, the juncture of ceiling and wall was typically marked with a cornice and the ceiling surface richly embellished. Baroque ceilings bore exuberant, high-relief patterns divided by grids, which eventually gave way to simpler Palladian detail in shallower relief. The ceilings of grand eighteenth-century houses were decorated with everything from asymmetrical Rococo designs that included shell, leaf, and bird motifs to strict Neoclassical designs. They were often painted in strong colors with their plaster detailing highlighted in white. During the more austere Regency period, ornament was restricted to the cornice and to a central medallion. Victorian ceilings, on the other hand, were embellished with staggering intricacy. Some were painted with imitation Italian frescoes or swag, flower, and festoon designs; some were decorated with cast and carved plaster details

An original stenciled and hand-painted ceiling is characteristic of houses built in Los Angeles during the 1920s.

73

ABOVE

Stamped-tin ceiling panels as they come from the manufacturer, W.F. Norman in Nevada, Missouri, and painted by a decorative artist.

RIGHT

A chandelier hangs from a ceiling on which artist Larry Young painted an elaborate trompe l'oeil of swagged fabric and decorative motifs. He distressed the image with steel wool and fine sand paper to enhance the illusion of age. Photograph by Cookie Kinkead.

drawn from Renaissance palazzi; and others were coffered in geometric patterns using carved beams, sometimes set with gilded medallions. One reaction to this ornamental excess was a taste for greater simplicity promoted by the Arts and Crafts School which favored the adornment of ceilings with printed papers.

The ceiling today functions primarily as housing for insulation, the mechanicals and ducts for climate control, lighting, sprinklers, and the wiring for sound systems. In addition, it establishes the height of a room. This makes it a principal element in determining the room's proportions. For this reason, it is important to the overall design of the interior to preserve your ceiling height as much as possible and add soffits only as necessary to house mechanicals.

TYPES OF CEILINGS

Vaults are the series of barrel, groined, or fan-shaped arches that represent one of the crowning achievements of Gothic architecture. Obviously, a room must be of lofty proportions to accommodate their soaring dimensions. Vaults can be left exposed or covered with masonry, which can, in turn, be ornamented.

Coffered ceilings are subdivided into recessed compartments by beams, moldings, or other decorative partitions. These recesses can be stenciled, papered, filled with relief ornament, or painted in a color or shade that contrasts with the walls and partitions. While coffered ceilings look best in rooms of substantial height, they can sometimes be used in rooms with lower ceilings as long as the moldings are kept shallow and are painted in values that diminish any contrast between the recesses and the partitions.

The first *beamed ceilings* were strictly functional, but as building technology changed, beams remained desirable as decorative features. Today they are used to evoke everything from the rustic grandeur of Adirondack wilderness retreats to the intimacy of a country cottage. Beams can be set into the ceiling surface for purely decorative effect.

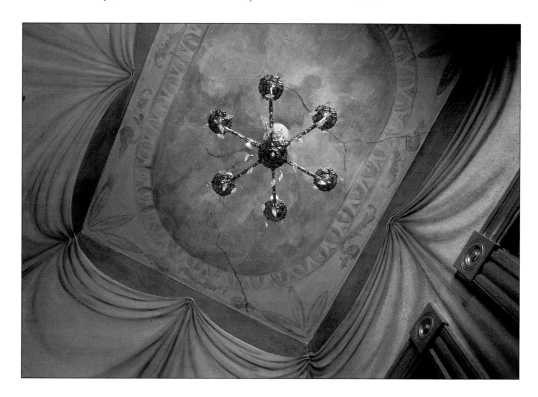

DECORATIVE CEILING TREATMENTS

As with walls and floors, painting is one of the easiest and least costly means of finishing a ceiling. The color most frequently applied today is white or off-white, partially in keeping with the monochromatic palette of modernism and partially because architectural details stand out in relief against it. The principal reason to paint ceilings white is to maintain the appearance of height. Painting a ceiling darker than the walls of a room will make the ceiling look lower than it is, which is almost never desirable.

Trompe l'oeil ceilings work as visual and spatial illusions on ceilings in much the same way as they do on walls. Common trompe l'oeil ceiling motifs are painted tent designs, trellises, and skyscapes of clouds and stars. This treatment is a wonderful way of adding drama or whimsy to a room.

Plaster, carved or cast into relief ornament, is one of the most beautiful and long-lasting of decorative treatments for ceilings. Unfortunately, it is generally costly because of the expense of the skilled labor required to properly apply it. Elaborate plaster work can be highlighted with color. Prefabricated wood, plastic (a lightweight urethane), and plaster moldings are now sometimes used to patch, repair, or simulate original decorative plaster elements.

Tin ceilings originated as imitations of the elaborate carved and cast plaster ceilings popular in Victorian England. Eventually they became fashionable on their own merits and continue to be available today. Some are still manufactured with the original machinery and dies. Pressed into decorative patterns, tin ceilings can be painted, as they were by the Victorians, or left in the "lusterless white" finish in which they come from the factory. A number of original nineteenth-century designs are still being reproduced today along with newer patterns, all of which are available in prefabricated pressed-tin panels.

Tented ceilings can bestow both romance and formality on a room. Some evoke the exoticism of Bedouin tents, others the Napoleonic classicism of campaign tents. There are many methods of fabrication: one is to seam fabric from the center to the corners of the room; another is to pleat the fabric from the center and bring the fabric to the wall (leaving the fabric loose and tentlike or stretching it taut and pyramidlike). Unless you are proficient at designing and sewing complex fabric constructions, it is advisable for the tent to be fabricated in a workroom and professionally attached to the wall.

Ceiling medallions, which frame the canopy of a chandelier or other pendant light fixture, are the most commonly used plaster ceiling ornament. Their early decorative patterns were based on stylized flower or Neoclassical motifs that combined harmoniously with densely ornamented ceiling surfaces. Today, contemporary and reproduction medallion designs, many manufactured in polyester resin, are used to add decorative interest to plain ceilings.

Corbels are decorative brackets usually found at the end of a beam where the beam joins the wall. Typically, they are made of carved wood or metal, and may or may not be treated with a decorative finish.

You will need to decide whether an overall decorative treatment or a simpler application better suits your needs.

Your choice will allow the ceiling to work as an effective feature in adding character to your rooms.

Stamped-tin ceiling panels as they come from the manufacturer, W.F. Norman, and painted with decorative motifs.

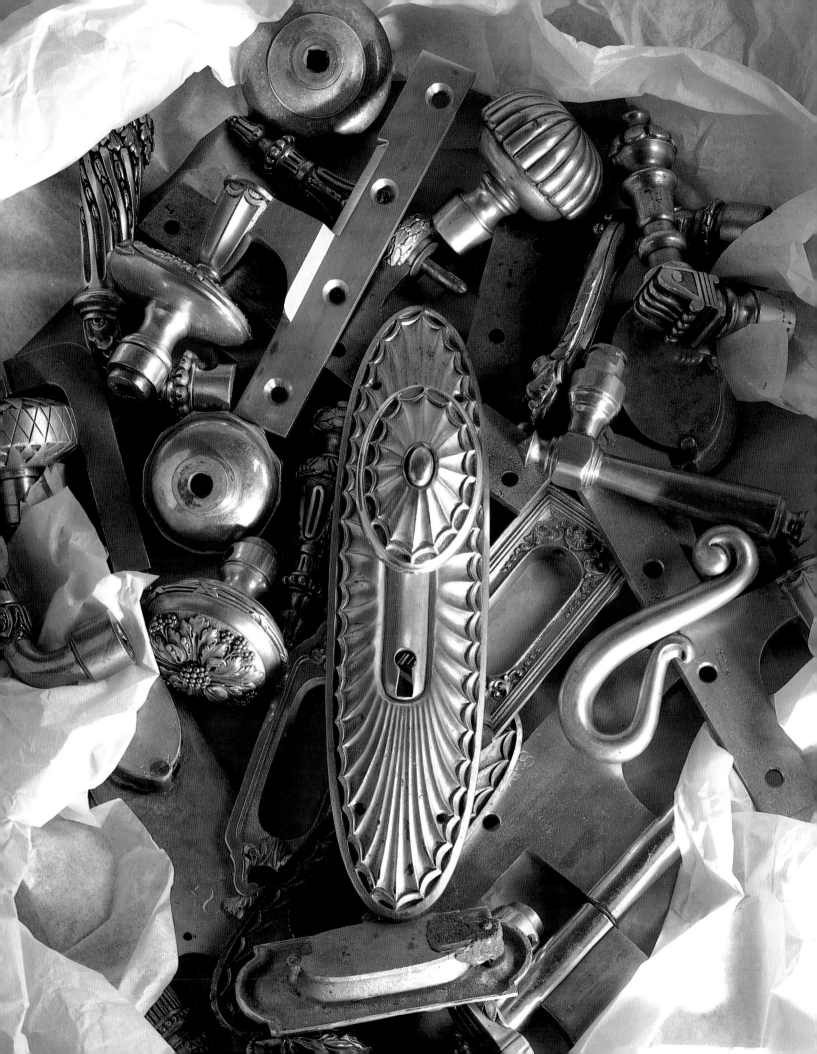

HARDWARE

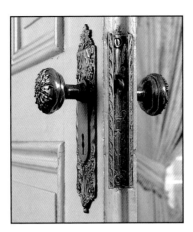

Hardware is the jewelry of the room.

L I N D A C H A S E

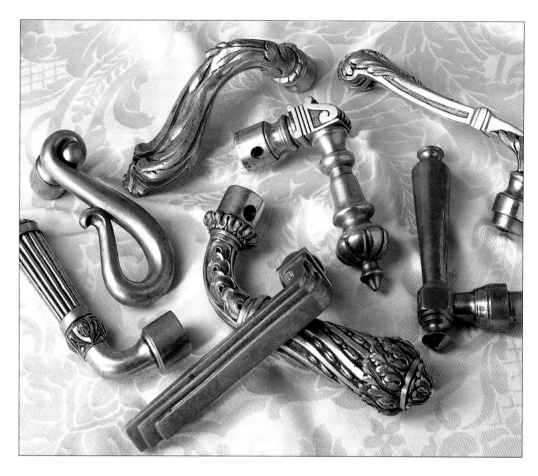

Essential in function and beautiful as ornament, hardware is the ultimate joining of the practical and the decorative.

Visually, hardware creates a strong impression that begins at the front door and is carried through the house from room to room. It plays an essential role in defining—or preserving—a home's character and can affect the look of a room as greatly as the choice of fabrics or accessories. For this reason, it is not advisable to economize on hardware. You can easily diminish the quality of an otherwise beautifully designed piece of furniture by applying cheap hardware. Also you do not want to compromise the architectural integrity of an otherwise carefully planned interior by selecting poorly crafted or ill conceived fittings.

Hardware can function either inconspicuously or as a distinct decorative accent. In each case, the style, size, material, and finish of the hardware must be selected according to the look and proportions of the element to which it is applied.

The earliest forms of hardware were likely knobs and pulls. As early as the third century B.C. the Egyptians were constructing chests with slide-out drawers that featured exquisitely fashioned knobs. Primitive pulls, such as short pieces of rope affixed to a lid or door, were probably common even earlier.

Decorative hardware first appeared in Europe during the thirteenth century when elaborate door hinges, locks, bolts, and open grilles were fashioned for Romanesque churches. The most notable product of the blacksmith's art was the ironwork made for doors, which reached the highest standards of technical skill. Massive vertical bars spanned the width of each door, and the spaces between them were often filled with openwork: crosses, rosettes, rings, interlacing

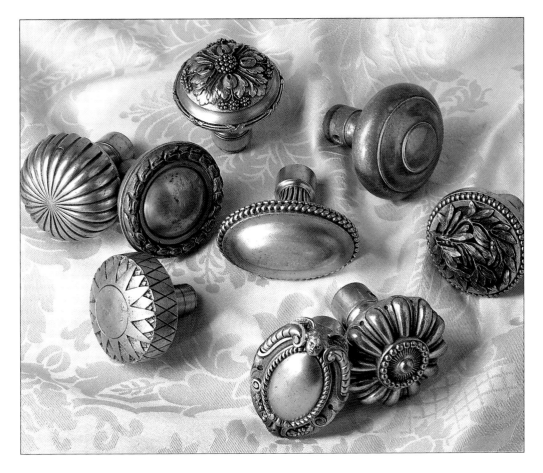

designs, and heraldic animals. The growing availability and diminishing expense of iron over the following centuries allowed craftsmen to form more and more architectural elements from metal, rather than stone or wood, including staircases, balconies, gates, and railings.

In eighteenth-century England, metalworkers applied their skill in cutting steel for sword hilts and jewelry to working brass into sconces, handles for cabinets and doors, escutcheons, hinges, curtain rings, and tapestry hooks. In each of the periods that followed, hardware was designed to harmonize with the style of the time. For example, Georgian cabinetmakers such as Thomas Chippendale fashioned hardware after the same Chinese motifs that inspired many of their furniture designs. (Chippendale's drawer pulls were virtual replicas of those used on Ming furniture.) During the Directoire and Empire periods much gilt-bronze hardware

bore the same classical motifs as appeared on the furniture. These were among the last hardware generally crafted by hand. By the mid-nineteenth century, a tide of technical invention transformed the hardware trades, and handcraft gave way to factory production.

TYPES OF HARDWARE

Interior hardware falls into two categories: *architectural hardware,* which is affixed to doors and windows; and *cabinet hardware,* which applies to both built-in and free-standing furniture pieces. Most rooms today are furnished with commercial, stock-pattern types. Generally these are available in brass, and they can be custom plated to your specifications.

A basic knowledge of the mechanical operation of the various kinds of hardware will be helpful to you in selecting the proper types and sizes. In addition to reviewing the

following lists, you may wish to consult the commercial catalogues of hardware dealers or speak directly with the craftsmen who make special-order hardware.

DOOR HARDWARE

Door knockers are intrinsically sculptural and therefore should be selected with special regard to their visual impact and to continuing the style of the knob or other door hardware.

Doorknobs, which are either round or oval, range in material from the commonly applied brass knob to faceted glass or molded plastic. Most often they are positioned at the side of a door about thirty-six inches from the bottom. Center doorknobs are often applied to doors of monumental size and can further dramatize doors of an unusual character.

Levers are straight or curved lengths of hardware whose function is to open and close a door in the same way a doorknob does.

Latches attach a door and jamb or two doors by means of a horizontal bar that pivots down from one surface to the other.

Catches are used to hold a door shut when its knob is fixed like a pull and does not turn. They usually slip into a locking mechanism where the door meets the jamb at the top.

Locks range in size and weight from diminutive cabinet locks to heavy dead bolts. They can be applied to the surface of a door (referred to as rim locks) or mortised into the door so that only their trim—knobs and plates—are visible.

Cremone bolts are surface bolts that run the full length of the door from top to bottom. They lock into the head and down into the sill by turning a knob or lever at a predetermined point. To obtain a properly fitting cremone bolt, it is critical to specify the overall height, the height of the knob from the bottom, and the type of strike (the small plate mounted on jamb or sill into which the bolt engages) at the head and at the sill.

Espagnolette bolts run the full length of the door and hold the door at the head and at the sill by a hook or tongue. The same information must be specified for these as for cremone bolts.

Flush bolts secure an active door against an inactive one in a pair of doors. A flipper mortised into the inactive door at the top and bottom secures it in the closed position. A latch then locks the active door against it.

Mortise bolts contain dead bolts controlled by thumb knobs. They are typically used along with a standard latch bolt on interior doors.

Surface bolts or *slide bolts* are often decorative. They are mounted on the inactive leaf of a pair of doors, usually at the top and bottom. Their purpose is the same as that of flush bolts.

Until about 1700, *hinges* were typically made of wrought iron that was occasionally ornamented. Early hinges—made with a long strap attached to the door dropping onto a sturdy pin fixed to the door post—have evolved into a number of varied and complex mechanisms.

A hinge, or *butt* as it is more commonly known, typically consists of two rectangular flaps meeting at a joint called the knuckle, where two to five interlocking leaves are held together with a single pin. According to one of the United State's longest-established resources for quality period and reproduction hardware, J. P. Guerin in New York, it is advisable to use butts with ball bearings in order to minimize friction and wear for extra-wide doors or doors made of unusually heavy hardwood. The company also suggests that where door jambs or architraves are especially heavy and the doors must swing open 180 degrees, it may be necessary to have a butt of a size larger than normal for the particular door thickness. This larger size allows the knuckle to project some distance away from the face of the door, affording a wider swing.

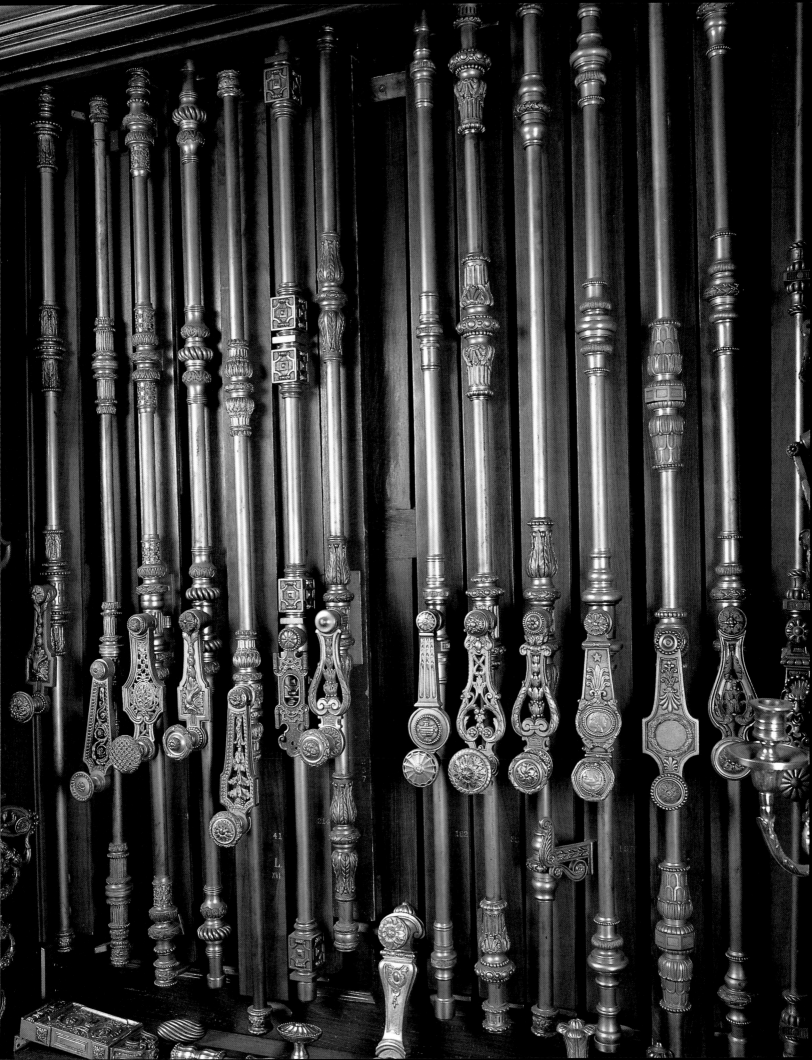

A *rising butt hinge* is designed with a knuckle that enables an opening door to elevate slightly and then close by its own weight.

A *piano hinge* or *continuous hinge* has leaves that extend along the entire length of the two surfaces it joins.

CABINET FITTINGS

Brackets, hardware used to hold shelves, must be made of a material capable of bearing the weight of the shelf and its contents. For glass shelves, the bracket material should match other surrounding hardware if the brackets are visible.

Drawer and cupboard *pulls* vary widely in design, material, weight, size, and finish. Drop pulls, for example, have as a main feature a hanging pendant. Recessed pulls are either completely or partly mortised into a drawer or door. A flush ring pull is mortised into the drawer or door and has a drop ring that folds flat into a recess. Drawer pulls have been made of materials ranging from glass, china, and bone to the ubiquitous brass, wood, and plastic as well as a list of exotic materials.

Cabinet handles, like pulls, have been man-ufactured in an enormously wide range of materials. Besides being aesthetically pleasing, it is critical that they be easily grasped.

OTHER HARDWARE

Nailheads, which were among the first examples of hardware used as pure decoration, can be hammered in patterns on doors.

While door *chains* are intended to provide security, they can be employed with the decorative finesse of a pocket-watch chain.

Escutcheons are carved or molded shield-shaped ornaments often used as a central decorative feature on large pieces of furniture. The term also refers to the elaborately decorative metal plate, usually of silver or gilded brass, that surrounds and protects a keyhole.

Grilles and *railings,* whose practical function is to provide protection, have a long history of elaborate decorative design that began with the doors of medieval churches and the staircases and fireplaces of royal palaces. Today, they continue to be designed as much for beauty as for security.

Beautiful antique drawer and cabinet *keys,* left in the keyhole with the embellishment of

beautiful decorative trim known as passe-menterie, can add an elegant finishing touch to the decoration of a room.

MATERIALS

Metal hardware has historically been made of nickel, chrome, brass, bronze, iron, steel, gold, or silver. Today, most decorative hardware is made from brass, an alloy of copper and zinc. Steel, the strongest of these metals, can be used to make all manner of hardware, from heavy-duty hinges to thin, stamped catches. Aluminum is often used as a lightweight substitute for other metals.

Cast-metal hardware is produced through a process of melting the metal, pouring it into a mold, and allowing it to cool and solidify. Metal poured into a mold made from a mixture of sand and clay is called *sand cast* and provides a surface of considerable detail. Even greater detail can be produced through a process called *lost wax,* in which a model of the object to be cast is formed in wax and then covered with plaster or other heat-resistant material. When molten metal is poured into the cast, the wax runs out of drain holes and the molten metal solidifies in its place. The process is quite costly.

A less expensive technique for manufacturing decorative hardware is *die-casting,* which uses a permanent steel mold—or die—into which liquid metal is forced. In America, most mass-produced cast-brass decorative hardware is die-cast. In Europe, especially Italy, the process is used to produce some examples of fine decorative hardware.

Forged hardware is created by the hammering of metal. Iron is usually forged by hand, brass by a power-driven hammer. Wrought iron, the raw material of the blacksmith, is tough and malleable and effectively forged into pulls, latches, and hinges as well as architectural railings and grilles.

Cast iron is hard and brittle and used most often today for reproductions of Victorian hardware.

Commonly used *nonmetal* materials include wood, stone, glass, crystal (glass with lead added to it to increase clarity), porcelain, and certain plastics.

FINISHES

Brushing softens or quiets the tone of a metal finish. An actual brush or a piece of fabric is used to bring about a satiny look.

Chasing is a process of filing and chiseling that sharpens the edges of cast relief ornament. Filing refines the details to make them appear crisply dimensional. Chiseling further clarifies the ornament's sculptural quality.

Plating involves the immersion of a piece of hardware into a chemical bath of liquid metal that is electrically bonded to the object. Metals commonly used for plating include brass, nickel, copper, chrome, bronze, pewter, silver, and gold.

Polishing, accomplished by either hand or machine, increases the sheen or brightness of metal.

RECOMMENDATION

BECAUSE CONTEMPORARY FURNITURE MANU-FACTURERS OFTEN DESIGN THEIR OWN HARD-WARE, MODERN HARDWARE CAN BE MORE DIFFICULT TO MATCH THAN ANTIQUE. IT MAY BE ADVISABLE TO SEND A PHOTOGRAPH OF THE SPECIFIC PIECE OF HARDWARE TO THE MANUFACTURER OR DEALER FOR REPLACE-MENT. TO DUPLICATE ANTIQUE HARDWARE, BRING OR SEND THE PIECE TO BE MATCHED TO A STORE SPECIALIZING IN ANTIQUE OR REPRO-DUCTION HARDWARE. ❧

ABOVE AND OPPOSITE
Details of cast-aluminum door handles created by London-based designer Innes Ferguson. They are also available in polished aluminum, brass, copper, and black leatherette through I.F., London.

LIGHTING

The light was sometimes diluted by the silk curtains hanging

before balconies, or heightened by beating on some gilt frame or

yellow damask chair which reflected it back. Sometimes, particularly

in summer, these rooms were dark, yet through the closed blinds

filtered a sense of the luminous power that was outside; or sometimes

at certain hours a single ray would penetrate straight and clear. . . .

T O M A S I D I L A M P E D U S A

ABOVE

The silhouette of a standing luminaire emphasizes the bare-bones approach taken by Peter Carlson in designing this showroom for Karl Lagerfeld, Bijoux.

OPPOSITE

Natural light enhances the mood of this sensuous bath. Photograph by Jeff Beecroft.

PAGE 86

"Lou, Lou, Lou" a pendant lamp by Terzani of Florence, Italy. Photograph courtesy of Terzani.

PAGE 87

Ultimate satisfaction in any renovation relies on thoughtful placement of rough wiring and switching.

No other element of an interior influences the way a room is perceived as immediately as lighting. Subtle yet powerful, illumination establishes the emotional tenor of a space. Practically, it must provide sufficient light for the activities taking place in a room without generating glare or excessive contrast.

A good lighting scheme is produced through combinations of daylight and artificial lighting. It requires both technical and aesthetic planning to determine what kind of lighting will best serve each part of the room: direct (which casts light onto a limited area where clear vision is important); indirect (which throws light of considerable strength against a reflecting surface such as a ceiling or wall, typically producing a diffuse, soft, and shadowless quality); concealed (set in a cornice or cove); accent (such as a spotlight or picture light); or task (such as a desk lamp). It is also important to consider whether additional electrical outlets, switches, and/or dimmers are needed—and where. Since lighting technology is constantly changing in complexity and innovation, you would be wise to consult a lighting specialist.

DAYLIGHT

Ask any of the world's best interior designers and interior photographers and they will tell you that nothing flatters a room like natural daylight. Well into the seventeeth century, householders still positioned their chairs, writing desks, and other furniture primarily around windows to take the greatest possible advantage of sunlight, which, because of the angle with which it enters most windows does not have great qualities of penetration: Only about ten percent of the sunlight coming through a window effectively illuminates the space near the window and an even smaller amount reaches the far corners of the room. Nevertheless, direct and indirect sun-

light can generate considerable heat and diffuse light and must be modulated according to the direction the windows face, the seasons of the year, and the time of day. A room will look and feel different in cool northern light or warm southern light, in the yellow light of summer or the blue-gray of winter, in the soft tones of dawn or dusk or the white glare of the midday sun. The best means of preserving natural light in a room is to resist applying needless decoration over the windows.

ARTIFICIAL LIGHT

Given that few of us have lived even one day of our lives indoors without the benefits of artificial lighting, it is hard to comprehend just how recently developed is the ability to evenly light an entire room. Since the torch was first affixed to a wall and a wick was burned in the first oil lamp, artificial light principally consisted of single points of radiance spottily illuminating various areas of a room. When the wick was eventually encased in hardened grease or wax, the candle was born, but not yet general illumination. The hanging chandelier, developed in the seventeenth century, proved to be the first central lighting fixture, and over time was equipped with oil lamps, gas jets, and, finally, electric bulbs. Gaslight, the great lighting discovery of the nineteenth century, produced a comparatively steady light strong enough to illuminate an entire room and was greatly heralded despite its danger and heat. Thomas Edison's invention of the electric light bulb introduced the modern phenomenon of steady, diffuse, consistent, safe illumination.

LIGHTING SOURCES

Incandescent light is produced by the passage of electricity through a sealed bulb that contains a tungsten filament and is filled with

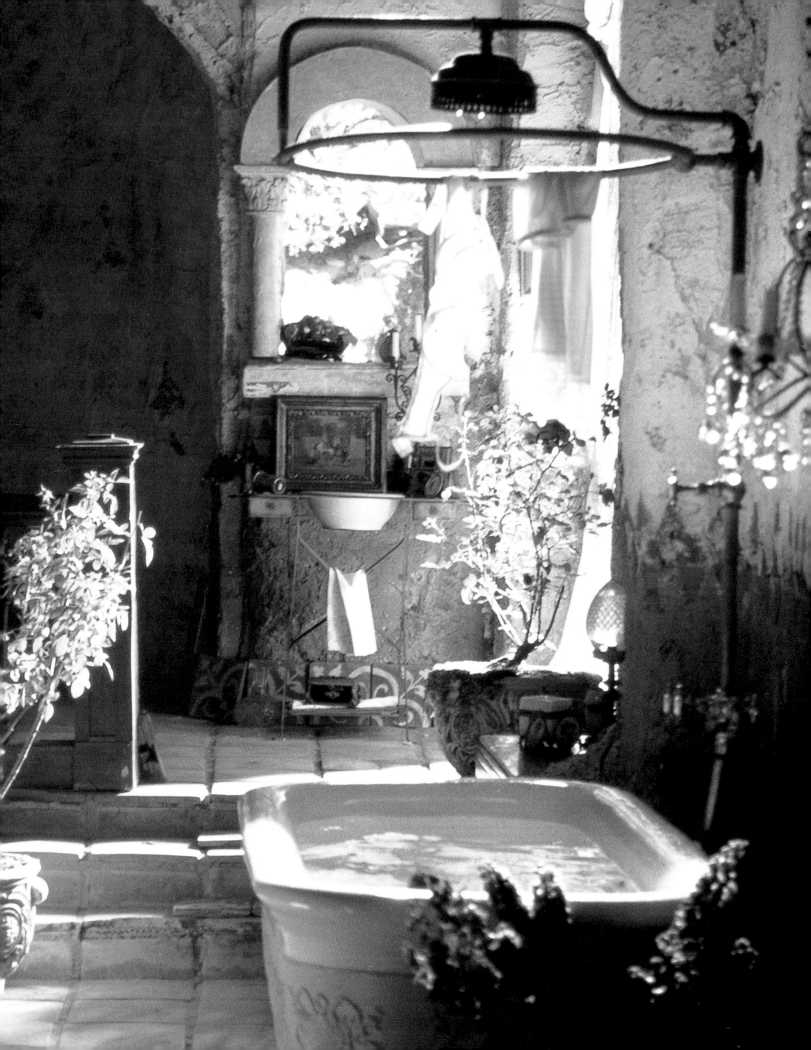

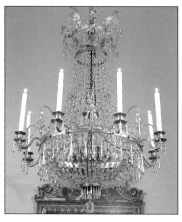

inert gas. It is inexpensive, warm in tone, and available in bulbs of a variety of shapes, sizes, and wattages for different applications.

Tungsten halogen, a type of incandescent light also known as *quartz-halogen,* emits an especially uniform and rather white color of light. It is more expensive than other incandescents, but has a far longer lamp life. A small halogen bulb provides the same amount of light as a standard bulb of much greater wattage and is effective in spotlights or uplights or where sharp, concentrated light is needed. Be advised that most halogen bulbs require special fixtures and transformers.

Fluorescent bulbs produce a strident light that has no place in the home, especially in the kitchen or bathroom where the diffused shadowless light they produce give food and skin an unappealing cast. If you have fluorescent light in your house, your rooms will benefit by replacement.

Cold-cathode lighting, which emanates from a thin tube configured to a specific form, is often used in more permanent installations such as coves. It produces light in many colors as well in several shades of white.

TYPES OF FIXTURES

Architectural lighting is often concealed in the structure of a building to provide overall low-intensity illumination reinforced by spots of concentration. While it is more commonly used in public spaces, such as offices and restaurants, combinations of architectural lighting with other types of lighting, such as surface-mounted fixtures and lamps, can also be applied to the home.

Recessed fixtures are set flush with the ceiling. The most familiar type is called a high hat. Interior focusing mechanisms allow it to control the direction, shape, and quality of the light beam to spotlight art works and to illuminate the area over tables and desks. Because recessed fixtures throw all their illu-

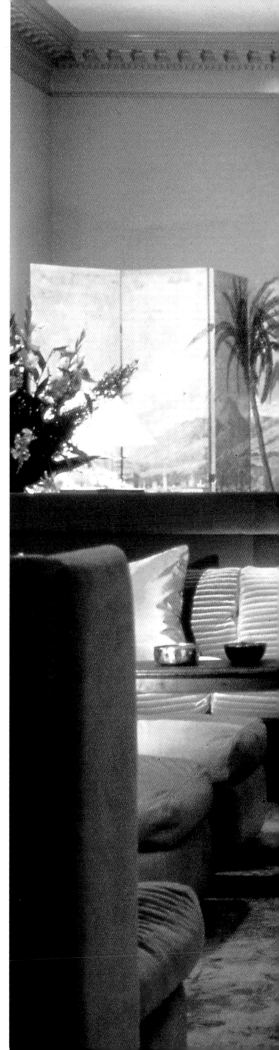

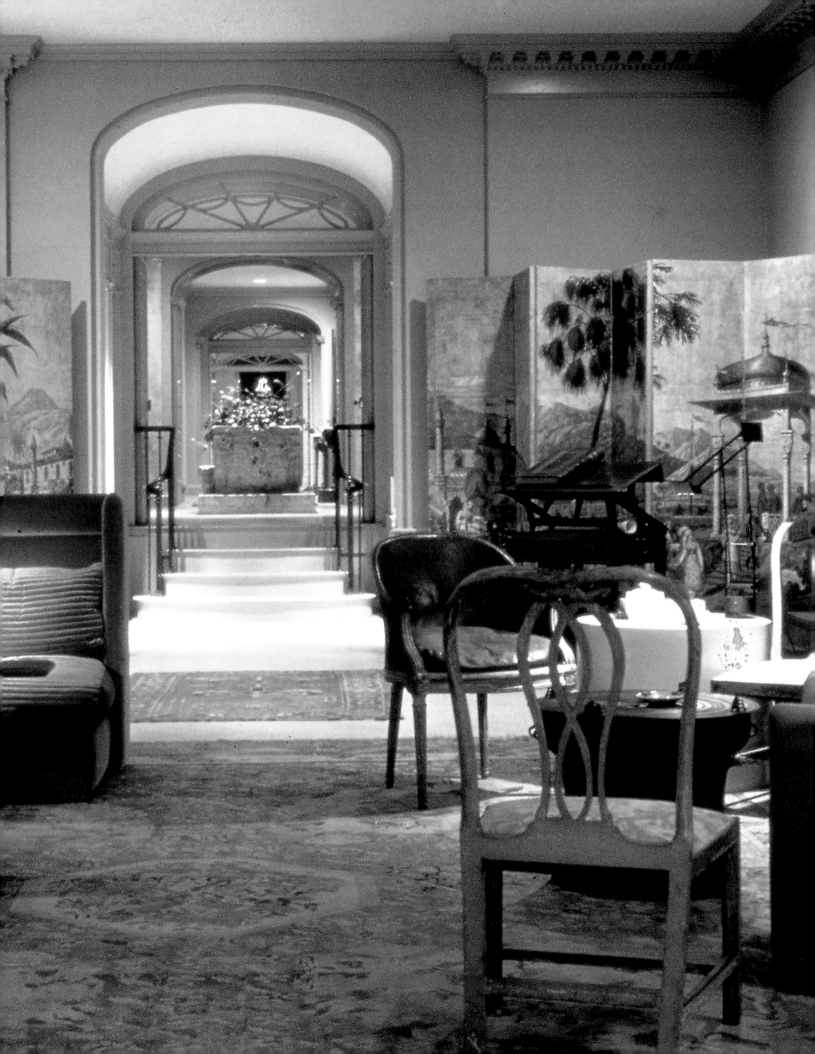

These handmade lamps were designed by the Venetian textile and costume designer Mariano Fortuny in the early 1900s. "Cesendello," at top, is available with a bamboo stand, wall bracket, or shade only. "Samarkanda," above, is available with canopy and lamp or shade only. "Scudo Saraceno," at right, has an adjustable drop and is available with canopy or shade only. All are available from Noble International, San Francisco and through Kneedler Fauchere in California and Colorado. Photographs by Alan Weintraub.

mination downward, they leave the ceiling in darkness. Although this gives the ceiling a clean, unblemished appearance, it also tends to reduce the apparent height of the room. Single recessed lights can create harsh shadows. You are better advised to use a group of several, aimed to break up the shadows. Recessed lights can receive flood or spot bulbs of varying intensities.

Concealed lights, tubular bulbs set in troughs, cornices, or coves, are excellent sources for indirect illumination. They should be installed no less than twelve inches below the ceiling or reflecting surface. The trough, cornice, cove, wall recess, or decorative feature into which the light strip is set must conceal the light source from all angles.

Downlights are among the most popular incandescent lights used for general illumination. They can be recessed, surface mounted, or hung on a stem, and are usually equipped with a lens or shade to prevent direct glare.

Wallwashers are continuous strips of recessed lights that direct illumination from

the ceiling onto a wall in a manner that bathes the wall with uniform light.

Spotlights and *picture lights* illuminate decorative displays and tend to create a sense of drama. Strongly directed spotlights will highlight a collection of objects, a group of pictures, or a set of bookshelves. Picture lights can be mounted on tracks as mini-projectors or attached to the picture from the back of the frame, which produces a more intimate style of illumination.

Surface-mounted ceiling fixtures or *pendant fixtures* can cast light either upward toward the ceiling or downward into the room. Either effect is highly efficient in diffusing general illumination. These fixtures are available in unlimited styles and can be used with various types of bulbs, globes, and shades.

Wall sconces, which evolved from the metal or glass holder of a candle or glass jet, are less efficient in casting illumination than a central light fixture, but are highly effective in creating mood. Their great variety of decorative shades also makes them beautiful wall ornaments.

Floor lamps provide indirect lighting when aimed upward against a ceiling and direct lighting when aimed downward toward a chair or furniture grouping. Torchères, floor lamps that have their source of light within a pierced dome or reflecting bowl, aim all light upward.

Table lamps, like furniture, can serve a decorative role in an interior. The best selections are those that are in keeping with the style of the other furnishings. It is important that the proportion of the lamp be as carefully considered as all the furniture in the room.

THE LAMP SHADE

Just as the style and proportion of the lamp must work harmoniously with the room, so must the shade be harmonious with the lamp. The shade must adequately cover the bulbs and direct the light where it is needed. Aesthetically, there are no absolute rules for shape, but in general, squat bases tend to look best with wide shades, and slender bases call for tall, narrow drums, bell shapes, or shades with flaring silhouettes. Today, shades are made of everything from elegant silks to metal mesh to parchment. When considering materials, remember that metals, leathers, or completely opaque fabrics tend to create dramatic spot effects, while translucent materials naturally allow for more-diffuse illumination. A lining of fabric or paper can be attached to the inside of the shade to modify the color and quality of the light.

COMMON MISTAKE

A room that is too evenly lit easily becomes boring or monotonous. It is far more interesting to use different sources of light to create overlapping, concentrated pools of light.

RECOMMENDATION

WHEN HANGING A CHANDELIER IN A DINING ROOM, AS A GENERAL RULE, THERE SHOULD BE APPROXIMATELY THIRTY TO THIRTY-TWO INCHES BETWEEN THE TABLE TOP AND THE BOTTOM OF THE CHANDELIER, DEPENDING ON THE SIZE OF YOUR CHANDELIER AND YOUR CEILING HEIGHT.

WALL SCONCES GENERALLY SHOULD BE LOCATED AT A HEIGHT OF FIVE FEET EIGHT INCHES TO SIX FEET FROM THE FINISHED FLOOR, DEPENDING ON THE CEILING HEIGHT AND THE LOCATION OF THE WIRING AT THE BACK OF THE SCONCE. ❦

TOP

A sleek, contemporary pendant lamp of adjustable height from Tobias Grau, Hamburg, Germany. Photograph courtesy of Tobias Grau.

ABOVE

A classic floor lamp by Cedric Hartman provides perfect light for reading in a bedroom designed by Peter Carlson. Photograph by Lizzie Himmel.

C H A P T E R 7
C O L O R

*All my life I've pursued the perfect red. I can never get painters
to mix it for me. It's exactly as if I'd said, "I want rococo with a
spot of Gothic in it and a bit of Buddhist temple" — they have
no idea what I'm talking about. About the best red to copy is
the color of a child's cap in any Renaissance portrait.*

DIANA VREELAND

"If," John Ruskin wrote, "light and shade imply the understanding of things…color implies the imagination and sentiment of them." The application of a pleasing color scheme is unquestionably the easiest practical way to elevate the mood of a room and to alter the perception of space and dimension.

The legendary Dorothy Draper, a fearless user of color, was once commissioned to transform four nondescript rental flats in the then-obscure New York neighborhood of Sutton Place. She painted each of their front doors a different, strong, vibrant color: flaming red, grass green, chromium yellow, and cobalt blue. Inside, she applied a color scheme of black and white. The effect was so startling that overnight the Sutton Place flats became synonymous with drop-dead chic.

Color is one of the most critical factors in creating a mood. Achieving a successful color scheme requires a measure of basic knowledge as well as an understanding of the look you desire to achieve and your own personal style. William Pahlmann, who was head of the decorating and antiques department of Lord & Taylor from 1936 to 1942, created model rooms that became famous for their shockingly "new" style and dramatic combinations of color. As the designer Mark Hampton has noted, Pahlmann adored "powerful, strange red-oranges, sharp, exciting green-blues" and other colors he knew to have been favorites of Napoleon.

Napoleon's tastes in color were, in fact, as powerful as his ambitions. He is known to have ordered thousands of yards of silks and satins in golden yellow, bright green, and crimson. His Grand Cabinet was a pale brown, termed *Tabac d'Espagne*, that was bordered with blue and gold. A bed made for him in 1809 was upholstered in silk dyed the color of citrus wood, decorated with stars in lilac, and bordered with silver brocade on a lilac ground.

The color palette provides a background for forms, textures, and lighting, all of which must be simultaneously articulated and brought into harmony. Like light and texture, color must be used with purpose, and never independently of the other elements of the room. Dorothy Draper's own home expressed her strong, clear, and imaginative color sense, her distinct distaste for the demure, and her passionate love for the grand. Cerulean and sky blue were combined with lime green and poison green; her

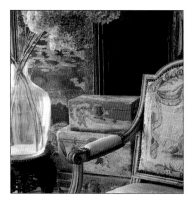

reds ranged from shocking pink to scarlet; she abhorred pastels and browns, and that included wood finishes. Even her clients' intricately carved or molded paneling was swathed in high-gloss enamel. The equally decisive decorator George Stacey has evolved a personal color hierarchy in which bright primary colors stand out against backgrounds of taupe, bone, and dark browns. He adds shimmering touches of gold for brilliance and richness.

COLOR AND LIGHT

An understanding of color begins with a knowledge of its source: light. Color emanates from rays of light, a form of radiant energy. The eye distinguishes different wavelengths of this type of energy and interprets them as different colors known as spectral colors, the dominant ones being violet, indigo, blue, green, yellow, orange, and red. Daylight, or white light, is a combination of all these colors. (Rays of light coming from an artificial source have the same general characteristics as those coming from the sun.)

Every material in nature has the capacity to absorb one or more of the components of a ray of white light. The rays not absorbed are reflected to the human eye and are perceived as the color of the material or object. A leaf, for example, absorbs the red rays and reflects the blue and yellow ones, making it appear green. This type of color perception is known as "subtractive color," and it is what we work with in interior design, as well as in other art forms and media that use pigments and dyes. With subtractive color, red, yellow, and blue, known as the primaries, cannot be produced through mixing. (Mix them together in pigment and you will not get white, as you would with light, but gray.) On the color spectrum (the band of colors arranged according to wavelength), the primaries alternate with secondaries—orange, green, and violet—their neighbors on the color wheel from which they can be mixed. The spectrum begins with red and ends with violet, a secondary made from blue and red, which brings the band of color full circle into what is known as the color wheel. Tertiary colors—blue-violet, blue-green, yellow-green, yellow-orange, red-orange, and red-violet—are created when a primary color is mixed with a secondary hue adjacent to it on the color wheel.

COLOR SYSTEMS

To describe and quantify color, most interior designers rely on specific systems. The Brewster system, also known as the Prang system, is based on the organization of color around the three primary colors—red, yellow, and blue. The Munsell system, which deals with colors produced by dyes and pigments, defines color in terms of three attributes: *hue, value,* and *chroma.*

Hue, what we recognize as the color itself, refers to a color's position in the spectrum. A hue, for example red, is the same whether it is a light or dark variation or a dull or brilliant one. The Munsell system recognizes five principal hues—yellow, green, blue, purple, and red—which are subdivided into as many as one hundred intermediate hues. Each hue and subdivided hue is assigned a number ranging from 2.5 to 5 to 7.5 to 10 that represents the degree of saturation of the hue.

Value describes the amount of light a color reflects or absorbs, which is determined by its position on a scale from black to white. When white, which reflects all light, is added to a hue, the result is referred to as a tint; when black is added to a hue, it is known as a shade. Pink, a tint of red, for example, is high in value; indigo, a shade of blue, is low in value.

Chroma, also called saturation, refers to the degree of intensity or brilliance that exists in a color. A clear red is highly saturated with

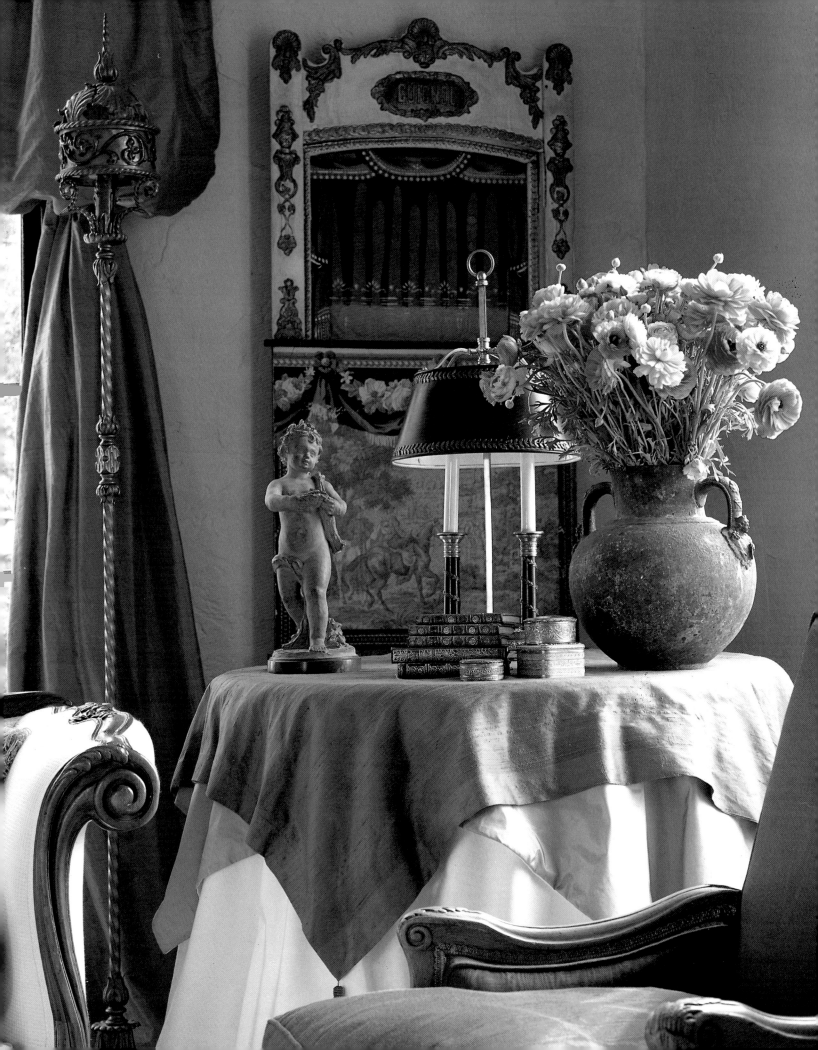

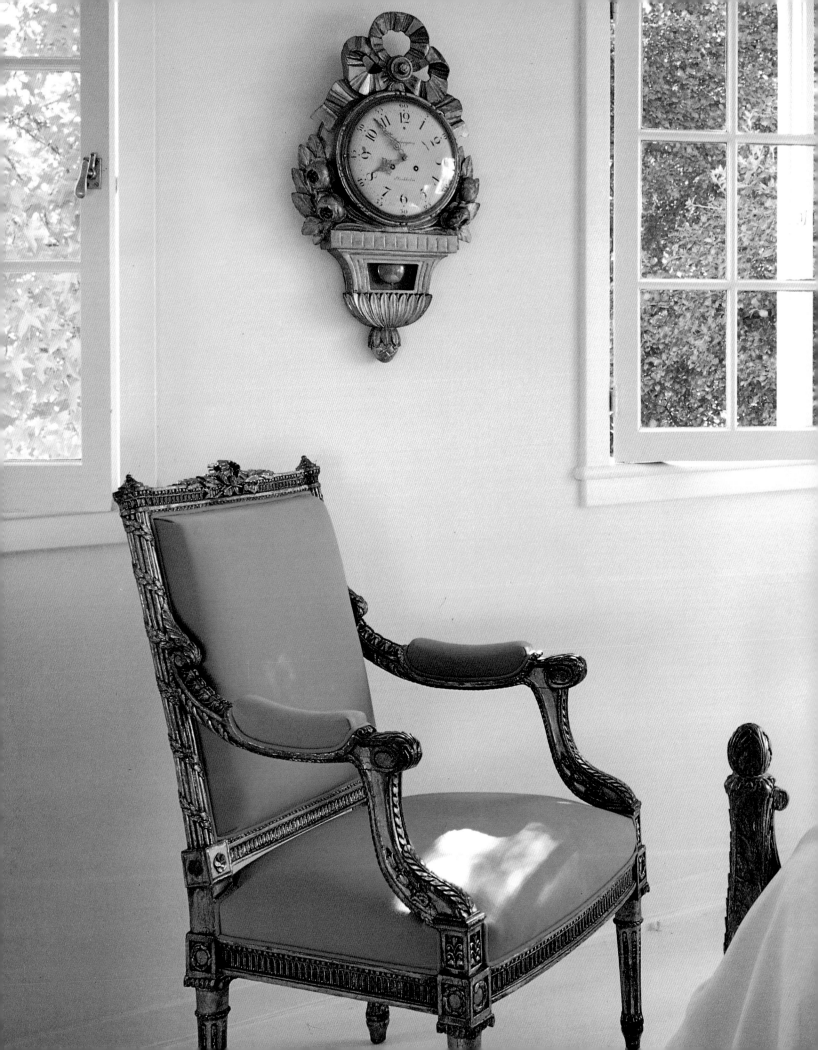

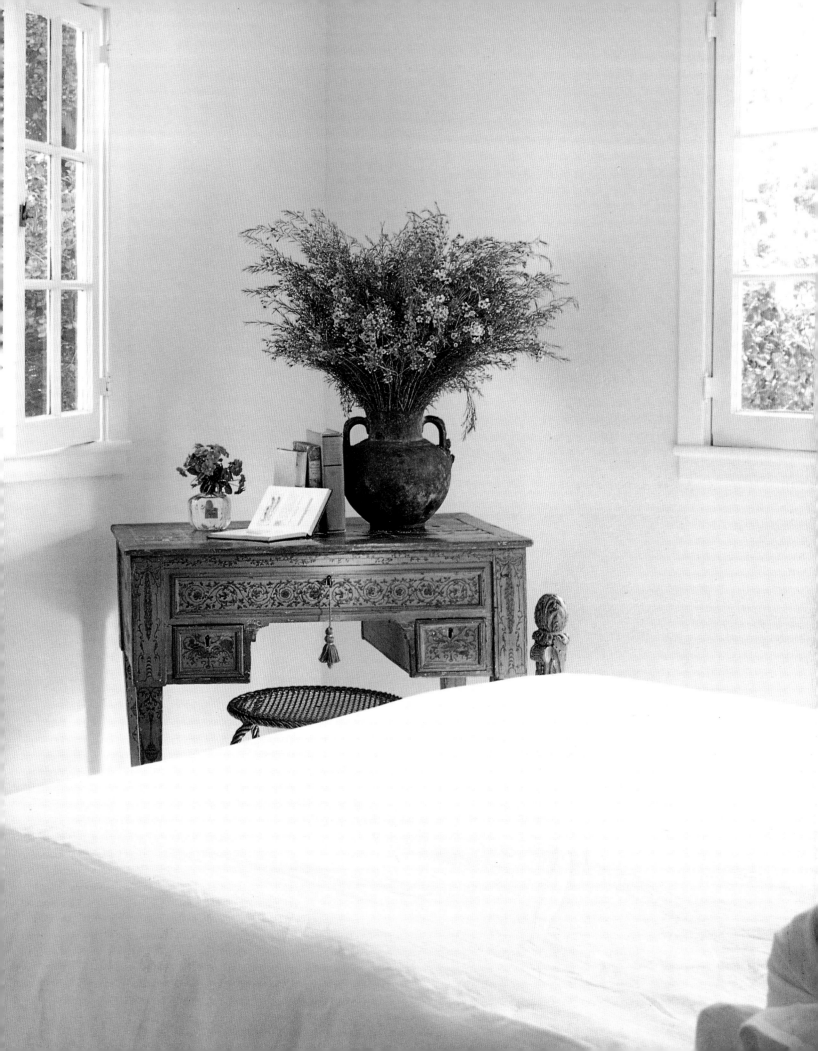

The stark elegance of a white room designed by Victoria Hagan emphasizes the furniture silhouettes. Photograph by William Waldron.

red pigment. A red mixed with another color is lower in saturation.

Primary pigments can be applied successfully in very modern rooms, for instance those that pay homage to classics of the period such as the De Stijl school and the paintings of Piet Mondrian. In more traditional contexts, however, the use of mixed colors produces more satisfactory results than pure primary pigments.

Complementary colors are found directly across from one another on the color wheel: red and green, orange and blue, yellow and violet. The result of mixing two complementaries is a neutral gray. In a complementary color scheme, complementary hues are used for the dominant and medium areas and sometimes repeated in higher chromas in the smaller areas.

EFFECTS OF ADJACENT COLORS

Complementary colors reinforce each other and, when placed adjacent to each other, will appear to heighten the other's saturation. For example, when a small area of one color is placed on a background of its complement, the small area of color will seem more intense.

Adjacent noncomplementary colors tend to tint each other, making them seem farther apart on the color wheel than they actually are. Such effects were the subject of the work of the artist Josef Albers, whose large, flat paintings of squares of color instruct, deceive, and titillate the viewer with the various optical illusions of adjacent hues.

WARM AND COOL COLORS

The warm side of the color wheel, composed of yellows, oranges, and reds, can heat up the psychological atmosphere of an interior. Warm colors also tend to advance and to make an object, such as a piece of furniture, appear larger. The cool colors—violets, blues, and greens—are traditionally used to refresh and soften the feeling of hot, sunny spaces and in rooms that require a soothing mood. A neutral gray will appear warm when placed on a blue background and cool when placed on a red background.

This knowledge can be used to modify the spatial quality of a room. A high ceiling will feel lower when painted a dark color. A narrow room will seem wider if the end walls are warm in color and the side walls a lighter, cooler color. An individual piece of furniture will gain prominence if it is lighter than a background of dark floors and walls. A large object appears diminished in size if its color is similar to its background.

THE PSYCHOLOGY OF COLOR

Dorothy Draper considered the psychological and therapeutic effects of color to be so potent that in 1940 on her radio show she advised, "A timid person can change to a more aggressive thinker by stopping being so nervous about living with color." Mrs. Draper would have agreed that color, imbued with connotation, history, and inferences of taste, is likely the most emotional and personal element of an interior.

Red is vigorous, stimulating, and often regal. Rich, lush reds can give dark rooms an inviting warmth. Coral tones of red work beautifully in dining rooms. Warm terra cotta red, the color of old frescoes and Chinese lacquers, is lovely in living rooms, libraries, or any room decorated with touches of leather, brass, bronze, or gold leaf. When used to balance blues and greens, red will add vitality to a color scheme. When used in large areas with green, it can produce an off-putting tension.

Orange, which shares many of the qualities

of red, can be used in small proportions to visually stimulate a cool or neutral color scheme.

Yellow, the mildest of the warm colors, is generally used to brighten a space. Yellow tints (creams and beiges) carry little connotative weight and are therefore generally "safe" and easy to apply. When not used as backdrops for strong architecture and varied pattern, however, they can easily appear bland and uninspired.

Green, the cool color closest to warm, is most associated with serenity—a tranquil green sea or a silent green forest. That feeling was voluptuously interpreted in the New York apartment of the late Van Day Truex, head of the Parsons School of Design and design director of Tiffany & Co,. Mark Hampton has described how Truex used his apartment as a color laboratory, decorating it in many shades of green. The walls were a dark, mossy green that welcomed many other shades of green, such as the acid green in the upholstery and the bleeding tone found in the Bessarabian carpet. Green porcelain, accessories of every shade, and even the leaves of flowers rounded out the range of the color. The result was a "basic quality of being richly colorful without seeming overpowering."

Violet, at the borderline between cool and warm, is expressive, regal, and sometimes volatile. Blue, the coolest of the cool colors, suggests repose. When overused, it can create a cloyingly calm atmosphere.

COLOR SCHEMES

In their classic text, *The Decoration of Houses,* Edith Wharton and Ogden Codman, Jr., waved a banner for *monochromaticism,* advising that "the fewer colors used in a room, the more pleasing." They felt that the effect of the use of many colors was discord, "a continuous chatter…fatiguing in the long run." The English architect and designer M.H. Baillie Scott was fond of saying, "When in doubt, whitewash," and the American decorator Elsie de Wolfe worked with the slogan "Plenty of optimism and white paint." Syrie Maugham, the English society hostess and decorator whose 1920s London drawing room was a sensation of modulated, creamy

The white of the walls, floor, and ceiling is relieved by raw steel and light-toned wood in this crisply efficient kitchen.

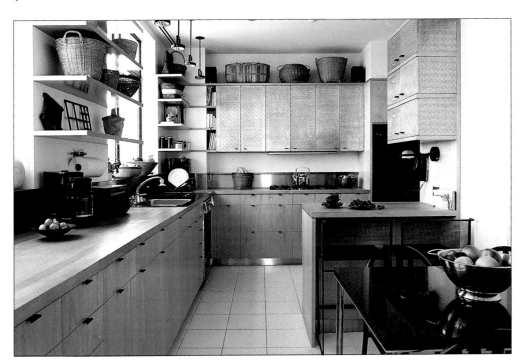

A Manhattan aerie was given a vibrant pink and orange color scheme reminiscent of the work of sixties fashion designer Courrèges, who was known for his use of geometric shapes and a shocking palette.

white monochromaticism, obviously agreed. Even her flowers were always off-white with all greenery removed. In a more pragmatic context, Le Corbusier, in his treatise on modernism, extolled "the bracing quality of chalk white." Yet he went on to caution, "Practice showed me that the joy of white explodes only when surrounded by the powerful hum of color."

Timelessly stylish, a grand sweep of *white* is also physiologically calming. According to art theorist Rudolph Arnheim, "the juxtaposition of complementary colors gives rise to an experience of balance and completeness. The underlying kinship of white (as the luminous fusion of all colors) must be the reason for this. White is undemanding physiologically, for it is the harmony perpetually established in the eye."

Sensitive to every hue, white is highly adaptable. Ideal for a room with a beautiful view, it allows the inside to fade out as it invites the outdoors in.

White can be used to achieve many moods and styles. In romantic rooms, diaphanous white gauze, white lace, white silks, and voluptuous white satins enhance the sensation of indulgence in the pleasures of the world. The unaffected charm of a rustic ambience emanates from white plaster walls and limed wood. Faded white fabrics can set the mood for crisp checks and profuse florals. A more sophisticated, elegant look can be achieved by using a variety of richly patterned white fabrics in a white room. This enhances even a pristine setting with wonderful accessories and abundant flowers, whether they are arranged in a Baccarat vase or in twig baskets.

The *neutrals*—black, white, gray, brown, and beige—are not found in the spectrum or on the color wheel, and therefore are technically not colors. Their most effective use is to draw attention to strong architecture in a space where color is less desirable. Being neither warm nor cool, neutrals can help unify several other colors. They can relieve the intensity of a bright palette and create the perfect backdrop for deep, rich colors. However, without a "punch" of colors, neutrals can descend from the tasteful to the downright boring. The very quality that makes them so versatile requires the vitality of their juxtaposition to a vibrant garden, bouquet of flowers, or a landscaped terrace— which is to say a big splash of color. Dorothy Draper referred to neutrals as "gravy" colors and eventually banished beige from her palette.

A *monochromatic* color scheme employs a single hue with variations only in intensity and value. While it is simple to implement, it can easily grow monotonous.

An *analagous* color scheme achieves harmony through the use of hues that are close together on the color wheel—typically, one primary or secondary plus the hues adjacent to it on either side, i.e., a segment of the color wheel that spans no more than about 90 degrees. This limited range of hues ensures a harmonious interaction of color and allows for a wide variation of values and chroma. Complementary colors work easily in this type of scheme as accents.

A *complementary* color scheme uses hues from opposite sides of the color wheel, typically one warm and one cool color plus some white or black for enrichment. Complementary schemes tend to look bright, and if not carefully handled, can appear garish. To prevent this, it is critical to vary the chroma or intensity of the colors. For example, both red and the adjacent red violet on one side of the wheel might be used with a slightly yellowed green opposite.

A *tetracolor* scheme uses two warm colors and one cool color, or the reverse. Because it employs a wide range of color, it tends to be difficult to implement.

HISTORICAL APPLICATIONS OF COLOR

"The meaning of color varies not only with changes of location and use, but also with changes in time," the design editor Stanley Abercrombie notes. "Taste in color does evolve and develop. Particular color palettes have been associated with historic periods, with regions, with decades, and even with specific designers."

During the Egyptian, Greek, Roman, and Gothic periods, the colors most used were strong primary and secondary hues. Neutralized colors, such as the dark hues found in the walls and textiles of sixteenth-century Italy and seventeenth-century France, were introduced during the Renaissance. Late-Renaissance tapestries are identified with neutralized browns and greens. The somber paintings of El Greco not withstanding, many brilliant primary and secondary hues were found in Spanish Renaissance interiors. Pale tints of neutralized colors dominated the walls and woodwork of eighteenth-century French interiors, while the so-called pretty tints of primary and secondary colors were used in their textile patterns. Patriotism ruled the Directoire period with strong reds, whites, and blues.

A shift toward severity occurred in the early years of the nineteenth century, when many color schemes exhibited a dominance of off-grays and blacks. A departure was the brilliantly colored backgrounds with pattern motifs in dull gold of some Empire textiles. The influence of Empress Josephine was seen in the pale dull blues, grayed purples, medium dull browns, and flesh colors that appeared in Malmaison, the interiors of the country house she shared with Napoleon.

In eighteenth-century England, neutralized colors and darker values predominated, as seen in the popular Wedgwood pottery colors—neutralized blues, greens, browns, and black. During the Adam period, dull blue, pale yellowish green, light gray, lavender, and other tints were favored. The Victorian period was so identified with neutralized reds that it became known as the "Mauve period." Other colors used in the Victorian palette were eggplant, bottle green, tobacco brown, and purple.

In Colonial America, oxblood, an earthy red that is informal in character, was commonly used with indigo blue. Bright colors were applied to textiles in provincial and peasant houses and used for painted decoration.

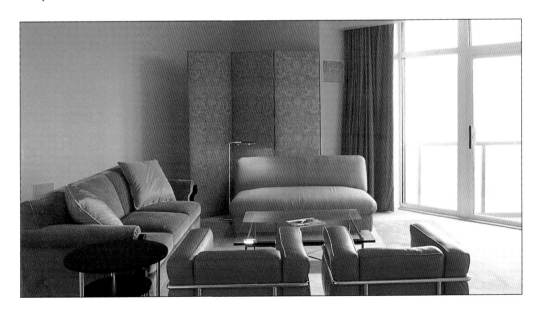

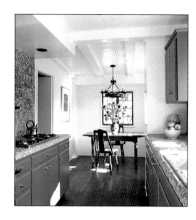

ABOVE AND OPPOSITE

Crayola®-colored Bachelder tiles, reminiscent of the colors in the paintings of Paul Klee, impart a playfulness to the sophisticated geometry of the mosaics in a Los Angeles kitchen designed by Billy Steinberg. The lively tile palette provides an opportunity for the use of brightly colored cabinets.

PLANNING YOUR COLOR SCHEME

To determine the approach to color that best suits your style, examine the mood and purpose of your room. Will you be more comfortable with soothing colors or do you desire to generate a feeling of excitement and stimulation? Is your look based on a historical reference that you want to replicate or reinterpret? Are you going to use color as a backdrop to set off particular furniture or art work? Or will you employ it to provide harmony in a house where that element is otherwise lacking?

When planning a color scheme, it is helpful to subdivide a room into component areas of color distribution. These include the dominant areas (wall, floor, and ceiling), medium areas (curtains, large upholstered furniture, bed coverings, etc.), small areas (smaller furniture, chair cushions, table skirts), and accents (pillows, small patterned motifs in wallcoverings and textiles, fabric trims, small accessories, and flowers). The treatment of the dominant and medium areas of a room generally define a color scheme. The smaller areas, while not as significant in their effect on the overall scheme, play an important role as accessory color and can unify the interior with repetitions of the same hue. According to the Law of Chromatic Distribution, "The larger areas should be covered in the most neutralized colors of the scheme. As the areas reduce in size, the chromatic intensity may be proportionally increased." A restful effect results from implementing or interpreting this law by using grayed values on a large plane and mild tonal contrasts in patterned surfaces. Keep in mind that this is just one approach to color application. Some of the most fabulous rooms, like Diana Vreeland's famous red living room, have been designed with totally unorthodox approaches to color.

Accessories are perhaps the easiest way to introduce color to a room. Even something as simple as a bowl of lemons or a bouquet of spring flowers can provide the unexpected excitement or contrast that will bring a room to life.

COMMON MISTAKES

Painting a small room in a light color generally only serves to emphasize how small it is. It is frequently better to work with darker hues to create a more intimate feeling. Your goal should be a jewel-box quality.

Changing wall color in every room is generally a bad idea. The more continuity, the richer the look.

RECOMMENDATIONS

SOME COLORS CAN MAKE A ROOM SEEM SMALLER, OTHERS LARGER. A LARGE SPACE DARKENED WITH COLOR WILL FEEL MORE APPROACHABLE AND LESS VAST, WHILE SMALL HALLWAYS, STUDIES, AND LIBRARIES WILL SEEM EXPANDED BY DEEP HUES BECAUSE THE BOUNDARIES OF THE SPACE—WALLS AND CORNERS—ARE LOST IN SHADOW.

ACCENTUATE THE HEIGHT OF THE CEILING BY APPLYING SUBTLE VERTICAL STRIPES TO WALLS, OR BY PAINTING THE CEILINGS AS LIGHT A VALUE AS POSSIBLE.

FOR SMALL ROOMS, COLOR AND CRISP PATTERNING WILL DRAW THE EYE INTO THE SPACE. HORIZONTAL LINES WILL VISUALLY WIDEN IT. LIKE SMALL ROOMS, ROOMS LACKING NATURAL LIGHT CAN BENEFIT FROM DEEP BACKGROUND COLORS. CONCENTRATE STRONG COLOR IN UPHOLSTERY FABRICS IN INTIMATE SEATING GROUPS ARRANGED TOWARD THE CENTER OF THE ROOM. ❦

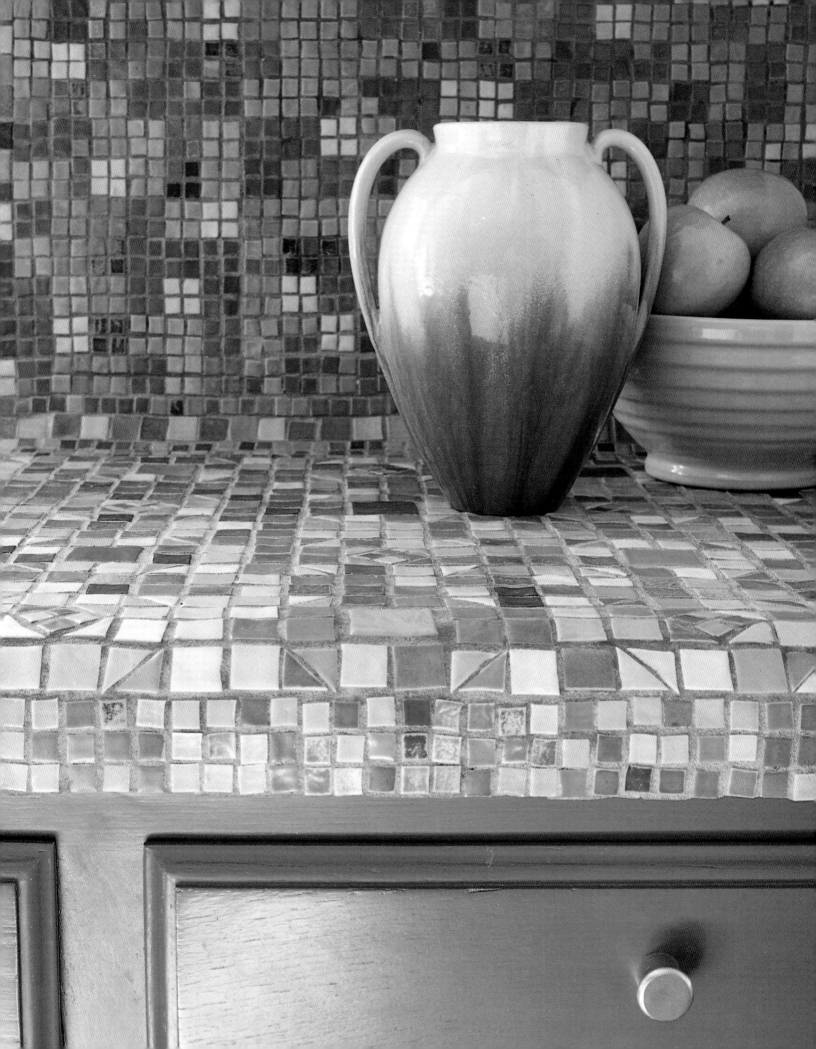

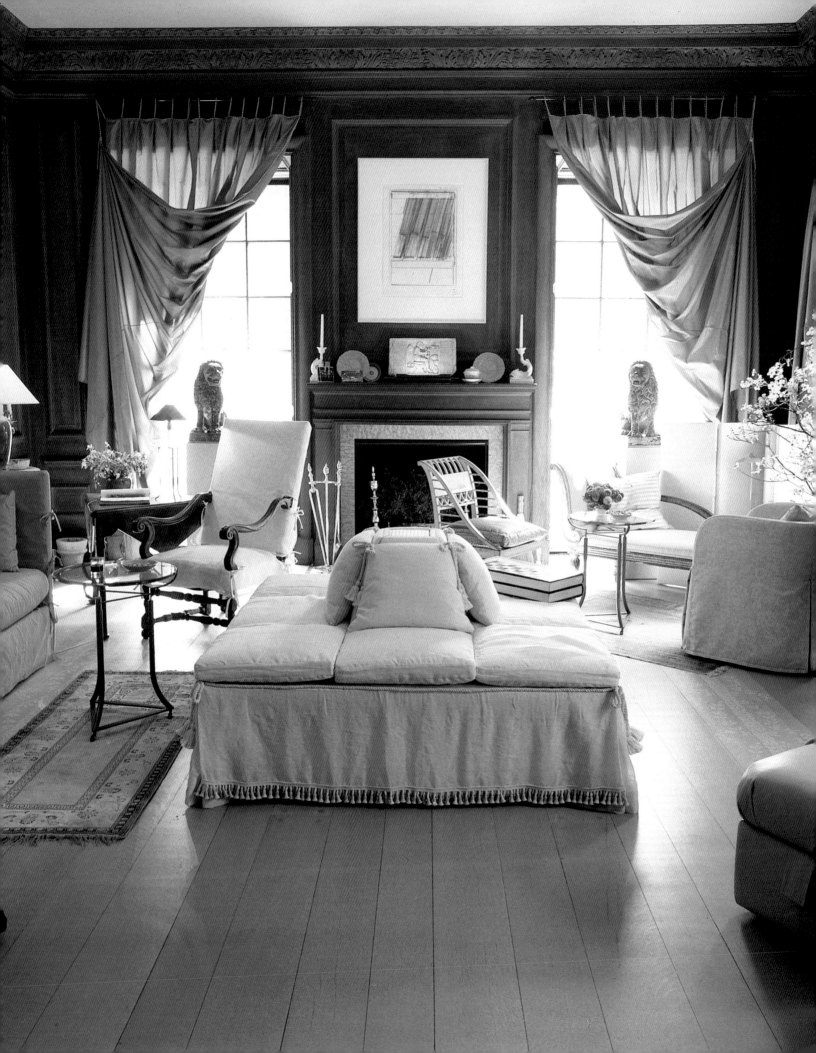

FURNITURE ARRANGEMENT

The impression a room makes at first sight is largely conditioned

by the furniture it contains and how this is arranged. Of these two

factors, it is the arrangement that is the most important. If pieces

are positioned awkwardly, the fact that they are the finest antiques

will make no difference, and the room will still look static and

indifferent. It is not what you own, but how you use it.

DAVID HICKS

RIGHT

Peter Carlson and Linda Chase employed a pair of sofas, a love seat, and a trio of tables to delineate the sitting area in this large room. The repetition of identical shapes gives weight and structure to the furniture grouping.

PAGE 108

A series of vignettes are arranged around a bourne at the center of a room designed by John Saladino. Photograph by John Nihoul.

PAGE 109

Miniature furniture from Doll House Antics, New York.

In a dining room designed by Victoria Hagan, a Palazetti table is centered under a 1940s Venetian chandelier. Custom high-backed slipper chairs and Victoria Hagan's signature "clock chairs" surround the table. Photograph by William Waldron.

AESTHETIC CONSIDERATIONS

As in every aspect of designing an interior, scale, pattern, and texture are the primary considerations in arranging furniture. The size of the room and its architectural elements will have great influence on the scale and placement of furniture. Here scale refers to the relationship between the size of one piece of furniture to the size of another as well as to the proportions of the room. Well-designed furniture is scaled to the human frame. The textures and patterns of furniture surfaces and upholstery also must be considered when composing a furniture layout.

One key to successful furniture arrangement is to use unifying features. A simple background, for example, is necessary in a room that contains many different types of furniture or that mixes a number of furniture styles. Continuous flooring, wall-to-wall bookcases or cabinets, or a neutral overall color scheme can enhance a sense of continuity. Designer Michael Taylor was famous for successfully mixing numerous large-scale pieces by setting them against backgrounds of harmonious neutral tones. Billy Baldwin integrated various styles of furniture with his signature use of tailored upholstery and subtle tones.

ORGANIZATION OF SPACE

The most successful furniture layouts allow the lines of the furniture to follow the form of the room. For example, you would want to place larger linear pieces parallel or at right angles to the walls rather than on the diagonal or in cater-cornered arrangements. In fact, it is best to completely avoid diagonal placements as they tend to look amateurish and hinder the movement of people about the room.

One of your first decisions in planning a furniture layout is to determine whether the room is to look formal or informal. A formal room calls for a more symmetrical arrangement of furniture; informality invites asymmetry. Period rooms tend to call for formal settings.

The traditional focal point of a room is its most obvious architectural feature, or possi-

bly its view. Decide on your focal point and start with this grouping first. Once the principal grouping has been determined, it is much easier to make decisions about the other pieces of furniture. Tempting though it is to arrange furniture around a wonderful view, such a plan is also quite predictable and leaves little to the imagination. Instead, incorporate your view into the total design of the room and allow for the element of surprise. A successful furniture arrangement would direct the eye *eventually* toward the view, enhancing it with a sense of discovery.

PERIOD AND FORMULA ROOMS

With the exception of reproduction rooms in which a particular historical period is being replicated, most interiors that literally reprise a specific style tend to appear lifeless, unimaginative, and sometimes even a bit precious. Similarly, modernists who cut themselves off from the past deprive their rooms of the richness and quality of previous eras. "Total looks" too often come across like stage sets. It is advisable to avoid prefab-

ricated solutions. The introduction of historical or exotic furniture usually adds vitality to a room, wakens the eye to the qualities of the individual pieces, and helps to define your personal style. Nevertheless, mixing periods requires a surety of taste and vision, one that recognizes how a coromandel screen might dramatize a contemporary chair frame covered in raffia, or how a sleek steel settee can work with an eighteenth-century guéridon.

METHODS THAT PROFESSIONALS USE

Organizing a furniture plan is relatively simple and extremely helpful in avoiding potentially costly mistakes. Begin by measuring your existing furniture and planning for the furniture you intend to purchase. Next, draw the furniture shapes to scale on graph paper. Generally, architects and designers work in a scale of 1/4 inch to 1 foot. Many laymen find it easier to work in a scale of 1/2 inch to 1 foot.

Cut the shapes out and place them on a plan of the room which has been drawn to

BELOW

The same dining room as seen from the living room where an eclectic furniture grouping combines a fauteuil, at left, with Angelo Donghia's "Ghost" chair, center. Photograph by William Waldron.

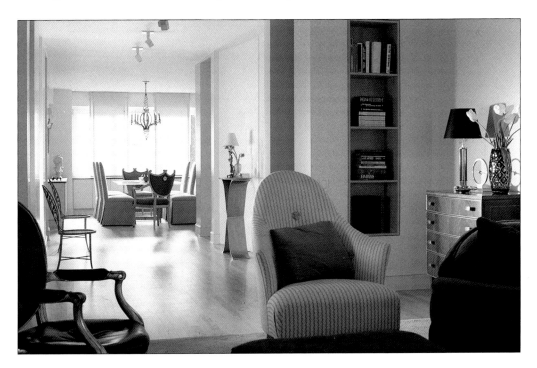

The symmetrical placement of the
furnishings in this living room
designed by Peter Carlson respond
to the strict geometry of the archi-
tecture. Sculptural shapes, rich
fabrics, and strong color provide
visual relief. Photograph by
Michael Mundy.

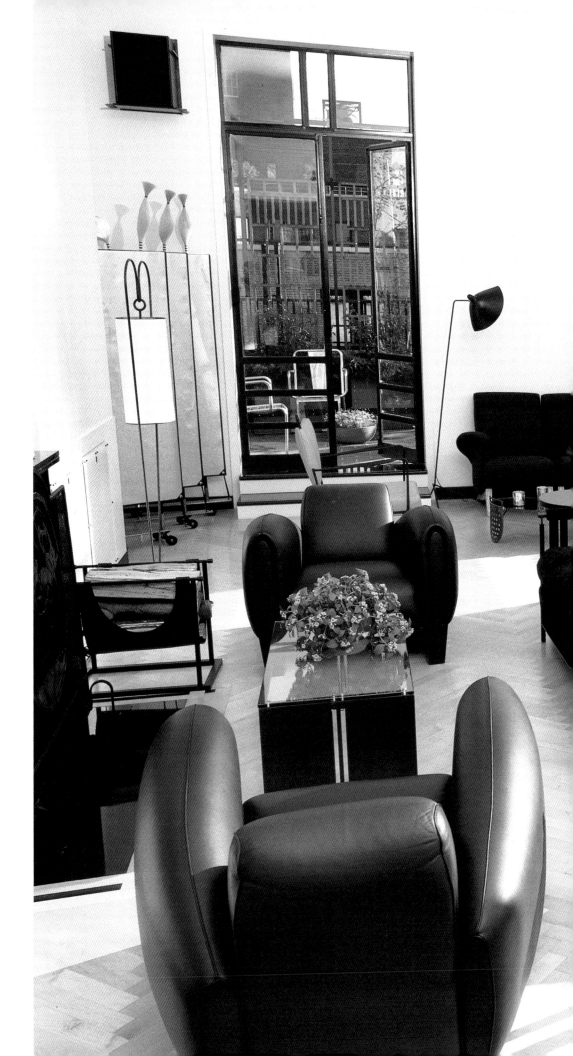

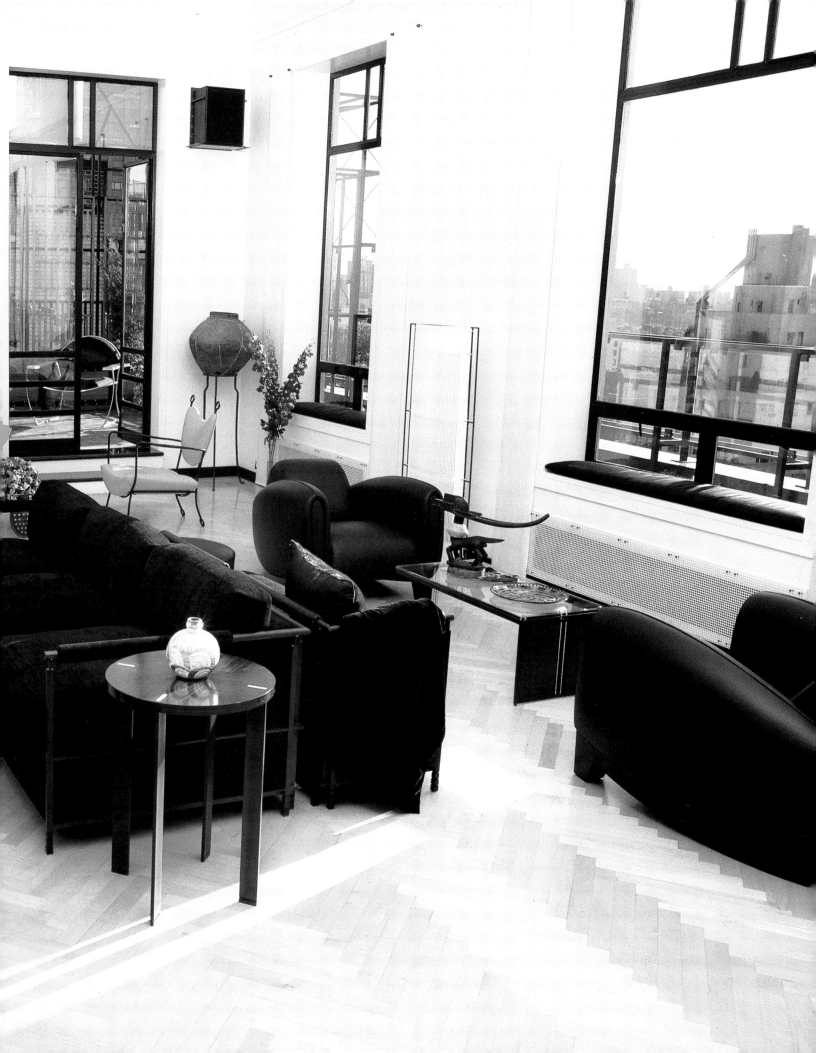

the same scale. You can then move the pieces about to experiment with different arrangements and determine the ideal sizes for the pieces you intend to purchase or have made. Remember to allow enough space for door, cabinet door, and drawer clearances and to take into account traffic patterns, the location of windows, access to furniture, and necessary leg room. If you find it difficult to visualize a plan in miniature or on paper, cut outlines of your furniture out of newspaper or packing paper and place them in the actual space.

Keep in mind that even though your ideas work in two dimensions, they still require visualization in three dimensions. For example, you would not want to place a secrétaire or a pair of wing chairs where their height would obstruct a great view of a fireplace.

Regardless of the specific function of a room—whether for dining, entertaining, reading, sleeping, or intimate conversation—the most important practical consideration is comfort. There should be enough distance between furniture pieces to maneuver around (a minimum of three feet, and preferably four, wherever access is needed) and enough proximity within conversational groupings for everyone to be easily heard. No matter how attractive a room, if the layout makes it difficult to move about or to hear, your experience of the room will be unsatisfying.

FURNITURE LAYOUTS FOR SMALL ROOMS

It is often easier to plan the layout of a smaller room than a larger one because you usually have only one principal grouping. If the room is exceptionally small, the most obvious way to make it appear larger is to pare down the number of furniture pieces as much as possible, while taking care to preserve the sense of character. Another simple way is arrange the pieces close together

rather than spacing them distantly. For a sleek yet compact look, use, for example, two small settees in place of four club chairs.

Built-ins are another consideration in planning the furniture arrangement of a small room. Built-in cabinetry, seating, or shelving provides great space efficiency. Keep in mind that built-ins should be beautifully detailed and well constructed. Often built-in furniture becomes part of the architecture and is a beautiful backdrop for other, softer furnishings.

FURNITURE LAYOUTS FOR LARGE ROOMS

The larger the room (especially one with an open plan), the more difficult it can be to create successful furniture arrangements. A large room should not be treated as a scaled-up version of a smaller one. In fact, its expanded form makes it more akin to a series of rooms that must be drawn into relationship with one another. Few furniture layouts will deaden a room, especially a large one, as quickly as lining the furniture against the walls. Creating more than one grouping of furniture within the room, possibly even placing sofas back to back, will generate greater visual interest. There is nothing wrong with floating a table in the middle of the room or placing chairs and consoles at either end. Screens are another especially effective way to give a large room an added feeling of height and a suggestion of spatial separation, if desired.

ARRANGING FURNITURE FOR DIFFERENT TYPES OF ROOMS

The *entrance hallway,* as a public area, should be welcoming and should suggest the character of the house without revealing all that lies beyond. It is best to keep this area simply

furnished and uncluttered, using only a console, a chair or two, some wall decoration (preferably a mirror), and an appropriate overhead light. If you must use a coatrack or row of coat hooks, choose a location that is not highly visible. A wall full of outdoor wear does not make a particularly inviting introduction, unless, of course, the house is extremely informal.

The *living room,* typically the most public of all the rooms in the house, must provide inviting areas for entertaining. If the room is spacious, it is best to create more than one conversation or seating area, each of which needs to be complete in both a practical and visual sense. One approach is to arrange two sofas back to back in the middle of the room and arrange the rest of the furniture toward the perimeter. Another arrangement ideal for conversation is to have a table in the center of the room and seating areas at either end. One area could include a sofa and two comfortable chairs, the other a pair of loveseats and an ottoman. There are many possibilities. Regardless of the size of the room, tables to hold lamps, books, and drinks should be placed in comfortable proximity.

Libraries and studies, like living rooms, can be arranged either formally or informally, depending on look and function. The more commonplace *den* or *family room* is usually arranged less formally and tends to address comfort more than other aspects.

The *dining room* is the one room of the house that benefits from underfurnishing. The furniture is meant to serve as a beautiful backdrop that allows the focus of the room to center on the company and the food. A dining table, serving tables, comfortable chairs, and attractive wall decoration are all that are necessary. If the scale of the room will accommodate it, a chandelier hung over the center of the dining table provides ideal lighting.

The form of the dining room will dictate the most suitable shape of the dining table: A rectangular or oval table is best for a long room; a circular table is ideal for a square room. When not in use, the dining room will look more composed with the chairs arranged against the wall rather than drawn up to the table (although one chair can be left at each end).

Today's *bedrooms* are put to many uses—study, library, media center, even gym. Nevertheless, the bed still remains the dominant feature. Usually it stands against the widest wall or the one that takes greatest advantage of a view. This does not preclude other arrangements, such as positioning the bed sideways against a wall or floating it in the middle of the room. Sleigh beds, for example, gain the look of a daybed when placed sideways against a wall and decorated with beautiful pillows. This treatment is especially desirable in a multifunction room such as a study where you might wish to have the bed look more like a sofa.

Armoires, large free-standing wardrobes or cabinets, are common options for bedrooms with insufficient closet storage. (Remember that double or triple hanging in a closet can increase the efficiency of a closet with limited space.) Armoire placement is almost always determined by the size of the wall that can accommodate it. Another resource for extending bedroom storage is a chest of drawers or a trunk placed at the foot of the bed. This might be an ideal place for storing additional bed linens and blankets.

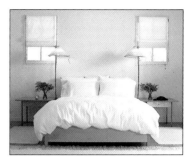

ABOVE AND OPPOSITE

Symmetry is one of the most effective tools for arranging furniture, providing a room with gravity and balance.

OVERLEAF

In this New York pied a terre designer Jeff Bilhuber has arranged modern classics to permit flexibilty. Photograph by Peter Vitale.

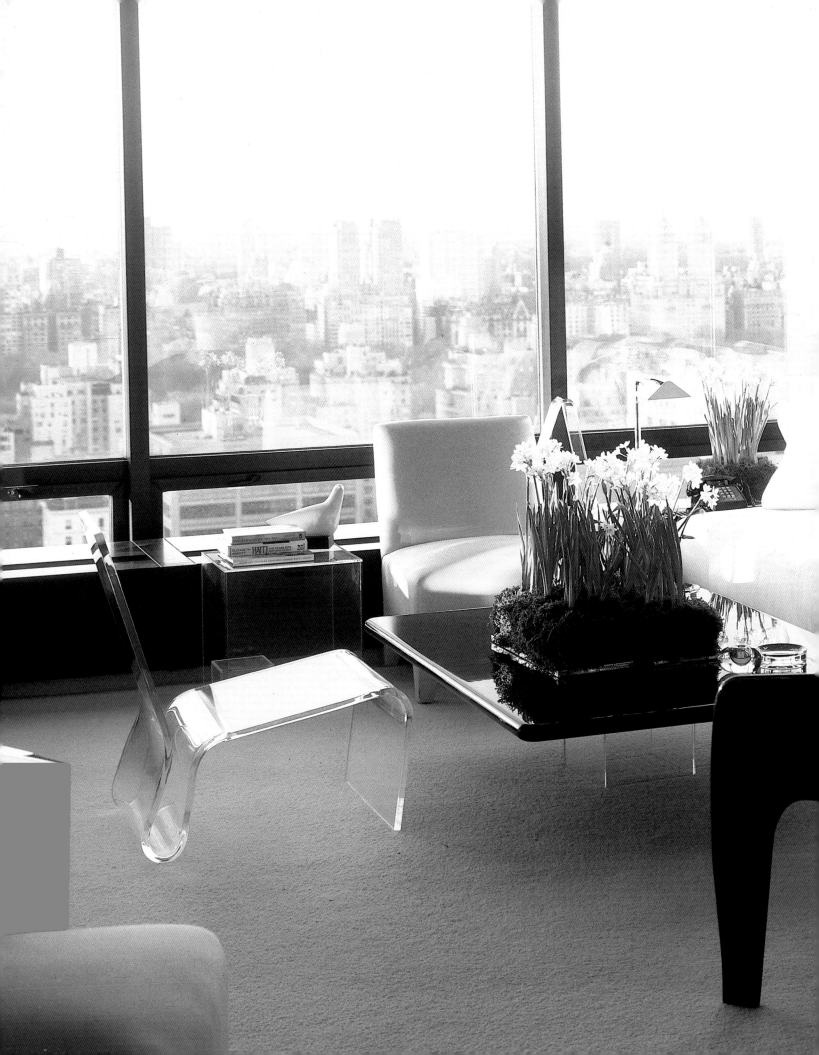

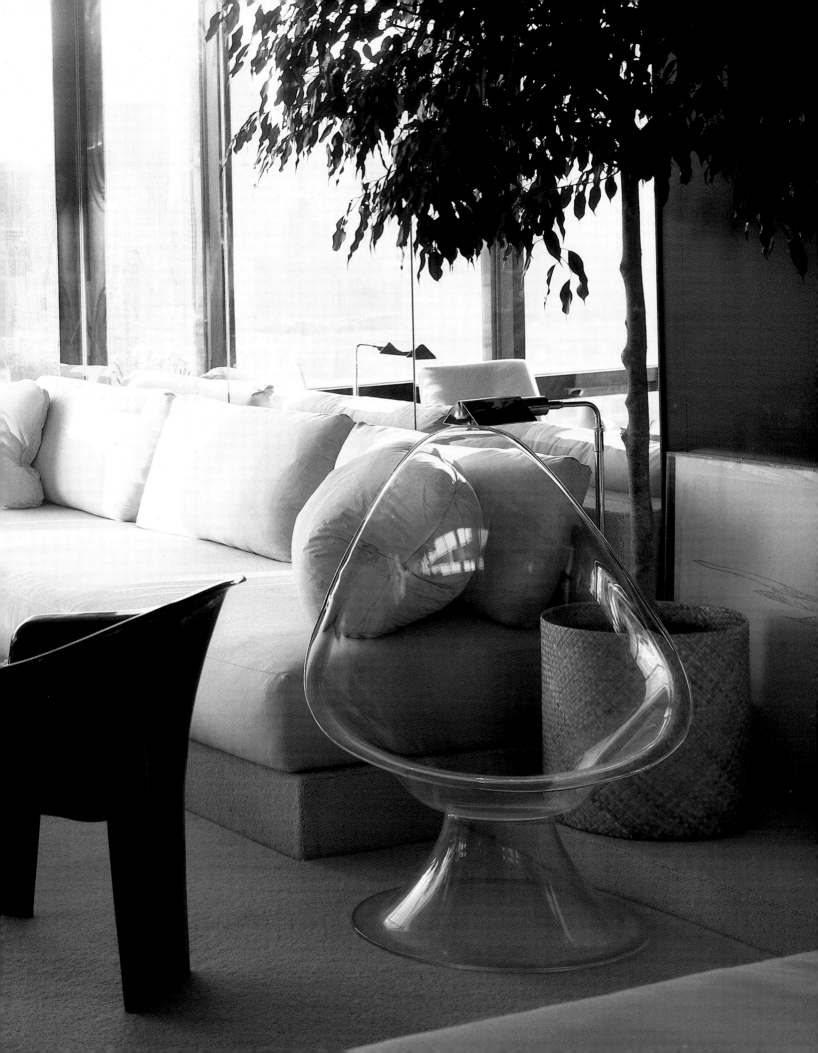

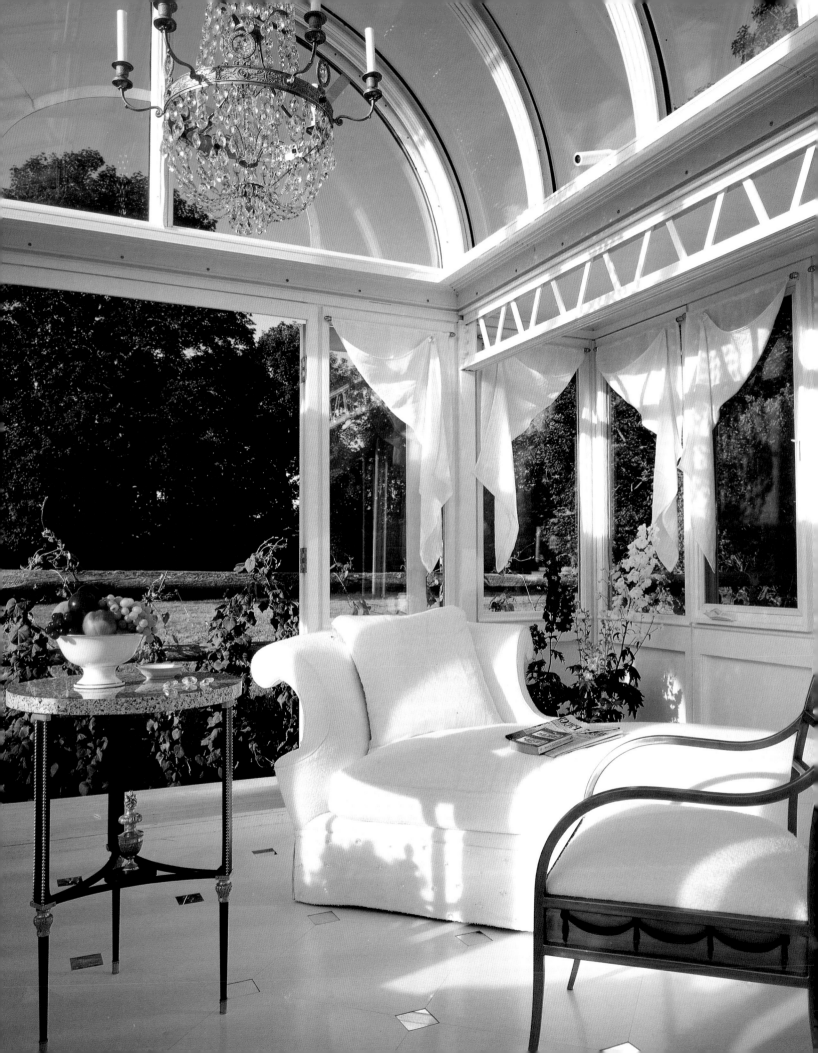

WINDOWS

AND

WINDOW

DRESSINGS

At the beginning of each season, the window dressings in all the

private quarters of the palace were replaced, changing from silk to

linen to brocade to tapestry. Yet, in Madame du Barry's chamber,

no matter what time of year, curtains embroidered with patterns

of cascading roses billowed from the windows.

LAURA CERWINSKE

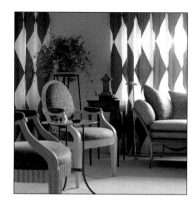

ABOVE

Silk fabric pieced in the shape of diamonds was sewn together to create a harlequin pattern in this floor-to-ceiling curtain. Because the room lacked high ceilings, Peter Carlson created maximum visual interest in the patterning rather than in the curtain heading to focus visual impact at eye level. He also designed the diamonds in an elongated vertical shape to further enhance the illusion of height. Photograph by Lizzie Himmel.

OPPOSITE

A simple black grosgrain ribbon, a witty allusion to the great Coco Chanel, decorates the curtains in this showroom for Karl Lagerfeld, Bijoux designed by Peter Carlson and Joel Gevis.

PAGES 120 AND 121

The interior of the Machin conservatory is designed to emphasize the reflective and refractive qualities of light. The curtains, which are made of a jacquard woven silk from NKA of New York, are secured with crystal tie backs to reiterate the light's brilliance. At dusk, the curtains also provide a measure of privacy. Photograph on page 120 by Lizzie Himmel; photograph on page 121 by Phillip H. Ennis.

Although the principal function of a window is to bring fresh air and sunlight into a room while providing a view outside, the character of the window and the treatment it receives do much to set the tone of a room. Even at night, when they are relieved of their scenic role, windows have great effect.

The tops of all windows within a room should be aligned. Placing them at different heights detracts from the architecture by creating discord and eliminating architectural harmony. Unaligned windows present major problems in determining a curtain style and in installing the curtains.

Function and style are the primary considerations for determining the most appropriate type of window for a room. Steel-framed windows would be appropriate for a contemporary house, while windows with divided lights—a series of smaller panes—are best suited to traditional styles. Vertical windows are *always* preferable to horizontal.

In a warm climate, *casement windows,* which swing open from the sides of the frame, will increase ventilation. They can swing either outward or inward and most often appear in pairs. *French windows,* a type of casement window, extend down to the floor. They commonly have divided lights that are individually framed by wood divisions called mullions.

Double-hung windows incorporate a window sash and have two upper and lower movable units that allow the window to open at either the top or bottom or both. They are the most tightly closing of the movable window types and are the easiest to weatherstrip. Therefore, they are especially effective in cold climates. In a Colonial house, they can enhance the authenticity of the style.

Sliding windows move sideways along a track located at the top and bottom of the frame.

Bay windows, a group of windows set at an angle to each other or in a curve, form a recess or small alcove in the wall of a room. They can be either casement or sash. A curved series is called a bow window; if located on an upper floor, it is called an oriel.

Palladian windows are arched windows framed by applied pilasters. The design was created by the sixteenth-century Italian architect Andrea Palladio, whose work is known for its exquisite proportions and elegant simplicity of line.

Dormer windows are windows that project from a sloping attic roof.

Clerestory windows are short, horizontal windows located just below the ceiling of a room. They were designed not only to allow in light, but also specifically to release the heat that rises to the ceiling in a naturally ventilated room. During the late 1950s and throughout the 1960s they were often used in interior as well as exterior walls.

Fixed glazed windows, or picture windows, a common feature in 1950s and 1960s residential architecture, were typically specified where the view was of primary concern and ventilation not necessary. It is best to leave picture windows untreated: To add curtains around or in front of them is a contradiction. If, for privacy's sake, some dressing is required, keep it as simple as possible.

In most rooms, the windows should be played up as focal points. However, if they are poorly placed or incorrectly proportioned, they should, if budget permits, be replaced or disguised. If you choose to replace the windows, keep in mind that you must consider the exterior facade as well as the interior spaces. It often requires professionals many hours to design a window scheme that works effectively for both.

If renovation is impossible, you can disguise unattractive windows by painting the window frame the same color as the wall and by selecting curtain fabric that is identical to the surrounding wallcovering. In some cases, the use

A steel rod with nickel rings and linen ties give a quirky twist to a tailored curtain heading designed by Carlson Chase Associates.

OPPOSITE

This handwoven silk and canvas fabric from weaver James Gould employs finished selvage edges and a random jacquard square to complete the precise detailing in this library by architects Deamer + Phillips, New York.

OVERLEAF

Shocking pink silk taffeta banners on unusual rods give the illusion of strong vertical windows in the whimsically innovative London flat and showroom of designer Carolyn Quartermaine. Photograph by Rene Stoeltie, courtesy "World of Interiors."

of a neutral color scheme throughout can be helpful in camouflaging an unattractive window. Also, you can arrange furniture in a manner that will draw the eye away from any obtrusive windows and shift the focal point of the room to a more desirable element, such as a fireplace or other important feature.

CURTAINS

Curtains were originally devised for purely practical purposes—to keep out drafts, keep in warmth, provide privacy, soften the outlines of angular architecture, and diminish glare. As such they were designed in strict accordance with the size and proportions of the window openings. As recently as the turn of this century, Edith Wharton wrote, "The real purpose of the window curtain is to regulate the amount of light admitted to the room, and a curtain so arranged that it cannot be drawn backward and forward at will is but a meaningless accessory." Think how chagrined Mrs. Wharton would be today surveying our interiors and seeing room after room where curtains are used as much for decoration as for function. She would find that often the walls around the windows receive curtains instead of the windows themselves, and that these curtains play a leading role in the composition of the room and in the visual correction of structural defects (which should be attended to, if possible, before decorating).

Mrs. Wharton would also be amazed by the number of unexpected materials such as paper, plastic, and aluminum that she would find today in curtain applications. As early as the 1920s, Cecil Beaton draped foil and plastic behind the celebrities he photographed to "create an extraordinary atmospheric effect of shimmer, like sunlight on water." A decade later, painter Florine Stettheimer used cellophane for curtains in her Manhattan apartment and for the sets of an opera, crumpling and

draping it "to look like spun sugar." The writer Jody Shields explains that "to appreciate the use of ephemeral materials in decor, it helps to forget about their normal, everyday uses. Plastic, one of the most practical, versatile, and sturdy materials available, creates a translucent, almost weightless effect when used for curtains. Paper is sweetly fragile and flexible. The goofy glitter of foil can cover walls . . . like a three-dimensional coat of paint."

Overblown curtains that are out of scale with a room, such as valances (the device that fits over curtain headings and conceals rods or fitting mechanisms from sight) that are too deep or fabrics that are too full, cheapen the look of the interior. The scale of the curtains and valance must be appropriate to the ceiling height. For an eight-foot ceiling, for example, the simplest curtain is best. (This height came into being with the mass-produced architecture of the 1920s and 30s, and in the original modern interiors, curtains were never designed with valances.) A good choice would be a curtain on a track or rod that is clean and "architectural" in appearance. Select a fabric or material that is harmonious with everything else in the room, preferably one without a pattern. If you do choose a patterned material, use a vertical design to draw the eye up and down and create some illusion of height. For fourteen-foot ceilings there are far fewer restrictions. Although your choice should take into consideration the style of the room, the function of the curtain, and any architectural conditions, your options are essentially unlimited.

For windows that benefit from minimal dressing, you can consider a roller or inverted roller shade, a Roman or Austrian shade, a straightforward curtain with an interesting pleat, or a simple swag of fabric draping over a pole to the floor. Solid-panel shutters, too, make a simple but effective solution to lighting, ventilation, and privacy. Such "dressed down"

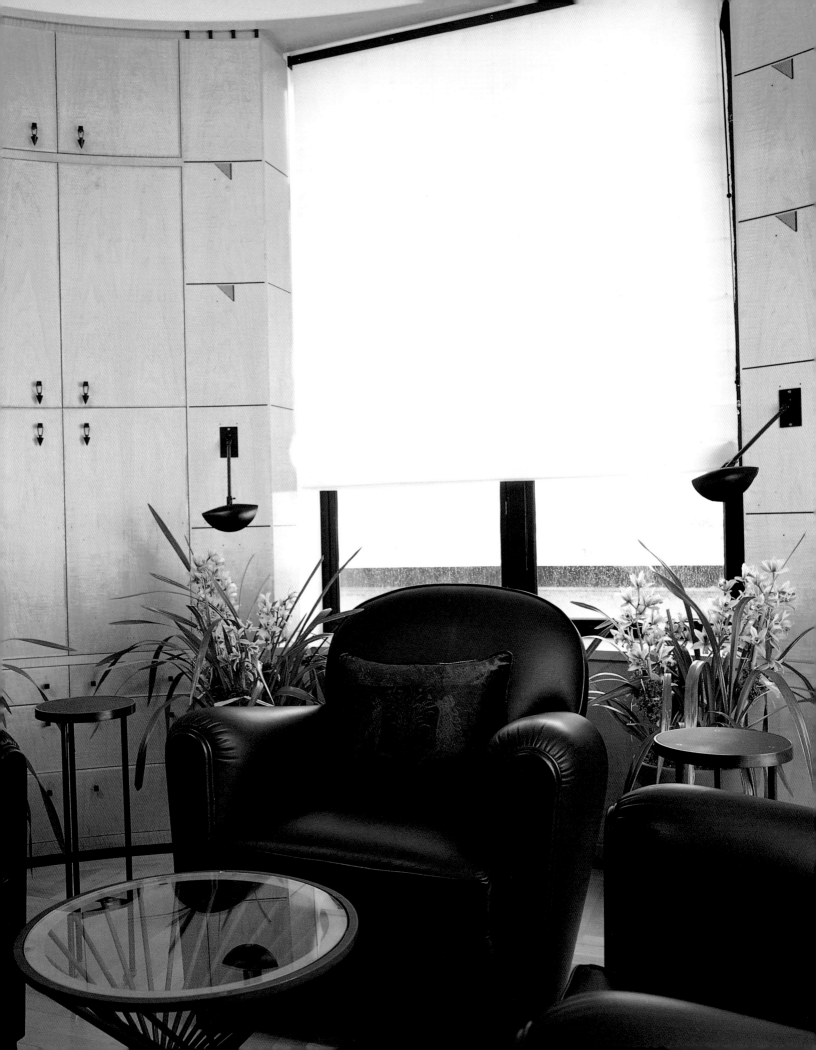

An assortment of handcarved, painted, and gilded curtain rods with decorative finials crafted by Joseph Biunno, Ltd., New York.

Drapery rings, poles, and finials in verdigris, antique white, and gilt crafted by Joseph Biunno, Ltd., New York.

treatments emphasize the form of a room. For a subtle but rich application accomplished through the use of texture, simple tailored curtains of gaufrage velvet or plissé—a puckered cotton—can be applied to a large window.

Before you decide on a style of curtain, the size, shape, function, and mode of operation of the window must be assessed. Next and equally important are the period, style, and design of the window dressing. Expensive, elaborate curtains, for example, look out of place in rooms of modest scale or lacking in fine furniture. In such rooms, oversized valances and swags would be equally inappropriate. As another example, the small windows of a cottage or seaside bungalow are best left undressed. Think of an English cottage with vines growing in the windows and consider how yards of fabric would smother that bucolic charm. Simple, short curtains in a crisp little check or old floral chintz, sheer gauze curtains, or muslin shades would not conflict with the unpretentious nature of such a setting.

Low, horizontal windows, used in many contemporary houses, typically require curtains that are clean in line and unfussy. An alternative is to leave the windows unadorned. In a traditional interior, a period curtain design would be a comfortable, conventional choice, and many fabrics employing patterns taken from the original printing blocks are widely available today as well as many excellent reproduction prints. Less predictable in a traditional room would be a tailored treatment with clean lines.

STYLES

Window curtains were not divided in the center until the eighteenth-century, when window sizes expanded and curtains became too heavy to be held in one solid piece. This simple change also served to make the drawing of the curtains much easier.

Early in the nineteenth century, a number of unashamedly luxurious dress-curtain designs, inspired by the popular Empire style, were published throughout France and then

in London in magazines and catalogues aimed at upholsterers and their clients. These lavish window dressings are still evoked in interiors today and can be adapted to a range of budgets and styles. Some designs are more complicated than others, but in all, the desired effect is an appearance of fabric voluminously falling, folding, and draping itself. In addition to the Empire, other period styles, including Queen Anne, Early Chippendale, Later Georgian, English Regency, and Victorian, lend themselves to the use of heavily draped dress curtains.

These traditional styles as well as contemporary designs draw on different technical applications. *Draping* refers essentially to the attractive falling of a fabric into folds. *Pleating* includes a long list of techniques in which fabric is sewn together to create fullness, such as accordion, pinch, box, pencil pleats, and several others. *Ruching* refers to the gathering or pleating of fabric in a specific, typically narrow, area, such as in piping, welting, or ties for tiebacks. *Shirring* involves the gathering of fabric by sliding a rod or dowel through a fabric channel.

When stationary curtains are hung purely for effect, such as in panels of fabric too narrow to be drawn across the window, they create the impression of floor-to-ceiling curtains, a lush quality that can serve as the dominant decorative feature in a room. They are also a clever option when you cannot afford floor-to-ceiling yardage, or where volumes of fabric might not be practical.

Any fabric that falls in folds, such as silks, muslins, broderie anglaise, or fine wools, will work. To make the curtains look dressier or more dramatic, linings and undercurtains in contrasting colors, fabrics, and patterns can be added. Antique fabrics, especially when faded by the sun or worn with age, have a romantic look. Teamed with modern reproductions of antique wallpapers, they beauti-

fully enhance the period appeal of a room. More-provincial styles typically call for something less fussy. A modest cafe curtain or straightforward shade are good choices. If a window that is surrounded only by side panels requires covering, a blind or shade that can be pulled down can be installed, usually, but not necessarily, in a matching or coordinating material.

Thin, translucent curtains, known as *sheers* or *glass curtains,* have been used since the seventeenth century both as simple window dressings in their own right and as part of multilayered designs. Today, they appear taut and stretched in cool, minimalist interiors as well as lavishly draped in romantic rooms. A curtain made of double layers of sheers will diffuse light in varying degrees of softness. In formal arrangements, sheers can be one of many layers of fabric, enhancing, for example, a textured brocade or sumptuous velvet.

BLINDS AND SHADES

Blinds and shades are used primarily to control light and provide privacy. The classic *Venetian blind,* with its wood or metal slats, allows for the most precise light modulation. The striped shadows they cast can, themselves, be incorporated as a decorative feature, looking especially dramatic against a plaster wall.

Simple and essentially austere, *roller blinds* are made of specially stiffened fabric and are held in place with a wooden curtain rod. They obscure little if any daylight and do not obstruct an inward-opening window.

Tailored Roman blinds pull up into even horizontal folds by means of cords slotted through ringed tape that is stitched to the back of the blind. The cords are knotted together and secured around a cleat positioned at the side of the window. A good quality cotton lining will ensure that the blind hangs properly. *Austrian blinds* can soft-

TOP

An assortment of handcarved wooden finials finished in water gilt, a multi-step process that is the oldest technique for applying gold leaf. Crafted by Joseph Biunno, Ltd., New York.

ABOVE

Examples of the most intricate designs for handcarved gilt finials include the Prince of Wales feather at top, and a shell motif, crafted by Joseph Biunno, Ltd., New York.

The workroom of Anthony Lawrence in Cos Cob, Connecticut shows the paper patterns, steamers, and mechanicals used in creating meticulously detailed curtains, pillows, tablecloths, bedspreads, and upholstered wallcoverings, many of which are handsewn.

en the look of a room with their fanciful dense gathers. They are drawn up in the same way as Roman blinds and can be given extra fullness with the addition of a lining. A special Austrian-blind track makes their installation quite simple. Like Austrian blinds, *festooned blinds* enhance the feminine nature of a room. Twisted pull-up blinds, usually made of a diaphanous fabric, are seductively elegant. A narrow cord slotted through a central casing pulls the hanging fabric into an unusual twisted shape. The fabric and cord are attached to a batten fixed at the top of the window. Grommets, devised to protect the hole through which a cord is guided, can also be used as a decorative treatment and even become the jewelry of the shade.

PORTIERES

While curtains, blinds, and shades are used for windows, portières are hung in doorways. Among the most popular fabrics for portières are tapestries, brocades, damasks, velvet, and velours. For summer or warm climates, taffetas and chintzes will work in a great variety of shades and patterns. Whatever the choice, it must harmonize with the side walls it divides as well as with the carpet or flooring at its base. When possible, design from the ground up, allowing portières to be slightly lighter in tone than the carpet or floor and the side wall to be still lighter in tone.

CURTAIN FABRICATION

Linings provide additional weight and feeling of substance to a curtain while also enhancing insulation against drafts and noise.

Interlinings, which can be made from lightweight batting or from a stiffened fabric, depending on the style of the dressing, add further insulation and provide an additional filter for light. They also add body and give a luxurious look.

Weights help to keep hems straight, even, and held toward the floor. There are various forms of weights—round or rectangular lead weights, fabric-covered weighted tape, or chain sold in yard lengths—all of which are meant to be concealed inside the curtain hem.

WORKROOMS

Whatever specific treatment you decide upon, it is critical that you choose a reliable workroom to fabricate your curtains. You can judge the quality of their work by visiting the workroom and asking to see examples of their curtains. Examine the cleanliness and organization of the shop. You will want to determine how their prices compare with those of other workrooms. Do they handsew (which is, of course, more expensive) or machine make their curtains? (Most workrooms do one or the other; a limited number do both.)

Once you have selected a workroom, they should take their own measurements (which will ensure that they are responsible for accuracy). They will give you a price quote for labor and a yardage quote for both fabric and trim. In order to determine the yardage, you must convey to them the style of the curtain, the kind of fabric you have selected, the width of the fabric, and the size of any repeat in the pattern. The workroom will then tell you how much yardage to purchase. Do not buy the fabric before you have selected a style, had the window(s) measured, and been given a written quote as to necessary yardage based on your fabric. Also, give the workroom a sample of the fabric before you purchase it so they can examine its pliability and tell you if it can be successfully used.

Generally, workrooms calculate an overage to cover any unanticipated needs or flaws. When your curtains are finished, you can ask for the remaining fabric.

If you are making the curtains yourself, be sure that you measure every window separately and accurately. Never presume that window sizes are standard.

CALCULATING YARDAGE

When calculating yardage, determine the placement of the curtain rod and decide whether you want the curtains to hang so the window frame is completely exposed or completely covered. Decide also whether curtains are to hang from a traverse rod or from a pole, so that you can allow for their particular requirements. Except for a cottage or a rustic room, curtains should be floor length if at all possible, regardless of their style, falling to one-quarter inch of the floor. Curtains designed to puddle onto the floor require an extra two to four inches. Sill-length curtains should be measured from the bottom lip of the window apron. It is standard procedure to add 10 percent overage to your calculations of what is needed.

As a general rule, to give simple gathered curtains a feeling of fullness, calculate yardage according to one-and-a-half times, but preferably twice, the window width. Highly decorative and extravagant pencil-pleated curtains (sometimes called regis tape), which produce a tight, even band of gathers, require two-and-a-half times the window width.

One formula for calculating the *finished length* requires measuring the distance from the top of the installed curtain rod to the desired bottom of the curtain. The cut length is calculated by measuring the distance from the top of the rod to the desired bottom of the curtain and adding 18 inches (in a sheer fabric) or 13 inches (in a lined fabric) for hems and top headings.

To determine the finished width of fabric required, you must calculate what is known as the "return," i.e. the distance of the rod from bracket to bracket plus the distance the brackets extend from the wall. To this mea-

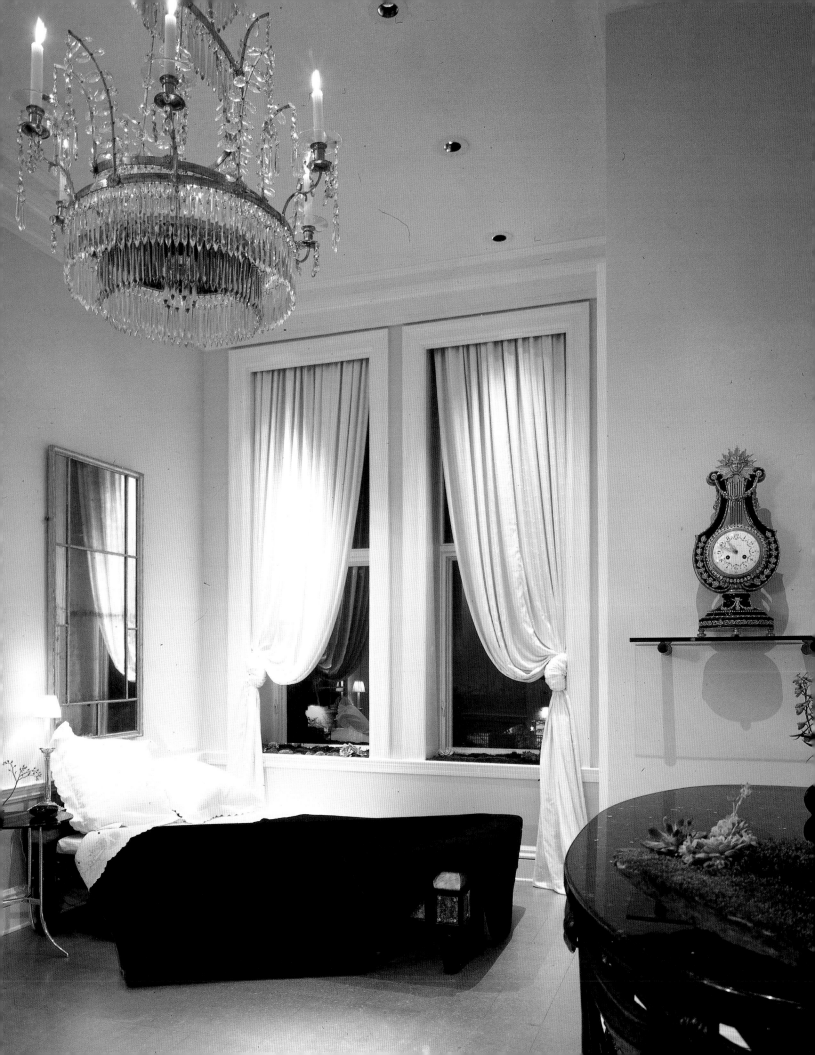

surement, another six inches must be added for the center overlap. Of course, the number of fabric panels needed to span this distance will depend on the fullness appropriate to the style of curtain. For 100 percent fullness, you would double the width; for 150 percent fullness, multiply 2.5 times the width. For some sheers, which require 200 percent fullness, you will need three times the width.

Properly constructed curtains should have a double hem, i.e., the hem width folded back twice. A six-inch hem therefore would require twelve inches of fabric. This not only adequately tailors the curtain, but also gives you the flexibility to adjust its length if you should move.

In addition to the yardage required for the curtains, you will need yardage for valances, tiebacks, and trims, if desired.

FINISHING DEVICES

Valances, lambrequins and *pelmets* all refer to the skirtlike contrivance or wood cornice at the top of a curtained wall or window. (Both in the trade and in general usage, the terms have become somewhat interchangeable.) Because they combine architectural construction and decoration, they make a significant visual statement.

Jabot refers to a formal cascading fabric treatment that falls to a point in between swags or festoons.

Tiebacks, whether plaited, bow-trimmed, jeweled, or piped, can be used as subtle or outrageously decorative ornaments. Tiebacks should never divide the window into obvious quarters, thirds, or halves. You can avoid these divisions by tying back the curtain well above or below its center and allowing the fabric to hang in loose, graceful folds.

Curtain headings can be fabricated in a wide variety of styles, including gathers, French pleats, pencil pleats, goblet pleats, and scalloped pleats.

CURTAIN HARDWARE

Curtain hooks are available in a variety of applications, including one-prong hooks, pin-on hooks, and sew-on hooks.

Rods must be as suitable to the style of the curtain as the curtain is to the style of the window. Decorative rods and finials add a finishing touch, whereas purely utilitarian rods are better suited to cleaner, simpler styles. Rods may be round or flat; single, double, or triple; stationary, swinging, or traverse. The choice depends on the function and style of the curtain. For glass curtains, crossed curtains, and curtains with intricate valances, a double or triple rod will be needed. Whatever its type, the rod must be strong enough to hold the weight of the fabric without bending. Be advised that overextending rods will weaken them. One way to compensate for this is to install an additional bracket.

Rings, like rods, can be decorative or purely utilitarian in style. Whether they are made of wood or metal, they should be handsewn to the top edge of the curtain with hidden rings or curtain hooks attached three to four inches below the top edge of the fabric back so they are not visible from the side or above. These hooks must be sewn or pinned behind each pleat of the heading and then inserted into a separate ring on the curtain rod.

RECOMMENDATION

WHEN BUYING FABRIC, INSPECT THE YARDAGE TO BE SURE THAT THE PATTERN IS PRINTED ACCURATELY—THAT THERE ARE NO FADED SPOTS OR FLAWS IN THE WEAVE. DEVIATIONS FROM A STRAIGHT WEAVE CAN BE CHECKED BY FOLDING BACK A SMALL PIECE OF THE FABRIC FROM SELVAGE TO SELVAGE WITH WRONG SIDES TOGETHER. ❧

COMMON MISTAKES

Elaborate curtains are not the answer to bad architecture any more than expensive fabric is the answer to poor upholstery.

The drama of the curtains in a room designed by Peter Carlson derives from the combination of an elegant pearl-encrusted fabric from Gretchen Bellinger with the casual conceit of a simple knot. Photograph by John Elliott.

C H A P T E R 1 0

FABRICS

AND

TRIMS

When you have had it with such cheerless admonishments as 'Less

is more' and 'Form follows function' then you probably want to turn

to the more sensuous realm of silk, velvet and brocade.

M A R K H A M P T O N

istorically, fabric was a symbol of household wealth. Influential Greeks and Romans swathed their couches with layers of drapery and often used curtains in place of doors. Medieval aristocrats covered the cold, bare walls of their castles with tapestries and embroideries and hung curtains around their beds to keep out drafts. In fashionable rooms of the Renaissance, the window curtains were coordinated with the wall hangings. Fabric-covered chairs came into vogue in the seventeenth century, making the upholsterer an instrumental figure in determining the look of interiors. A little more than a century later, the French Empire style swept Europe and America, and fabric wall hangings and draperies flowed in voluptuous abandon; whole rooms were tented in silk and covered in muslin. Today, when fine fabric no longer remains out of reach to all but the privileged, its application is still one of the most effective means of bringing a look of luxury to an interior. Fabric is also an excellent way of adding softness to a room with many hard edges.

Of all the elements that compose an interior, fabric is the one most closely aligned with clothing fashion. In just the last half century, we have seen the influence of technology in the introduction of man-made fibers first in fashion and then in interior design. A revival of paisley prints instigated by fashion designer Yves St. Laurent in the 1960s spurred a revival of similar patterns for use in the home. In the seventies, when fashion reflected a natural palette, earth tones became popular in home decor. Interior designers such as Michael Taylor made neutral schemes the fashionable look. While professional prognosticators, from members of the Color Council to editors of fashion and lifestyle

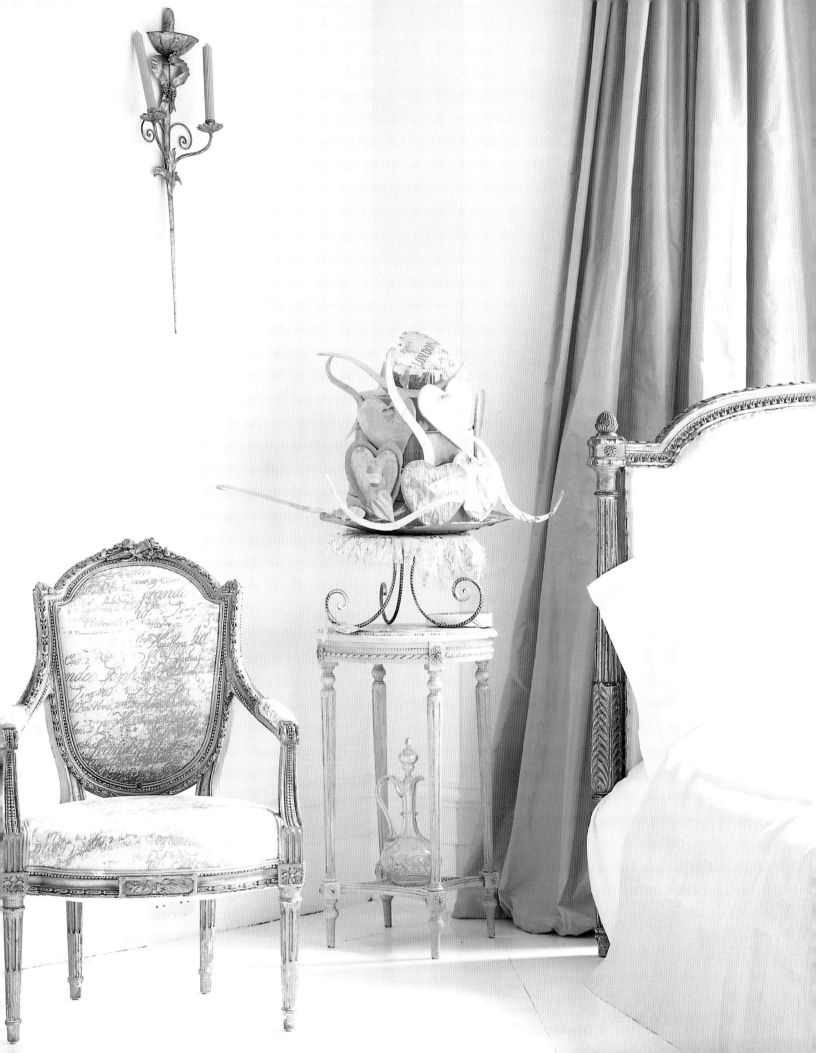

LEFT

A variety of woven fabrics from Mimi London provides tactile interest in this room designed by Carlson Chase Associates. The interplay of textures can exceed the importance of color when judiciously employed.

OPPOSITE

Manuel Canovas fabrics are known for their wonderful use of color and crisp texture. This collection of vibrant woven cottons includes "La Percuse" at left, "Bien Aimee," at center, "Ansedonia," at bottom, and "Vivian" at right.

magazines, look into their prismatic balls, we can only wonder what revival will spark the next trend and what elements of contemporary living will tie it to our time.

A knowledgeable selection of fabric involves both visual and practical considerations, regardless of the style or specific taste with which a room is designed. Visually, these considerations are color, texture, and pattern. The choice of colors should reflect your personal preferences as well as more practical considerations. Black-and-white fabrics can be highly sophisticated, sleek, strong, and dramatic. They offer the opportunity of introducing patterns. All-white and off-white schemes in carefully chosen textures can be very rich. When Syrie Maugham brightened her London house with white furnishings and accessories, including white fabric-covered sofas and white leather chairs that stood near a table dressed in ivory lace, she launched a craze for all-white decor. Even though all-white interiors are not practical for most households,

an assortment of woven white fabrics can be used in a wonderful backdrop for an art collection or the display of flowers.

Many people think of color as the primary visual consideration in selecting fabric. However, pattern and texture offer as much diversity and interest as color alone and are equally important. In a room with several bold patterns, for example, small repeating designs will offer relief. They will also play off the colors in those designs and enhance their effect. Like patterns, textural qualities, whether uniform or varied, can determine the overall spirit of a room. Think how readily the use of velvet, brocade, or damask establishes a tone of formality, and how different a feeling glazed chintz or polished cotton will give from heavy linen, even if the colors and pattern are identical. Chintz is a hallmark of the enduringly popular English-country-house look, a refined style of seemingly careless informality. Both English and American designers, including John Fowler, Nancy Lancaster, Elsie de Wolfe, Rose

ABOVE

Carolyn Quartermaine covers a Louis XVI chair in her silk-screened "Mozart" fabric. Photograph by Steve Dalton, courtesy "Vogue Entertaining."

BELOW

Stamped snow leopard and painted velvet pillows provide an exotic counterpoint to an architectonic bedroom designed by Peter Carlson.

Cumming, Dorothy Draper, and Sister Parish, have championed the fabric for its warmth and colorful patterning. Mark Hampton writes how Mrs. Parish's rooms demonstrate that "by using chintz in place of richer, more ponderous materials, you are able to use more-elaborate pieces of furniture without sacrificing the desired effect of inviting warmth."

The specific combination of fabrics in a room also significantly influences its look and feel. Apply a putty-colored linen throughout and you will have a crisp, tailored interior that would work well with sisal carpet. A room filled with silk brocades, patterned velvets, and rich taffetas, on the other hand, conjures images of eighteenth-century France. The English designer Geoffrey Bennison became known not only for his use of muted, tawny colors and subtle patterning, but also for mixing worn fabrics with new objects. Bennison's look evolved into what is known today as "shabby chic."

When selecting fabric, it is important to consider the material's *hand*. The fabric's appropriateness to its intended use is also important. The following list is a glossary of terms with which you should be familiar.

Batiste is a fine, semi-sheer cotton that is frequently embroidered or printed.

Bouclé is a highly textured fabric made from tightly looped yarn, used most often for curtains and upholstery.

Brocade, a heavy patterned silk, satin, or velvet, woven with a raised, embroidered design, is suitable for curtains and upholstery.

Brocatelle is a fabric similar to brocade in which the design is woven into such high relief as to appear embossed.

Casement cloth, a generic term, refers to loosely woven, open, and lightweight curtain fabrics that are more or less translucent.

Cashmere is the yarn spun from the fine, downy wool made from the hair of Kashmir goats of India.

Chenille is a soft fabric woven from silk, wool, cotton, or rayon with a deep, ball-like pile that protrudes on all sides. In the nine-

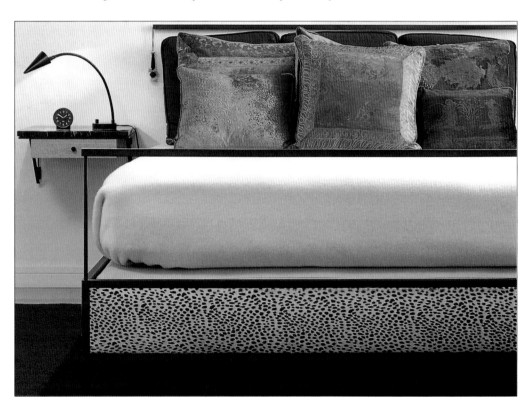

teenth century it was often used for portières and curtains. Today it is typically used for bed coverings and in rugs.

Chintz is a glazed, medium-weight cotton typically printed with colorful floral designs. Developed in India in the second half of the seventeenth century, it was called "chittes" by the Europeans. Chintz is used today for curtains, slipcovers, and light-wear upholstery and favored for traditional interiors and those where the English-country-house look is desired.

Corduroy is a heavy ribbed cotton or cotton blend generally used for upholstery.

Cotton, one of the most versatile of fibers, has the widest range of weights, textures, and patterns. Different grades and sources produce varying qualities of the fabric. Egyptian cotton and lustrous Sea Island cottons are among the finest.

Damask is a flat-pattern taffeta woven with lustrous silk, linen, cotton, or synthetic fibers in richly patterned designs. It is used most often in curtains and upholstery.

Flannel, a soft wool, is used for light upholstery.

Fortuny fabrics are named for the Spanish artist who invented the original process and designs that transform ordinary silks and velvets into what are among the most beautiful fabrics in the world. Mariano Fortuny's inspirations derived from such diverse sources as cloth fragments from Mycenean antiquity, the velvets and brocades of fifteenth-century Florence and seventeenth-century Venice, from antique French tapestries, and from Persian, Chinese, and Turkish patterns.

Gaufrage is an embossing technique used to create a textural pattern on plush, velvet, leather, and some silks and wools. The term refers to the metal "book" in which the molds that impress the pattern are enclosed.

Gingham, a woven cotton with a striped or checkered pattern, is used for curtains and tablecloths, most typically in rooms where a quaint or country look is desired.

Horsehair, a fabric made with a cotton or linen warp and an actual tail- or mane-hair weft, is principally used for upholstery. Variations in solid color are typical because of the natural variation in the way the hair may absorb dye.

Lace is an ornamental open-mesh fabric made from a network of threads that are sewn, knitted, crocheted, or tatted into patterns. For centuries, the art of lacemaking by hand signified the degree of civility of various European cultures. Today much lace is made by machine.

Linen, a fabric woven from the long fibers of the bark of the flax plant, is known for its crisp, tailored qualities.

Mohair, made from the wool of the Angora goat, is woven with other fibers to produce one of the strongest of upholstery fabrics.

Moiré is a taffeta in which a design with an elegant watered effect is woven. It is used for curtains and tablecloths.

Muslin, a plain-weave, medium-weight cotton cloth, is used anywhere a gauzy look will work.

Paisley, a colorful wool, elaborately printed or woven in stylized leaf designs, originated as a shawl pattern in the town in Scotland for which it is named . It is used principally for tablecloths, curtains and all manner of light-wear applications.

Sateen is a smooth, shiny-faced, satin-weave cotton that is typically used for window dressings and bed coverings.

Satin is a glamorous cotton, silk, wool, linen, or synthetic woven with a lustrous finish on one side and a dull finish on the other.

Silk, a fine, lustrous, long-lasting fiber extruded by the silkworm in the spinning of its cocoon, is the finest, smoothest, and strongest natural fiber. Soft to the touch,

A slipper chair is covered in "Ribbons," a glazed cotton chintz by Rose Cumming.

"Aspide," a silk damask from Old World Weavers.

"Damasco Grifone," a woven cotton and silk damask from Clarence House.

long-lasting, and easily dyed in vivid colors, silk is used in all manner of applications. In France, the silk trade was long supported by the crown, making French silks a luxury sought throughout the Western world. Thai silks are among the most beautiful in the world today.

Taffeta, a closely woven, highly lustrous fabric made of silk, cotton, rayon, wool, or acetate, is used for curtains, table skirts, and other light-wear applications where a crisp yet elegant fabric is called for.

Tapestry, an intricately designed fabric woven with multicolored dyed yarns, is used for upholstery and wall coverings.

Toile de Jouy, a woven cotton or linen with pastoral or mythological scenes printed in one color on a beige ground, was produced in the eighteenth and early nineteenth centuries. It is used today in a wide range of applications.

Tweed, originally an all-wool Scottish homespun, refers today to loosely woven twill or herringbone fabrics woven in two or more colors.

Velour, a conspicuously napped fabric in a satin or plain weave, is used for upholstery.

Velvet, a double-woven fabric with a soft, thick pile, is readily available in mohair, cotton, linen, and silk as well as in washable synthetics. It can be embossed in a wide variety of patterns. See Gaufrage.

Voile, a transparent, sheer, plain-weave fabric, is used primarily for curtains.

Wool is the fiber shorn from sheep, lambs, or Angora goats. Each breed produces different types and grades of wool. It is known for its resilience, strength, and warmth, and its elasticity makes it capable of draping in supple folds and gentle contours. For soft furnishings it is usually blended with fibers such as linen or silk.

Yarn refers to the threads made from a fiber. They themselves can be of various constructions such as spun, twisted, or plied.

WOVEN FABRIC

Weaving is the interlacing of two sets of threads at right angles. The manner in which the warp, or lengthwise threads, intersects with the weft, or crosswise threads, can be varied almost infinitely. Along with the use

of different colors and weights of threads, the pattern created by these intersections gives fabric its textural quality.

The most prevalent type of weave is called the two-element weave, an over-and-under interlacing of the warp and weft. Basic two-element weaves include plain and twill, with satin weave as a broken variation of twill.

Intricate fabrics such as damasks and brocades are made from what are known as fancy weaves. Corduroys and velvets are woven from pile weaves in which additional threads are combined with the warp and weft.

The woven pattern of a fabric becomes an explicit design feature when warp and weft threads of different colors are grouped in specific configurations. The most basic examples of this construction would be checked and striped fabrics, which were among the first products of American cotton textile mills. A more complex—and the most common—example is known as *jacquard*, named for the inventor of the loom that first enabled intricate designs to be woven into fabric, rather than having to be printed on the surface. Jacquards can be produced as tapestry, brocade, or damask in a range of textures with a depth of durable color that printing cannot match.

Fabrics woven from the same fiber can achieve varying appearances simply by adjusting the yarns and methods of weaving. Handweaver James Gould works with linens and silks to produce fine textiles that rely on the intrinsic qualities of these materials.

Woven fabrics, in general, are hard-wearing and excellent for upholstery and curtains. They are easily identified by the colors on the underside of the cloth, which reveal the reverse of the design. Often the reverse of a woven cloth is as interesting as its intended "right" side.

PRINTED FABRIC

The earliest method of fabric printing was block printing. A pre-industrial technique, it is still practiced today, while innovations in technology have facilitated both the development of new techniques and the consistent reinterpretation of established fabric-printing traditions.

ABOVE

"Delphine," a cotton and silk damask from Carlton Varney.

BELOW

"Damas Palmette," a woven cotton and silk damask from Clarence House.

Block printing requires a block of carved wood or wood embedded with metal for each color or motif, which means that an overall pattern could require up to a hundred blocks. The block is loaded with dye paste, carefully positioned, and then stamped onto the cloth. Labor-intensive and expensive, the technique is practiced as a craft in the West by individuals and small firms and as a traditional business in India and Pakistan. Each piece of block-printed fabric is unique and can offer an original solution for unusual sites.

Copper roller printing, a technique in use since the 1820s, involves engraved rollers attached to a machine that prints up to twelve colors consecutively. The process is used only for mass-produced fabrics, manufactured in runs of 10,000 yards or more.

Silk screening, a less expensive printing technique adopted in the 1930s, has largely replaced block and cylinder printing. Color is forced through the fine mesh of a taut silk screen, much like a stencil. The process requires separate screens and exact registration for each color, and usually not more than 21 colors can be accommodated.

Handpainting produces fabric with a unique identity that cannot be precisely replicated. Using brushes, palette knives, and a range of other tools, artists can create an unlimited range of patterns and designs. Handpainted fabrics typically have more delicate surfaces than most printed fabrics and should not be applied where heavy wear will occur.

Stenciling is derived from the Japanese art in which delicate patterns were applied to a fine silk or muslin through a precut template. The contemporary process makes use of a rectangular wooden- or metal-framed screen covered with tightly stretched gauze or synthetic fabric. A separate screen is used for each color element in the design and for each area of pattern repeat. Areas where color is not required are treated with a resist material that prevents the dye from penetrating the fabric.

Batik and other resist techniques provide the best means of getting colorants, especially vegetable dyes, into the fiber. They involve the drawing, stamping, or stenciling of a design onto the fabric with an impenetrable material such as wax (as in the case of batik). The fabric is then dyed, dried, and the resist removed. The process must be repeated for each color.

Dyeing includes a variety of techniques. With stock-dyed fabrics, raw fibers are dipped in dye before they are spun. Yarn-dyed or vat-dyed fabrics have their spun threads dyed before weaving. The result is more permanent coloration than in fabrics in which the whole cloth is dyed after weaving, a process known as piece-dyeing.

Finishing includes a variety of techniques that produce all manner of surface effects ranging from rolling, napping, embossing, and coating to flocking, shearing, and sculpturing. Besides these effects that are applied principally for appearance, other finishes are applied for functional purposes such as fireproofing, mothproofing, mildewproofing, and stainproofing. For example, protective finishes such as Scotchgard and Fiberseal are often used on fabrics that receive extensive wear.

SUITABILITY

From the list of terms, you can see that certain fabrics are manufactured with upholstery in mind, while others such as gauze and batiste are more commonly used for window dressings. Still others are ideal for wall and ceiling applications. This does not mean you must not use a fabric for other than its intended purpose, but you may have to alter its application or specially treat it. For instance, blue printed fabrics have a greater tendency to fade in direct sunlight, and silk taffeta may need to be knit-backed for added strength.

TOP

"Couvert de Feuilles," a cut velvet from Clarence House.

ABOVE

At left is "Zebra Velours Soie," a silk velvet from Clarence House; at right is "Jaguar Velour Soie," a silk velvet from Clarence House.

OPPOSITE

A handwoven Regency cut velvet in gold and crimson from Lee Jofa.

"Palerme," a decorative tieback from Houlès lies on "Sherlock Holmes," a woven chenille pattern in cotton from Clarence House.

A variety of ropes, tapes, fringes, and trims from Houlès.

PASSEMENTERIE

The intricate handcrafted trimmings that are applied as a means of elegantly finishing upholstery, window dressings, and other elements of an interior are known collectively as passementerie. Small works of art in themselves, they can be as important as the main body of the item they define, because the eye is inevitably drawn to the outer contour. Effective in integrating a color scheme, the trimmings also can enhance the authenticity of a period room when used as historical details. The legendary English designer John Fowler enjoyed experimenting with unusual passementerie, such as borders designed with decorative Neoclassical ornaments and gimps beneath which cords in the shape of Gothic arches hung.

The finest examples of passementerie are made by artisans who, as the firm Scalamandre describes, are trained in such skills as knotting tiny woven threads into fine netting, wrapping silk threads around a mold to create sculpted forms, and twisting cords on a wheel to fashion bullion fringe. Even the traditional machinery used to make passementerie was designed by great artists: the wheel still used today for crafting bullion fringe was invented by Leonardo da Vinci.

Borders range from 2 1/2 to six inches in width. Highly decorative, they are used on the skirts of upholstered furniture, on curtains, wall upholstery, ottomans, decorative pillows, dust ruffles, and bed linens. Borders can also be used as architectural detailing, applied to cornices and used in place of chair rails. Borders can be woven in plain patterns or in intricate designs.

Braids, also known as galloons, are generally 5/8-inch to four inches in width. Their edges can be cut, looped, scalloped, or straight. Narrower braids are used to cover staples or nails on wall upholstery; wider examples are applied to the edges of curtains, to the skirts of upholstered furniture, to table skirts, decorative pillows, cornices, valances, and bed linens. As with gimps, styles vary. Flat galloons often have geometric or floral designs. Raised openwork galloons have small scroll-shaped or half-scroll-shaped plaited and woven plies applied on a flat fabric background.

Cords add physical balance as well as beauty to swags and jabots. Ranging from 3/16 to one inch, they are used most frequently on upholstered and carved furniture, on cushions and pillows, on the edges of curtains, at the top of valances, and as festoons over swags. They are also used to cover tacks, staples, or butted edges on wall upholstery. Made of plied yarns that have been twisted together, they can be produced in plain or gimped styles. A plain cord is made of two or more plain plies, in a single or several colors, twisted together. A plaited cord is made from two or more gimped plies twisted together. A plain crepe cord is made of two or more plain cords twisted together. For more intricate effect, these three styles of cords can be combined with each other.

Fringes are composed of a gimp-like or braid-like heading and a skirt of loose, looped, or twisted yarns. They serve to protect the edges of fabric from dirt and sunlight. Ranging in width from one to twelve inches, they can be made of a single-colored yarn or of different-colored yarns randomly arranged in patterns. Fringes can be applied to curtains, upholstery, pillows, and valances. Styles of fringe vary from the simple moss fringe with its plain, woven heading and full cut or looped skirt to the elaborate base fringe with its intricately tied yarns and rosettes, tassels, or covered vellum embellishments.

Gimps, flat, narrow woven textiles, conceal tacks and staples on walls and wood-frame-furniture upholstery. They are usually 3/8- to 1/2-inch wide, i.e. narrower than most braids and borders, and made in a variety of styles—primarily flat, corded, and raised surface. Flat gimps can be plain or woven in a number of designs, including scrolls, diamonds, chevrons, or ribbed patterns. Corded gimps have cord sewn down the center or along an edge. Raised-surface gimps are dec-orated with elaborate scrolls made of yarns wrapped tightly around a narrow core. The selection of the size and style of a gimp should be determined by its use—whether on wall upholstery, decorative screens, pillows, lamp shades, or for covering upholstery tacks on furniture. When selecting a gimp, do not try to match it to your fabric. Choose a contrasting shade of a one-color gimp, or one with a value that differs slightly from the fabric. Apply a multicolored gimp to a fabric of a color that appears nowhere else in the room.

Ropes, cords with diameters of an inch or more, are principally utilitarian, although still decorative. Their yarns must be twisted tightly, in a gimped rather than plain style, for reasonable wear.

Rosettes, as the name implies, are decorative stylizations of the rose. All manner of components, from silk or metallic threads to beads, can be gathered by hand and arranged concentrically to form representations of the flower. Rosettes are generally placed in the center of the rolled arm of a piece of furniture, at each end of a bolster, on pillows and cushions, and at the curve of a swag. Often, one is used to form the apex from which a tasseled cord hangs.

Tapes are applied to the edges of curtains, the seams in upholstery, and as binding on chintz curtains, valances, and bed coverings. They are usually made in cotton or linen and can be striped in more than one color.

COMMON MISTAKES

Matching colors identically can induce an overly decorated, artificial atmosphere. Matching trim on pillows to carpet color and to the stripe in a fabric, for example, will create a claustrophobic, ungenerous feel. Instead, the colors of fabrics and trims should breathe into one another naturally.

A variety of custom tassels, mold fringes, gimps, tapes, and cords from Scalamandre.

FURNITURE

AND

UPHOLSTERY

Furniture is as useful an indicator of style and fashion as the setting

in which it (is) placed and the clothes worn by those who use it.

C A R O L E T H O M E R S O N

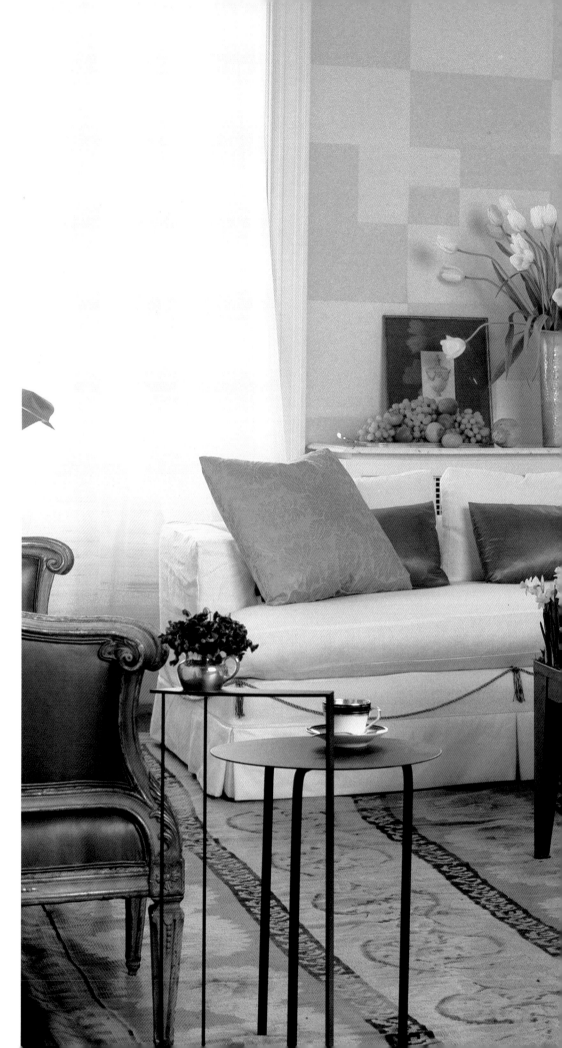

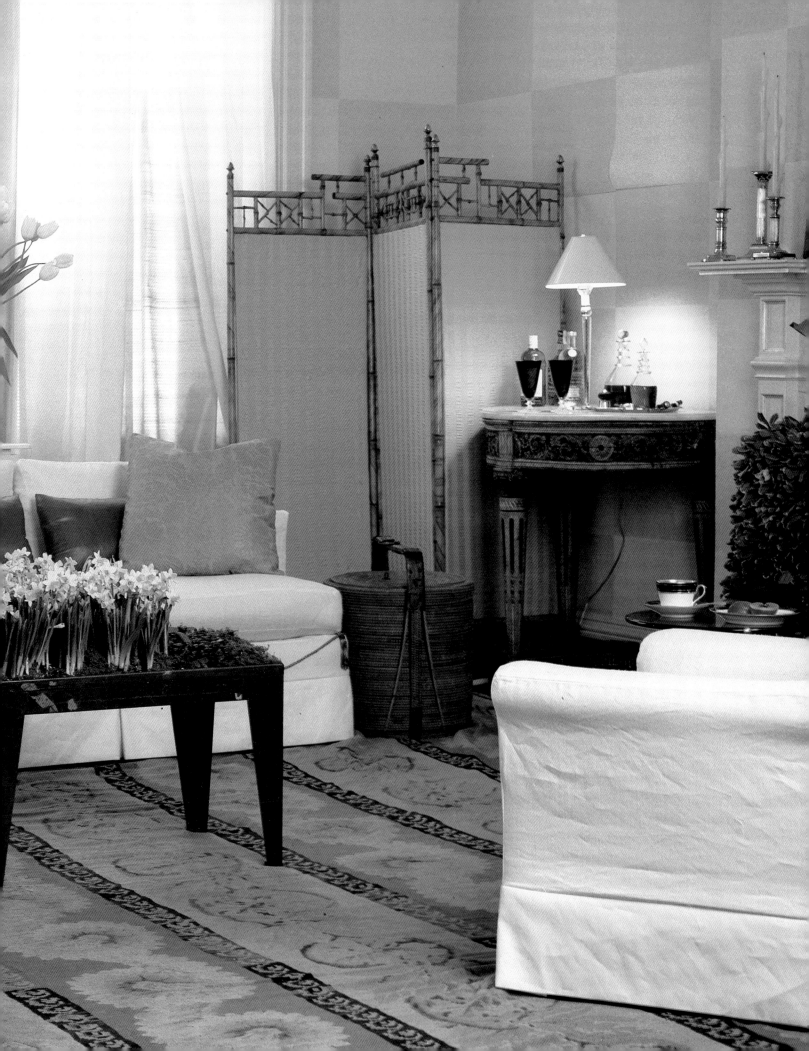

Perhaps no other aspect of the interior asserts domesticity as clearly as furniture. In fact, it can be thought of as the scenery for the theater of personal life. By virtue of its size, furniture implies settledness; by reason of its function, it expresses the activities of house and home. Is not sitting at table to break bread the quintessential domestic image?

In Western culture, the stool and chair have the longest continuous history, connoting the evolution from subsistence living (and the abandonment of animal habits and postures) to "civilized" living. Later, tables and chests developed as places to rest and store possessions, and beds and couches provided places to sleep and recline.

The chair, the most anthropomorphic example of all furniture with its humanlike arms and legs, has so natural and common a place in Western culture that we would easily assume it to have always been present in the home. We know that the Pharaonic Egyptians favored beautiful, inlaid-wood chairs for purposes of ceremony, and that the Greeks refined Egyptian proportions to create the elegant and comfortable klismos chair with its low, concave backrest shaped to the human body, and splayed legs that allowed the sitter to lean back. But, although the Romans introduced the chair to Europe, after the collapse of their empire until the fifteenth century, the free-standing chair was essentially forgotten.

The first domestic interiors of Europe began to evolve during the Middle Ages in the houses of the town-dwelling bourgeoisie. Unlike the nobility, who traveled among many residences, and the poor, who lived wretchedly in huts of mud and straw, the

merchants and artisans enjoyed their relative degree of medieval prosperity in long, narrow, two-floor townhouses where they combined living and working—virtually camping inside. As the architect Witold Rybczynski has described, the main or street-facing floor was a work area, and the living quarters consisted of a single larger chamber, open to the rafters, where any number of people cooked, ate, entertained, and slept. The rudimentary furnishings of these medieval houses were sparse: built-in and portable chests for storage, seating, and sometimes sleeping (the clothes inside the chest serving as a mattress); stools and folding benches for additional seating; and trestle tables for eating and working. Beds could be either collapsible for easy transport or, in the houses of important personages, large and permanent.

Typically, when the nobility traveled, they took their furniture with them, folding their tapestries, gathering up their chests, and collapsing their tables and chairs. In fact, it is from these movable furnishings that the word *furniture* derives in many European languages—*mobiliers* in French, *mobili* in Italian, and *muebles* in Spanish—all meaning movable. In bourgeois homes, too, portability was important—furniture was constantly and haphazardly rearranged according to the function of the great room and the number of people present at any given time.

The chairs most used in households of the Middle Ages were X-frame chairs, simple folding stools made of an X-shaped wooden frame across which canvas, webbing or leather was slung as a seat and stretched as a back. Simple and portable, it was derived from the Egyptian X-shaped folding stool.

It was not until the sixteenth century that furniture began to evolve in both design and ornamentation. By the seventeenth century, an increased control over materials and expanded expertise in production enabled furniture pieces to be used as part of the decoration of the room. Fabric and padding were customarily attached to a chair frame with nails, the fabric and nails lending ornament and the padding comfort. For the first time, furniture came to be considered a valuable possession.

The basic chairs of this period were made of four-square wooden frames whose members were carved, turned, painted, or gilded. Upholstery was still essentially unshaped. The wealth of the owner was demonstrated by the intricacy with which the nailed-down fabric that covered the padding was embellished.

The rudimentary medieval X-frame chairs grew into "chairs of estate" and even royal thrones, ornamented with great quantities of fringes, tassels, and decorative nails and upholstered with substantial seat and back cushions. Every surface was used to express wealth and power. Even the simple, square-framed, armless back stool, like the X-frame chair, achieved prestige by virtue of its covering and trimming. Coverings ranged from plain hides to gilded leather, satin and silk brocades, silk velvets, and needlework. Larger, more lavish back stools were known as great chairs. Large ornamental nails, known as "great-chair nails," which anchored the covering to the frame, were often arranged in patterns. In humbler households or in puritan circumstances, these decorative nails took the place of fancy textiles and trimmings.

Toward the end of the seventeenth century, the considerable development of upholstery techniques coincided with a growing grace in the line of the furniture frame. The *fauteuil*, the classic French open arm chair with stuffed back and huge down cushions, was desired for its elegance and largesse. Curving, commodious, and abundantly

Often elements of a period piece can be exaggerated in reproduction. Linda Chase selected a periwinkle cotton duck by Manuel Canovas to add to this chair's unusual character. Upholstery by Classic Designs, Los Angeles.

A custom sofa in the foundation stage of upholstery, with springs, webbing, spring twine, and burlap in place. Photographed in the workroom of Anthony Lawrence, Cos Cob, Connecticut.

BELOW

The oak frame of the same sofa prior to the application of webbing.

stuffed, it was the first example of furniture to represent a real understanding of comfort as well as luxury. A story about Mme Elisabeth, a daughter of Louis XV, illustrates the fauteuil's attraction: when asked why she had not entered a convent as had her sister Mme Louise, she responded, *"C'est un fauteuil que me perd"* (it was an armchair that was my undoing). So universal was the fauteuil's appeal that it was copied in most European countries throughout the next century.

The eighteenth century achieved the pinnacle of chair design, and furniture finally revealed itself as a servant of fantasy. Early in the century in France, the backs of chairs were sometimes designed to reach more than twice as high as the distance from the seat to the ground to accommodate the fabulous heights of ladies' wigs. Decades later, narrow chair seats were introduced to accentuate the simply cut gowns of the favored Grecian-style fashions. Taste and fashion had become an obsession under Madame de Pompadour, official mistress of Louis XV, who raised the decorative arts—furniture, porcelain, bronze, and wall paneling—to a high art form, insisting that everything in the rooms of her fourteen residences fit together harmoniously. Her favored style was the highly curvilinear and ornate Rococo which became influential all over Europe, especially in Germany,

where it reached its apogee, and in Italy, where Venetian lacquer furniture expressed the style with distinct theatricality and delightful color. Special care must be taken with original examples of this Italian furniture as it was much less fastidiously constructed than the French or even German Rococo.

Luxury furniture of the eighteenth century was the result of a collaboration among a number of different crafts, most notably the *ébénistes,* or cabinetmakers, and *menuisiers,* who made chairs and anything carved, such as mirror frames and bases for console tables. Makers of design for ornamentation, *ornemanistes,* were another distinct guild.

Just as these craftsmen had elevated their skills to the level of art, upholsterers had learned to shape surfaces by molding and securing stuffing. Fine line and beautiful proportion combined with upholstery expertise to provide comfortable and elegant repose. All the components of present-day traditional upholstery—quality workmanship, highly developed techniques, and generous but not extravagant designs—were finally assembled. For the first time since antiquity, form and function became truly united.

Even tufting, a seventeenth-century upholstery method of arranging and securing the stuffing in mattresses, was modified to become

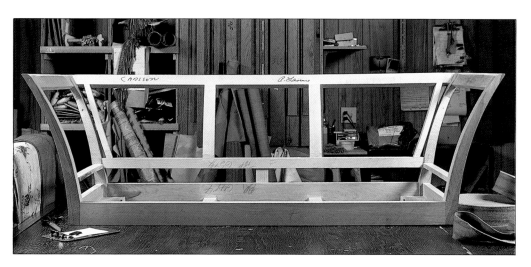

a decorative technique. (Tufts are short strands of silk or linen threads tied in the center and looped through the upholstery.)

In addition to the Rococo style, the eighteenth century also gave birth to the Neoclassical and Georgian styles. With the discovery of the ruins of Herculaneum and Pompeii in the eighteenth century, a rage for all things antique swept Europe. Proponents of the resulting Neoclassicism would design every detail of the architecture and its interior, including furniture, in classical proportion and with Egyptian, Greek, Roman, and Etruscan ornament. Rooms took on the character of classical imperial fantasies as carved and gilded heads of helmeted warriors and winged figures appeared on finials; lion paws on table legs; and archaic lions, griffins, sphinxes, and owls on arm rests and chair frames. Dining-room and drawing-room furniture was made of hardwoods—mahogany or rosewood inlaid with classical motifs in brass. It reflected the strong geometry of its surrounding architecture and was seldom comfortable—line being more important than springs or padding. The upholstery, usually confined to the seat, was covered with sumptuous cut velvets, silk, or satin damasks, or specially woven Gobelin tapestry to match wall hangings.

The nineteenth century saw the culmination of great workmanship in furniture. By the time the high Victorian style had exhausted the design world with its excesses, emphasis was shifting to mass production, and the skills of the highly trained upholsterer were heading toward obsolescence. In the twentieth century, the arrival of foam padding revolutionized the upholstery trade as pads could be sculpted into virtually any shapes with glue and staple guns.

RECOMMENDATION

COFFEE TABLES SHOULD ALWAYS BE CONTEMPORARY IN STYLE SINCE THE FORM ITSELF DEVELOPED ONLY IN THE 1920S. A COFFEE TABLE DESIGNED IN THE STYLE OF AN EARLIER PERIOD, UNLESS INTENDED AS A CONSCIOUS AESTHETIC STATEMENT, TOO EASILY LOOKS PRETENTIOUS OR AS IF IT CAME FROM AN UNKNOWLEDGEABLE SOURCE. ❦

A GUIDE TO STYLES OF FURNITURE

In common parlance, the terms *antique* and *period* are often interchanged. In the design world, however, the terms have distinct meanings: in America, *antique* refers technically to any furniture or object made before 1830, or loosely, one that is more than one hundred years old; *period* refers to furniture created during a precise time, usually defined

TOP

The "Marshall Field" chair shown with a down-pad overlay, covering horsehair, burlap, and springs.

ABOVE

A tufted arm chair that has been double-stuffed with horsehair on the seat, arms, and back and covered with a muslin overlay.

LEFT

The handstitched interior of a tufted sofa that has been covered in muslin prior to the application of cotton over which the upholstery fabric will be applied. All photographed in the workroom of Anthony Lawrence, Cos Cob, Connecticut.

by a monarch's reign or the influence of school of design.

Régence is the French Rococo style that flourished from the time of the Baroque in the late seventeenth century to the end of the reign of King Louis XV in 1725. Marked by exaggerated curves and a total avoidance of straight lines and symmetry, it made elaborate use of flower, shell, and scroll motifs. Régence furniture was usually gilded or painted in pastel colors and luxuriously upholstered.

Queen Anne furniture of the early eighteenth century is small in scale and graceful in line. Its characteristics include the cabriole (deeply curved from the "hip") leg, the claw-and-ball foot, and the scallop or shell motif. Splat chairs with curved top rails, tall highboys, and various decoratively edged occasional tables were popular.

Chippendale is named for the gifted English cabinetmaker Thomas Chippendale who, in the mid-eighteenth century, elevated the use of exquisite carved decoration. Much Chippendale furniture is made of mahogany because the wood lends itself well to carving the French-style ribbons and bows that appear on chair backs, the curved pediments on highboys and secrétaires, and the Oriental-like fretwork on the legs of some camelback sofas and wing chairs. Cabriole legs and claw-and-ball feet of the earlier Queen Anne period also appear in Chippendale furniture.

Adam refers to the late-eighteenth-century revival of classical design in English cabinetry promoted by the Adam brothers, Robert and James. As architects as well as cabinetmakers, they extended the application of architectural details such as urns, egg-and-dart moldings, laurel leaves, and column-shaped legs to furniture. They preferred straight lines to curves, and oval chair backs to square or rectangular ones.

Biedermeier furniture was created principally between 1815 and 1848 in Germany and Austria. A pared-down derivation of French Empire and English Regency design, it emphasized proportion, usefulness, and elegance. Conceived in a climate of conservative politics and bourgeois values, its aesthetic called for the truth of natural materials and simple, solid construction. Light-colored fruitwoods, beautifully grained veneers, and functional metal hardware, usually concealed, are characteristic of the Biedermeier style, as are applied Neoclassical decorative elements, such as cornices, columns, capitals, and pediments, or motifs from classical mythology. Many pieces look like miniature buildings.

Hepplewhite, the classically influenced style of the late eighteenth and early nineteenth centuries named after George Hepplewhite, favored, like the Adam style, oval backs on chairs as well as shield backs. Also characteristic were tambour doors on cabinets, and ornaments in the form of rosettes or medallions. The earlier taste for highboys gave way to long, low Hepplewhite sideboards and chests of drawers.

Regency, often described as the English version of the French Empire and German Biedermeier styles, or as a comfortable, domesticated Empire design, dates loosely from the last decade of the eighteenth century through the 1900s. It was usually constructed in rosewood or mahogany and painted in black and gilt.

Directoire and *Empire* represent the early-nineteenth-century French rejection of regal excess. Under the Directoire, Rococo curves were replaced with straight, severe lines and classical proportions. With the ascent of Napoleon, classical design grew imperial in appearance and scale: furniture became massive and displayed a wealth of Roman and Egyptian ornaments and military symbols.

Victorian design embraced the ornamenta-

tion of every surface. Opulence was considered to bestow prestige, and in Victorian furniture, lavish upholstery eventually dominated the frame. Lines not only curved but swelled, and seats, arms, and backs were given all manner of scrolled, rolled, and gathered edges. A crescendo of stuffing and springs was enveloped in a profusion of buttons, corded rolls, scrolls, fringes, tassels, and valances.

Arts and Crafts School design spread throughout Europe and America in the late nineteenth and early twentieth centuries. Its sober aesthetic was based on the value of handwork, reverence for materials, and simplicity of design. Massive, squarish oak furniture with beautiful wood inlays, medieval-inspired naturalistic floral patterns, and charming painted wood designs were representative of the style. A chief proponent was the English artist William Morris, after

whom the Morris chair—simple in line, with adjustable back and removable seat and back cushions—is named. The Scottish Arts and Crafts School designer Charles Rennie Mackintosh is known for his gracefully attenuated yet highly restrained wood furniture designs. A direct influence of the Arts and Crafts School in America is seen in the furniture designed by Frank Lloyd Wright.

The *Wiener Werkstatte* was Austria's contribution to this era that favored flowing lines, fine materials, and exquisite workmanship. Many furniture designs by its founder Josef Hoffmann are popular in reproduction today.

Art Nouveau design developed concurrently with the flowering of the Arts and Crafts School. The French interest in natural forms was openly sensuous and expressed itself in sinuous, freely drawn curves and a flowing and more fanciful look. The artists Emile

ABOVE

A marigold silk tassel enlivens these Constructivist-inspired chairs, adding a welcome note of whimsy.

OPPOSITE

Strict simplicity is key to the effectiveness of this dining room. Architecture and furnishings by Deamer + Phillips, New York.

BELOW

A table designed by Peter Carlson was inspired by Shaker precepts. Chairs are designed by Mathieu & Ray. Interior designed by Carlson Chase Associates.

The steel construction of these "Salonna" chairs designed by Peter Carlson allows for their thin and elegant profile. Photograph by John Bigelow Taylor. Courtesy Luten Clarey Stern.

Gallé and Louis Majorelle created exquisite, highly sculptural wood furniture, typically in mahogany and walnut with intricate wood inlays. In America, the lamps and accessories designed by Louis Comfort Tiffany expressed a more realistic, though nonetheless lavish, interpretation of nature.

The *Mission* style and the furniture designs of *Gustave Stickley,* known for their forthright straight lines, are American examples of the Arts and Crafts School. Mission furniture derived from the crude tables and chairs found in the old Spanish missions in the southwestern U.S. Stickley furniture, principally made of oak, was equally sober, but refined in line and construction.

Art Deco evolved as a synthesis of the exotic high taste of post World War I Europe (principally Paris) and the promise of modernism and industry. It evolved during the nineteen-teens and twenties, fusing fantasy with function and incorporating Russian, African, Egyptian, Aztec, Mayan, Moorish, Assyrian, and Oriental images with the sleek glamour of the period's streamlined cars,

ocean liners, and trains. In Europe, Art Deco furniture was inlaid with such luxurious materials as ivory, ebony, mother-of-pearl, rare woods, and marble. In America, the influences of Hollywood and mass production were seen in the style's embrace of such industrially produced materials as Bakelite, Vitrolite, and stainless steel.

Contemporary or *modern furniture* design is based on the revolutionary designs of the German Bauhaus of the 1920s, which stripped away use of classical and historical references and reflected the dictum "form follows function." The introduction of new materials such as steel, laminates, and plastics expressed the influence of industry on furniture. The furniture designs of the European architects Le Corbusier, Mies van der Rohe, and Walter Gropius have become classics of modernism.

COMBINING STYLES

When combining furniture of different periods and styles, you can apply either one of two basic approaches: Either choose pieces

for their similarity in characteristics and scale, or juxtapose pieces that are entirely different and emphasize the contrast. For example, a gilded fauteuil and a painted Italian side chair are two very different pieces of furniture that derive from the same period. The delicacy and femininity they share make them easily compatible. On the other hand, the simple lines of an Empire secrétaire can set off the exotic qualities of a Bugatti chair, just as an eighteenth-century upholstered armchair will be dramatized when juxtaposed against a tailored Billy Baldwin sofa.

You can create strength and unity in furniture selection not only through the lines of the furniture, but also through the application of the same or sympathetic fabrics. Keep in mind, however, that no matter how harmonious the fabrics, a combination of furniture styles that are unsympathetic in scale and form will never be successful.

RECOMMENDATION

IF YOU INDULGE IN IMPULSE BUYING, BE ADVISED TO CONFINE YOUR PURCHASES TO ACCESSORIES. MAJOR PIECES OF FURNITURE SHOULD BE PURCHASED AS THOUGHTFULLY AS ANY MAJOR INVESTMENT. FURNITURE BOUGHT ON IMPULSE GENERALLY PROVES A DISAPPOINTMENT. ❦

BUYING FURNITURE AT AUCTION

You can acquire fine-quality furniture at low prices by learning to shop at auctions. This requires both knowledge and discernment. First peruse auction catalogues to see what strikes your interest. Then research prospective purchases. Attend preview showings to inspect the items. If you are in doubt about the authenticity or value of a piece of furniture, consult an expert. Have house, room, and space measurements with you to be sure your choices will fit. Before deciding on your

bid price, find out what you would pay for a similar piece in an antique store. Finally, don't be intimidated by dealers bidding on the same pieces; you have the advantage since they will bid only up to wholesale value.

WOOD FURNITURE

There are two types of woods—softwood and hardwood. Softwoods are produced from coniferous trees with needles, such as pine and redwood. Hardwood is created from deciduous trees, those that shed their leaves in fall, such as ash, teak, cherry, maple, oak, walnut, and mahogany. Softwoods typically are more affordable, but scratch and dent easily. Hardwoods are the most frequently used in quality furniture. They are strong, durable, and with the rich-looking grain patterns that distinguish fine furniture.

The following are types and applications of wood in furniture:

Ash is a hardwood valued for its toughness.

Avondire is a light yellow wood used exclusively as veneer. It comes from a tree that grows only in Africa.

Burl refers to the figured, swirled patterns found in such woods as walnut, elm, maple or ash. Burls are often used in inlays and decorative veneers.

Ebony is a tropical hardwood that is especially dense and heavy. Black in color, it takes a high polish.

Elm is a tough, resilient wood with a light brown heartwood. It is used most commonly in cabinetmaking.

Fruitwood is a broad term applied to the wood of fruit trees such as pear, lemon, lime, apple, and cherry. Typically pale or natural in color, it was used so often by French Provincial furniture- and cabinetmakers that it became a characteristic of their work.

Marquetry is an inlay process that evolved during the height of seventeenth- and eighteenth-century furniture making. The art

TOP

Pink canvas upholstery adds a vivid twist to the classic Bertoia chair. Available through The Knoll Group. Upholstery by Classic Designs, Los Angeles.

ABOVE

The classic Cedric Hartman "AE" table can be fabricated in brass, bronze, and nickel silver with polished, oxidized, and rubbed beeeswax finishes. It is available through Jack Lenor Larsen, Los Angeles and Chicago.

BELOW

Classics of modern furniture design by the Bauhaus master Mies van der Rohe include the Barcelona chaise longue, ottoman and chair. At rear is the Brno chair. Photograph courtesy of The Knoll Group.

involves setting pieces of variously colored, very thin strips of woods, such as pale yellow sycamore, into the surfaces of tables, desks, and fancy chairs. *Boulle* marquetry takes its name from André Charles Boulle, an eighteenth-century French furniture maker and a favorite of the court. He inlaid brass with pewter, copper, tortoiseshell, and mother-of-pearl.

Papier mâché, a mixture of paper pulp, glue, oil, resin, chalk, and fine sand, was used for making furniture and decorative objects in mid-eighteenth-century France and England. The pulpy substance was molded into shape when moist and then baked until hard enough to be sawed. Papier mâché pieces were often given a high polish and inlaid with mother-of-pearl.

Parquetry is a variety of furniture inlay developed by seventeenth- and eighteenth-century woodworkers that typically employed different-colored geometric or other decorative patterns.

Rosewood is a fine hardwood, reddish black in color and streaked in grain.

Satinwood is a hard, light yellow wood. Its lustrous surface makes it especially desirable for fine furniture.

Sycamore is a hardwood that was highly popular for furniture in seventeenth-century England.

Teak is a strong hardwood, medium-brown in color and valued for its high resistance to moisture.

Steel replaced wood in many folding chairs, tables, desks, and beds in France during the late eighteenth and nineteenth centuries. It found its greatest expression during the Directoire period. Some of the most beautiful steel furniture ever made was produced by the Tula weapons factory in Russia. Like other industrial materials, it also found favor among designers of modern furniture.

WOOD CONSTRUCTION AND FINISHES

When purchasing a piece of new wood furniture, be certain to learn the type of construction and materials used. Even if a piece appears to be made entirely of wood, it may not be. Even if it carries a label with the name of a particular wood, the name may refer to the color of the finish and not the wood.

Solid wood means the piece is 100 percent hardwood with no substitute materials, such as particle board, or veneers.

Veneer, a practice invented by the ancient Egyptians and developed to its fullest in the

eighteenth century, refers to the minutely thin layers of rich woods such as satinwood, walnut, mahogany, and olive that are glued to the surface of furniture, which is usually made of an inferior wood such as oak or pine. Different colors and textures of rare or costly hardwoods may be formed into patterns or inserted into inlay designs by expert craftsmen.

Laminates are photographic reproductions of natural wood grains applied to thin layers of plastic, foil, or paper that are in turn bonded to reconstituted wood.

FINISHES

Finishes not only protect furniture but give it luster and added color. Hardwoods will typically achieve a high polish when treated with wax alone. Softwoods usually require a sealer.

Lacquer involves the application of numerous coats of finish, each requiring several days to dry. The technique was developed in China around 1000 B.C. and copied by the Japanese, who improved upon the inventors' techniques. When Oriental furniture began being imported into Europe in the seventeenth century, European cabinetmakers copied the finish and called it "japanning."

French polish is a procedure typically applied to fine wood furniture that involves the use of linseed oil and shellac. The two are rubbed by hand into the wood surface with a cloth separately or in combination. After the application has dried, the process is repeated until a permanent gloss is achieved.

Glazed finishes require a smoothly applied opaque underpainting and darker-colored transparent overpainting. The effect of depth they produce gives the furniture surface a distinctive richness.

Crackled finishes give furniture an antique appearance by the application of layers of incompatible paint or other substances which cause the surface to "scale" and look aged. A glaze is usually applied over them.

Distressed finishes are also artificial means of making furniture look aged. The means range from purposeful nicking and denting to chemical treatments.

Gilding and *silver leafing,* art forms presently experiencing a significant resurgence, add unique luster and richness to furniture.

Vernis Martin is a lacquer finish that imitates Chinese lacquer. Although less durable than its model, it exhibits a similar brilliance.

UPHOLSTERY

There are two types of upholstery—tight or close covering, and loose or slipcovering. Tight covering is tailored and preserves the

Modern furniture classics by the Bauhaus master Marcel Breuer include his Wassily chairs and Laccio tables. Photograph courtesy of The Knoll Group.

ABOVE

The character of a cabinet or furniture piece can be greatly changed by the addition of a different wood veneer.

BELOW

The "Finnform" chest is named for the highly quality Finnish plywood with tinted resin finish from which it is made. The grain is visible through the transparent finish. Both the knobs and legs are made from bronze which is first turned and then blackened. Designed and fabricated by Chris Lehrecke Furniture, Brooklyn, New York.

lines of the furniture. Slipcovers are more informal and easily removed.

Some styles of furniture, such as most antique chairs and sofas, *must* be tight-covered to look right; other styles can be treated either way. There is great flexibility in the choice of upholstery materials for both types, and certainly no requirement to cover a period piece in period fabric. The use of a textured weave on a Louis XVI chair, for example, would give it an unexpectedly contemporary feel.

Each technical procedure in the process of upholstering creates a different shape and provides a specific degree of durability and comfort. Only an experienced and talented upholsterer can guide you in making the correct decisions about the look you want.

MATERIALS

The frame should be made of a hardwood at least 1¼-inch thick. Inspect it to see that joints are held together with screws, dowels, and glue, and that legs are integrated into the construction, never simply screwed or glued on. Lift one end of the chair or sofa; if it feels unreasonably light or jiggles, sags, or creaks, there is a problem.

The positioning and fixing of *webbing* to the frame provides the support for the entire upholstery pad. Webbing must be uniformly spaced in order to take an even distribution of weight and to provide a firm base. The webbing or springs are typically covered with burlap.

For *stuffing,* the material that creates the depth and strength of the pad, 100 percent horsehair was traditionally the best material. It is no longer generally available unless found in old furniture and reused. The closest equivalent in the United States is curled hair, made of 50 percent hog hair. Stuffing should be evenly distributed, and packed not so densely as to diminish comfort and resilience. As padding for sofas and chairs, foam core surrounded by down gives both softness and firmness. If down, which is costly, exceeds your budget, polyurethane foam of a density of 1.8 pounds per cubic foot can be used.

When choosing an *upholstery fabric,* pay attention to the combination of fiber, weave and finish that gives the fabric its textural identity and determines its wearability. Choose a fabric whose look and feel suit the style of the piece of furniture, its surroundings, and its function.

Fabrics that reflect light, such as glazed chintz and satin-weave cotton and silk, will accentuate the contours in the upholstery and, thereby, the lines of the furniture. Surface texture also influences the quality of the fabric's color, which will appear different in artificial light than in daylight.

Patterns, too, have measurable effects. Stripes tend to elongate a shape; subtle patterns can be more difficult to work with than bold motifs that read easily at a distance; and repeats must be carefully matched or balanced.

Damask and other classic fabrics such as velvet, silk, cotton, and leather are available in a wide range of weights, shades, and textures. They are used in contemporary designs as well as in period reproductions. Antique fabrics such as old kelims or Aubusson tapestries can look beautiful on new or restored frames as long as the fabric is in suitably strong condition.

RECOMMENDATION

JUST AS YOU SHOULD ALWAYS PUT YOUR MONEY INTO THE BONES, NOT THE SKIN OF A ROOM, YOU SHOULD INVEST IN FURNITURE WITH QUALITY FRAMES. THE BEST SILK DAMASK WILL NOT CONCEAL A POORLY CONSTRUCTED PIECE OF FURNITURE. A LESS EXPENSIVE FABRIC ON A BETTER PIECE OF FURNITURE IS ALWAYS A WISER INVESTMENT. ❦

TRIMS

While trims are considered finishing touches, they should not be treated as afterthoughts. The piping, cord, rope, gimp, braid, fringe, tassels, or decorative nails must harmonize with the upholstery fabric and the style of the furniture, especially if it is a period piece. Some trims, such as piping, are sewn into the cover before it is fixed to the frame; others are used to cover seams and tacks. But even if they are applied as pure decoration, they must be considered early on, along with the selection of fabric.

CHOOSING A WORKROOM

In selecting a furniture workroom, first of all be clear about your requirements for comfort and aesthetics. Then look for a professional who has not only the experience, but also an appreciation for the effect you are trying to achieve. You can determine this by visiting workrooms and asking to see completed pieces and works in process. If possible, sit in completed pieces to experience their level of comfort. Examine them also to assess their quality of stitching, the accuracy with which patterns have been matched, and their attention to detail.

In upholstering, the effect of a large-scale pattern is completely undone by bad seaming. Be certain that fabric patterns are precisely matched. The larger the repeat, the more waste you will have, so do not skimp on yardage.

RECOMMENDATION

FOR MOST UPHOLSTERED FURNITURE, CUSHION COVERS SHOULD FIT SNUGLY, WITHOUT LOOSE CORNERS. SEAMS, WELTS, AND SKIRTS SHOULD BE STRAIGHT AND CRISP. STUFFING SHOULD PROVIDE FOR A CUSHIONY FEEL, NOT RESILIENCE. UNYIELDING FOAM RUBBER CANNOT BE DISGUISED. YOUR UPHOLSTERY SHOULD SUGGEST THAT SOMEONE HAS ONLY JUST SAT THERE AND, THEREBY, WELCOME OTHERS.

FABRIC PATTERNS ON UPHOLSTERY MUST BE PRECISELY MATCHED. EVEN THOUGH THE LARGER THE REPEAT IN A FABRIC, THE MORE WASTE THERE WILL BE, IT IS CRUCIAL NOT TO SKIMP ON YARDAGE. THE EFFECT OF A LARGE-SCALE PATTERN WILL BE COMPLETELY UNDONE BY INACCURATE MATCHING AND BAD SEAMING. ❦

A delicate interpretation of the traditional four-poster bed expresses the influences of Charles Rennie Mackintosh and Shaker design. It was designed and fabricated in dark-stained mahogany by Chris Lehrecke Furniture, Brooklyn, New York.

ACCESSORIES

Unless you have a feeling for that secret knowledge

that modest things can be more beautiful than anything

expensive, you will never have style.

ANDRÉE PUTMAN

From the time of the Renaissance until the twentieth century, the design of rooms in most European and American houses adhered to the stylistic prescriptions of their particular eras. General formulas of palette, scale, and type of decoration—typically evolved from royal examples—determined the look of whole nations of rooms. Today, freed from formula by nearly a century of cultural assimilation, interiors are more a vehicle of self expression than they have ever been.

Early in the twentieth century, world's fairs and international expositions did much to expose the public to the styles of other cultures. In Europe, the introduction of African art, the performances of the Ballets Russes, the highly publicized excavations of King Tutankhamen's tomb in Egypt, and the discoveries of Mayan ruins in Mexico contributed to a taste for the exotic. Oriental art and Moorish design increased in popularity, and the Italian Futurists, the Cubists, and the Surrealists exerted influences that reached from the art world into the worlds of fashion and interior decoration.

World War I propelled the transportation of European culture into America and, likewise, American culture to Europe. By the 1920s, numerous social conventions had been dispelled or at least relaxed, and the world of communications had vastly expanded through radio, telephone, magazines, and, perhaps most influentially, the movies. The broadening of travel via the automobile, ocean liner, locomotive, and airplane also contributed to a new visual and cultural consciousness.

The resulting synthesis of cultures and styles liberated interior decorators from formula, freeing them as never before to mix imitation with interpretation.

Accessories typically reveal the character of the inhabitants of a home more than almost any other aspect of an interior. Heirlooms and keepsakes illustrate family history; art and collectibles reveal interests and taste; travel mementos and maps suggest worldliness; religious and ritual objects create an aura of mysticism, while collections of dolls, perfume bottles, jewel boxes, and music boxes lend a sense of femininity. Regardless of their nature, accessories only make sense in a design scheme when they are truly reflections of *your own style.*

Aesthetically, accessories introduce ideas, shapes, color, pattern, and texture to a room. Their selection can make the difference between an atmosphere of artifice and one of genuine interest. One of the most direct approaches to choosing accessories is to emphasize the decorative qualities of functional objects such as clocks, mirrors, candlesticks, fireplace tools, pillows, and books.

ART AND COLLECTIONS

Alone, a work of art can define or transform a room. If it is the focus of the room, it must be positioned and lighted accordingly. As part of the overall texture of the interior, paintings, sculpture, and collectibles add a richness that ranges from serious statement to pure whimsy. A gallery of ancestral portraits creates an ambience quite different from the modest charm of a collection of Roseville pottery; an arrangement of Japanese lacquer boxes lends a sleek refinement that is distinct from the delicacy of crystal decanters or perfume bottles. Contrast these with the assertive beauty of a powerful painting or piece of sculpture and you can see how dramatically art sets the tone and affects the nature of a room.

PLANTS AND FLOWERS

Plants add color and sculptural form to an interior. A striated leaf set against a deep

Mirrors first became pervasive in the homes of the European gentry in the seventeenth century. Displayed as signs of wealth and prestige, they were also used to bring more light into rooms—doubling and redoubling the power of lamps and candles at night and amplifying the sunlight from a window. Today large expanses of mirror are frequently used to create illusions of greater space, and ornately framed examples, such as the Swedish one from Karl XII Swedish Antiques, at top, and the eighteenth century French gilt mirror with inset porcelain miniature, above, enhance the decorative quality of a room.

background or a beautifully attenuated stem arcing across a tabletop can add as eloquent a visual gesture to a room as a fine painting. The vase or planter in which the plant stands should be chosen either to harmonize with other elements in the room or to stand apart as a distinct accessory, such as a crystal and ormolu vase or an antique stone urn. The proportions of the holder must be considered in relation to the size of the plant so that it will not diminish or overwhelm the plant or flowers.

Flowers, ephemeral as they may be, are, like fragrance, vital to the aura of domestic beauty. Some decorators arrange flowers according to the color scheme of the room in which they are placed, and even in relation to the colors in the room seen beyond. Many English decorators have long favored natural bouquets of full-blown blooms. Others mass flowers to match the surrounding objects on the table. In an eighteenth-century country house, the Italian designer Renzo Mongiardino once mixed real flowers against a background of flowers painted on flower-printed scarves that had been pasted onto the walls. The effect was inventive and lush.

DISPLAYING ACCESSORIES

Accessories, by virtue of their vast variety in size, color, scale, and narrative content, are the easiest of all design elements to play freely with. Mark Hampton's description of one of his favorite rooms makes this eloquently clear: "Everywhere you look there are lamps and objects and pictures that form a varied collection of the arts. The arrangement is strict and orderly, but not spare;... comfort and beauty matter more than any amount of eye-catching monkey business. The kidding around is saved for the conversation, which, after all, is always better in a

beautiful room."

With some objects, the place to display them will be the logical setting, such as a console for a bust or a mantel for a mantel clock; and some types of furniture, such as vitrines and étagères, are designed specifically to hold accessories. As long as you remain sensitive to the color, texture, scale, and quality of juxtaposition among your objects, you will find great latitude in the mixing and positioning of accessories.

COMPOSITION

Accessories can be grouped in formal, symmetrical arrangements or in informal random arrangements, depending on the character of the room and the furniture layout. Composing thematically unrelated but visually compatible objects into formal still lifes (a signature of decorator John Fowler), can be arresting. You can also arrange classical objects informally to great effect.

TABLEAUX

Some designers think of tableaux as landscapes of objects that delight the eye as much as a painting or sculpture or other piece of fine art. The arranging of objects into a picturesque grouping on a table can be much like telling a story in which the "cast of characters" is composed of articles that relate your own history, interests, and humor. The arrangement of objects on the dining table also can provide a thematic focus for a gathering. While the laden table brings people together to nourish the body, a beautifully set table provides a feast for the eye.

COMPOSING ACCESSORIES BY COLOR

Color can be an effective means for organizing accessories. A collection of rose medal-

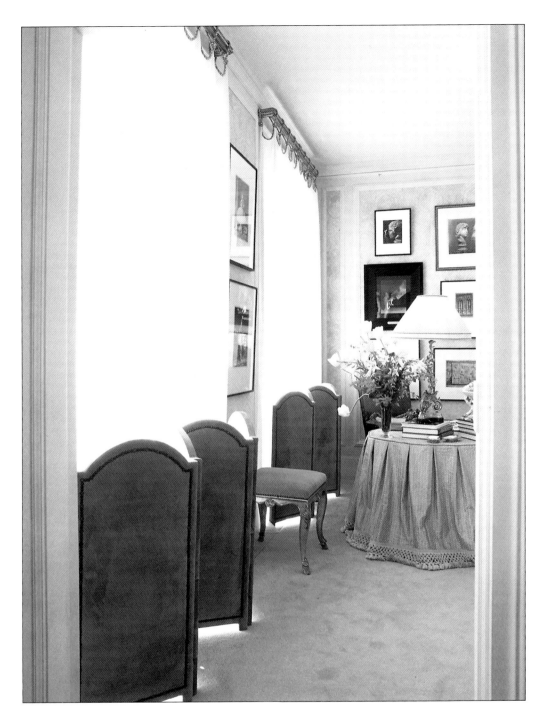

Framed nineteenth century water-color renderings of Regency-style curtains are cleverly displayed as a visual double entendre against a Brunschwig & Fils wallpaper designed as trompe l'oeil draped fabric.

LEFT

Screens were originally devised to guard against drafts and to provide privacy. They remain among the most practical and versatile of decorative accessories—used to divide a room spatially, to conceal disarray, or purely for their visual beauty. They appear here in a room designed by Paul Vincent Wiseman. Photograph by Cookie Kinkead.

lion porcelain or cobalt blue glass bottles makes a far stronger impact when the pieces are grouped together. Similarly, a collection of unrelated objects in the same color can make a strong visual statement.

FRAMING PICTURES

A well chosen picture frame should either extend the context of the image it surrounds or simply and discreetly border it. Traditionally, landscapes have been given concave frames that draw the eye into the picture. Shallower images, such as still lifes, portraits, or abstracts with little perspective, are often given convex frames that project the image toward the viewer and create an illusion of depth. Flat frames typically work well with prints and graphic art.

With an unlimited range of finishes, mats can be treated as simple, elegant borders or as decorative elements in themselves. The medium and nature of the art work should determine the appropriate choice. For example, subtle or soft media such as watercolors and lithographs typically call for cream, off-white, or pale-toned mats. Decorative prints, such as botanicals, are often matted with a color found within the art work. Bolder prints, such as maps, architectural renderings, and gouaches, may call for mats in stronger colors, sometimes embellished with marbled or colored papers, or thin strips of color or leaf.

Charcoal drawings and lightly fixed pastels benefit from the added distance from the glass provided by a multiple mat made from two or more mats stepped back from the image so that only the lower portion of the mat, sometimes only an edge, is revealed. A multiple mat with a narrow strip of light mat covered by a dark outer mat can add considerable depth and perspective to a picture.

An alternative to colored mat board is the fabric-covered mat. Linen, silk, and velvet add a look of overall richness to both the picture and the frame.

In addition to their decorative role, mats serve to protect watercolors, pastels, prints, and photographs from the damage that can result from direct contact with the glass that covers them. However, poor-quality mat board can discolor or cause deterioration to a picture. It is essential to use acid-free board made from rag or wood pulp treated to remove chemicals and impurities that can harm paper.

HANGING PICTURES

Designer Thierry Despont has been known to hang pictures in the way they used to be hung at the Louvre—all the way up to the ceiling. This idiosyncratic treatment works well in rooms of considerable height or ample proportions, and with extensive collections of pictures. In more modest rooms, it is a mistake to hang pictures too high.

The nature of the collection or individual piece of art also dictates much about the style and location of hanging. A collection of miniatures, for example, requires display as near as possible to eye level so that their fine detail is easily visible. Miniatures are engaging whether displayed alone or massed in picturesque groupings. Delicate in detail and diminutive in proportion, they are easy to arrange on walls and shelves. Large landscapes, important paintings, or strong portraits require more prominent positioning. If a painting is of considerable size, it is important to consider the structure and weight-bearing capacity of the wall you intend to hang it on.

ACCESSORY STYLES OF LEGENDARY DESIGNERS

Edith Wharton's revolutionary look of pared-down grandeur extended to her use of accessories. She cleared tables and desks of memorabilia to allow fine pieces prominence. Her preference for arrangement leaned, as with furniture, toward classical symmetry—nothing was placed at random. She insisted on pairs of urns, pairs of busts, and she consistently centered art work over mantels and consoles or between sconces.

The American decorator *Elsie de Wolfe* was renowned in Europe and the United States from the 1890s through almost the entire first half of the twentieth century. Passionate about eighteenth-century French culture, she transformed the dark, Victorian-style living rooms of the turn of the century into romantic visions inspired by the rooms of Louis XVI and Marie Antoinette. She preferred subtly gilded frames to brilliantly gild-

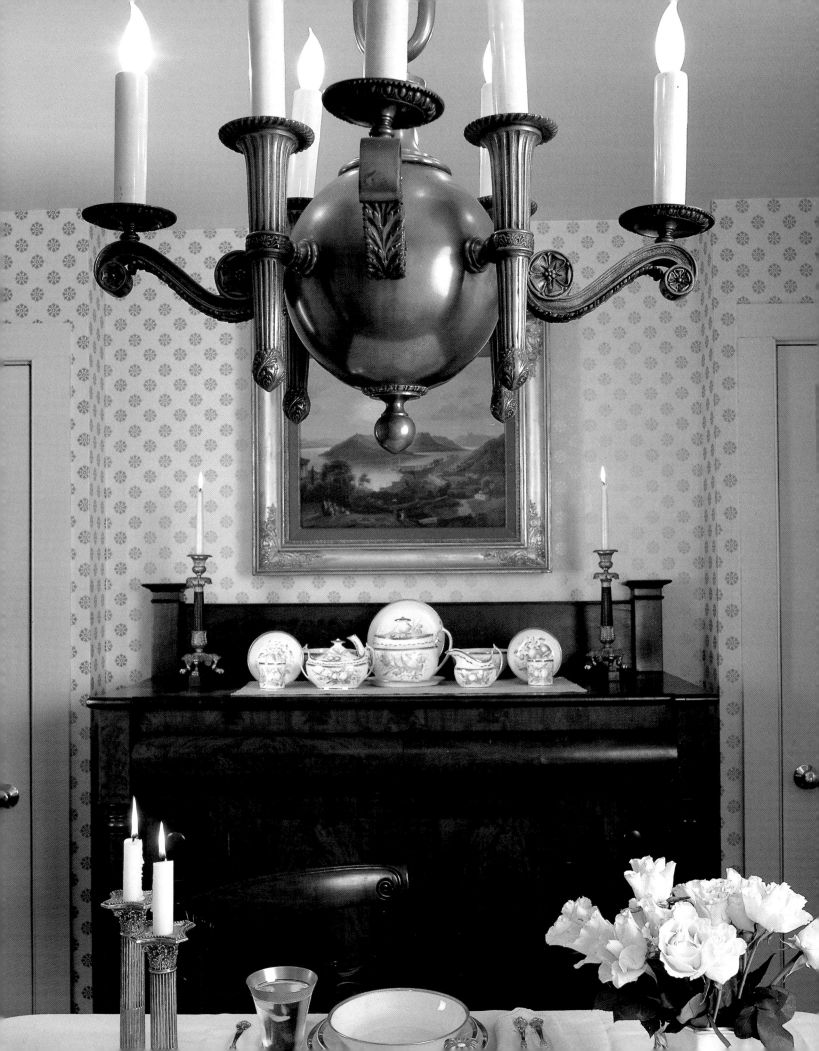

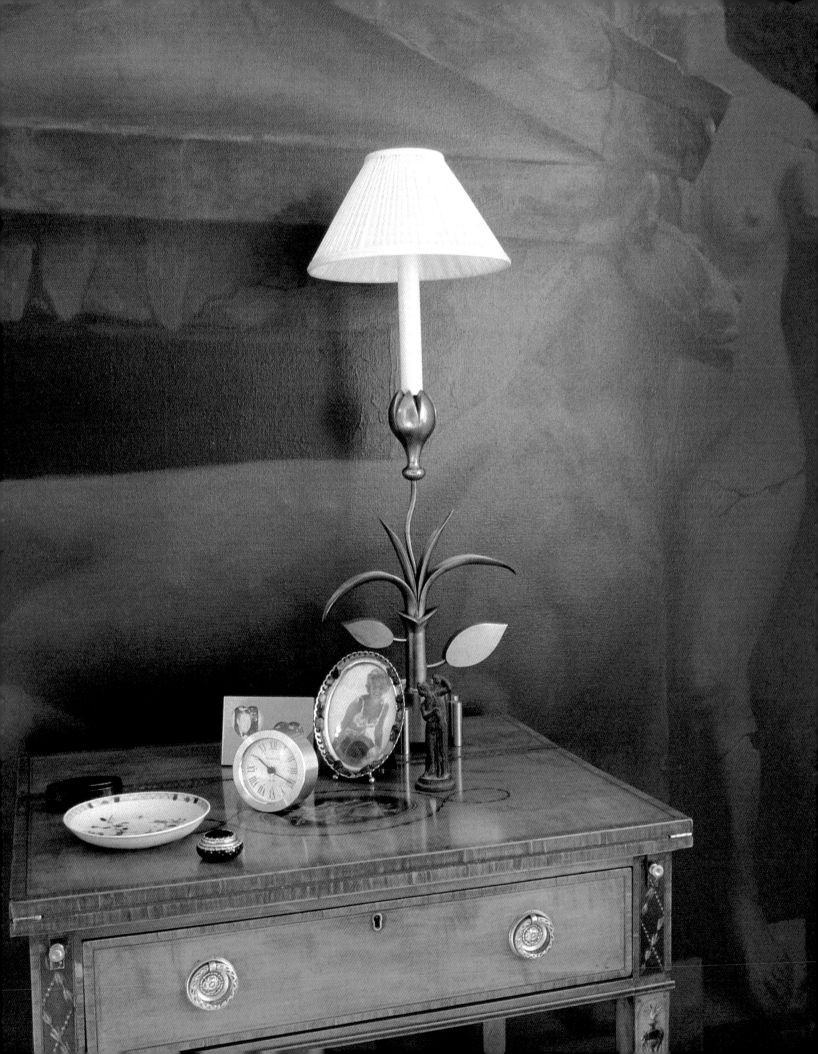

ed ones, and used busts of Marie Antoinette to enhance the femininity of her interiors. In later years, Miss de Wolfe's tastes grew toward the Venetian, and mirrors and black-amoors filled her fabric-tented rooms. Mark Hampton described Elsie de Wolfe's use of accessories as one of "restraint and connoisseurship without the sacrifice of chic and luxury."

Syrie Maugham achieved her signature style of extravagance without ostentation, in part, by combining antique objects with spare, contemporary ones. She applied her taste for graceful curves, which derived from the design of English and French furniture, to her selection of accessories, especially mirror frames, lamp bases, and other sculptural forms. White porcelain birds and knife handles appeared repeatedly as accessories in her drawing and dining rooms, which were known more for their urbane than romantic look.

John Fowler once said he "liked things that look simple but cost a mint." His knowledge of the history of decorative arts, combined with his taste for whimsy and experience as a professional fabric painter, brought an unusual style and grace to the grand scale of many of his interiors. In a room of Haseley Court—the house of his partner Nancy Lancaster—he combined Victorian gilt bronze chandeliers, chinoiserie screens, *torchères* with rococo carving, and carved stags' heads with real antlers. He produced a "humble elegance" in other interiors by, among other means, a lavish use of planters and a wealth of little details that he arranged in commanding symmetry.

The style of America's present grande dame of decorating, *Sister Parish,* can be described as one of cheerful, voluptuous femininity presented in a context of luxurious clutter. Her Anglophile tastes and Edwardian sense of romance are revealed in her propensity for chintzes, Colefax and Fowler fabrics, and an English-country-house-like emphasis on "creature comfort." Rooms overflowing with such old-fashioned details as needlework pillows, quilts, painted lampshades, fabric chair covers, and doilies reflect her signature love of handcrafted accessories and her tone of sunny domesticity.

Sister Parish's partner, *Albert Hadley,* expresses a more twentieth-century aesthetic in his selective juxtapositions of objects whose interest derives from their sculptural qualities. In an Albert Hadley room a wooden sphere solidly covered with nail heads and a gilded gourd coexist happily with fine eighteenth-century candlesticks.

COMMON MISTAKES

The display of a few striking accessories can have as much visual and narrative impact as an abundance. In fact, unless the objects in your collection are truly wonderful—whether genuinely beautiful or totally idiosyncratic—it is generally advisable to display a few rather than many. You can easily ruin the effect of an otherwise handsome room by placing inconsequential accessories all about.

In general, massing similar objects is preferable to scattering them throughout the room. Do not separate pairs of anything. Each half relies on the other for compositional completion.

Aggregate A rough-textured concrete mixture formed from a combination of cement with sand, slag, and pebbles.

A.I.A. American Institute of Architects, an organization whose goal is to advance the art of planning and building and to promote aesthetic, scientific, and practical efficiency in architectural design.

Architrave The decorative horizontal molding that frames an opening such as a door or window.

Armoire A wardrobe or cabinet of substantial size, typically fitted with doors, shelves, and drawers, used for household storage.

A.S.I.D. American Society of Interior Designers, the largest professional interior design organization in the world; its members are obligated to conform to a specific code of professional ethics and standards.

Atrium The inner courtyard of a house, which in antiquity was open to the sky.

Baccarat The eminent French glassworks, begun in 1818, whose stemware and art objects are prized throughout the world.

Baluster The column, usually wood turned, that supports a stair rail.

Balustrade A series of balusters.

Bergère An upholstered armchair with closed, upholstered sides that are often rounded, as is the chair's back, which is typically surrounded by a carved wood frame.

Bombe Late-eighteenth-century free-standing cabinet characterized by the swell of the front and in some cases the sides.

Bureau The French term for a desk or writing table. In American parlance it refers to chest of drawers typically found in the bedroom.

Cachepot A ceramic flowerpot.

Camel-back An English chair or sofa whose back swells upward in the center.

Cartouche A shield or partially rolled-up scroll design used as a furniture ornament.

Chaise longue A chair of extended length, usually made with an upholstered back, and typically used for reclining.

Chinoiserie, which first became popular in Europe in the seventeenth century, refers to the highly decorative designs based on Chinese patterns, figures, and landscapes found on Oriental porcelains, lacquerware, textiles, wallpaper, and furniture.

Claw-and-ball foot Originally a Chinese motif, adapted as a design for the foot of furniture legs. It was favored by the English designer Thomas Chippendale and appeared often in Georgian furniture and cabinetry.

Commode A low cabinet or chest of drawers usually on short legs.

Console A table attached in back to the wall and supported in front by decorative legs or brackets that often curve inward.

Cornice Architecturally, the horizontal band of projecting decorative molding located between the walls and the ceiling, usually having a curved or ornate profile. The term also refers to a molding that conceals curtain rods, picture hooks, or indirect lights.

Coromandel screen A heavily lacquered Chinese screen, typically with a black or dark brown background on which a design is carved and then painted in gold and other colors.

Dado The lower twenty-seven inches of an interior wall usually bordered at the top by a molding called a chair-rail or dado molding.

Dovetail A technique of interlocking woods in cabinetmaking.

Ebeniste A master cabinetmaker; the term derived from the name given to seventeenth-century French cabinetmakers who worked in ebony.

Elevation A drawing of one side of a building wall, whether exterior or interior.

Etagère An open-shelved cabinet typically used for display.

Facade The front exterior of a building or of a chest or cabinet of strongly architectural design.

Fenestration Configuration and/or arrangement of windows.

Festoon The scalloplike swag or looped design of a window dressing; or a carved or painted decoration of fruits, flowers, or leaves in a swagged curve.

Filigree A lacelike pattern of intertwined gold or silver.

Finial The ornament at the top of a piece of furniture, architectural element, or building.

Fresco The Italian term for a painting executed on a wall surface in wet plaster.

Gallery In architectural terminology, a covered walk or balcony or a room, hall, or wall on which art is displayed. As it applies to furniture, a pierced wood or metal railing around the outer edges of a table, shelf, or cabinet.

Gateleg A table with hinged leaves that fold down over legs that can swing closed like a gate.

Gesso A mixture of plaster of Paris, linseed oil, and glue that is used as a preparation for surfaces that are to receive raised decoration and/or gilding or painting.

Grille Metal or wood latticework typically used for the fronts of bookcases and cabinet doors or in decorative screens.

Gros point A coarse needlework technique in which wool is stitched on a canvas ground used for upholstering furniture.

Gueridon An occasional table with a round top that rests on a central post that is usually supported by three splayed legs.

Lattice An openwork carved or cut wood pattern.

Lintel The horizontal beam over a door or window opening that supports part of the weight of the structure above it.

Loggia The Italian term for a long, covered gallery that opens on one side to a garden or courtyard.

Mantel The architectural structure that surrounds the fireplace; the shelf above the fireplace.

Miter The carpentry technique by which two pieces of wood are joined at a corner.

Mortice In carpentry, the hole or notch cut into a piece of wood that is to receive a projecting piece.

Newel The post at the head or bottom of a stair that supports the handrail and balusters and is often ornamented with a wood turning or other finial.

Occasional furniture Small, movable tables and chairs.

Ogee A molding with an "S"-shaped silhouette.

Ormolu refers to furniture ornaments made of gilt brass or copper. They derive from the gold-leafed cast-bronze ornaments used on furniture in France during and after the seventeenth century. Today's imitation is an alloy of copper, zinc, and tin.

Overdoor A carved, painted, or otherwise decorative treatment attached to the wall above a door.

Petit point An embroidery technique employing tiny stitches.

Pilaster A nonsupporting half-round or rectangular column applied to the face of a wall or furniture facade.

Rattan Slender, resilient, malleable stems of the climbing Asian palm tree used in making tropical-looking furniture.

Récamier A backless chaise longue with curved ends, one higher than the other, named after a socially prominent French woman of the early nineteenth century.

Rush Hollow-stem reeds woven into chair seats and backs.

Saber Furniture legs curved in the shape of a saber or sword.

Sash The window frame holding the window glass.

Scratch coat The primary coat of plaster applied to a wall.

Secretary A desk with a slanted front, drawers below, and bookcase or cabinet on top.

Semainier A tall, seven-drawer chest that derives its name from the French word for "week," as each drawer was meant for use one day of the week.

Settee A small sofa with upholstered back, seat, and arms that is usually framed.

Side chair Armless chair characteristically used in the dining room.

Side table A long, narrow, rectangular table characteristically used in the dining room for serving.

Slipper chair A small, upholstered, armless, low-seated chair.

Sofa A piece of upholstered seating that accommodates a minimum of three people.

Soffit The underside of a roof overhang or of a projecting interior structure such as a cornice.

Stretcher The horizontal connecting piece that braces the legs of tables and chairs.

Swag A curved drape of fabric or a decorative carving or painting representing drapery festooned with ribbons, fruits, or flowers.

Tambour A piece of furniture, such as a rolltop desk, that has a door composed of narrow wood strips attached to a canvas backing that slides into a housing and disappears.

Trapunto A high-relief quilting technique.

Treillage Latticework executed in thin slats and applied to walls or ceilings.

Trumeau An elaborately framed combination of mirror and painting, the painting positioned at the top. Also a wall or pier between windows.

Turning Shaping wood by rotating it on a lathe.

Vermeil A rose-colored plating achieved by the application of powdered gold to silver or bronze.

Vitrine A cabinet with a glass door and sometimes glass sides used for display.

Wainscot A wood-paneled dado.

The sources listed here are principally located in the interior design capitals New York, Los Angeles, London, and Paris.

ANTIQUE AND REPRODUCTION FURNITURE

A La Vieille Russie
781 Fifth Ave.
New York, NY 10022
212/752-1727

Ann-Morris Antiques
239 East 60th St.
New York, NY 10022
212/755-3308

Alexandre Biaggi
40 Rue de Seine
Paris 75006
France
33-1-44-07-34-73

Rupert Cavendish Antiques
610 King's Rd.
London SW6 2DX
United Kingdom
44-171-731-7041

The Curio Shop
349 Miracle Mile
Coral Gables, FL 33134
305/444-7234

Delorenzo
958 Madison Ave.
New York, NY 10021
212/249-7575

Gregarius/Pineo
653 N. La Cienega Blvd.
Los Angeles, CA 90069
310/659-0588

Carlton Hobbs
8 Little College St.
London SW1 935H
United Kingdom
44-171-730-3517

Howard Kaplan Antiques
827 Broadway
New York, NY 10003
212/674-1000

Hyde Park Antiques, Ltd.
836 Broadway
New York, NY 10003
212/477-0033

Karl XII Swedish Antiques
8441 Melrose Ave.
Los Angeles, CA 90069
323/852-0303

La Maison Antiques
8435 Melrose Ave.
Los Angeles, CA 90069
323/653-6534

Licorne Antiques
8432 Melrose Pl.
Los Angeles, CA 90069
323/852-4765

Malmaison Antiques
253 E. 74th St.
New York, NY 10021
212/288-7569

Dorures Louis Mathieu
248 Rue St. Martin
Paris 75002
France
33-1-42-78-50-40

Florian Papp
962 Madison Ave.
New York, NY 10021
212/288-6770

Evelyn S. Poole, Ltd.
3925 N. Miami Ave.
Miami, FL 33127
305/573-7463

Quatrain
700 N. La Cienega Blvd.
Los Angeles, CA 90069
310/652-0243

Randolph & Hein
Pacific Design Center #B528
8687 Melrose Ave.
West Hollywood, CA 90069
310/855-1222

Rose Tarlow "Melrose Home"
8454 Melrose Pl.
Los Angeles, CA 90069
323/651-2202

Therien & Co., Inc.
716 N. La Cienega Blvd.
Los Angeles, CA 90069
310/657-4615

Frederick P. Victoria & Son
400 West End Ave.
New York, NY 10024
212/755-2549

Waldo's Designs
620 N. Almont Dr.
Los Angeles, CA 90069
310/278-1803

Wallach & Jiavis Antiques
8823 Beverly Blvd.
Los Angeles, CA 90048
310/278-5755

Isidora Wilke Inc.
3143 Ponce de Leon Blvd.
Coral Gables, FL 33134
305/448-5111

TWENTIETH CENTURY FURNITURE MAKERS AND GALLERIES

280 Modern
280 Lafayette St.
New York, NY 10012
212/941-5825

Arango
7519 Dadeland Mall
Miami, FL 33156
305/661-4229

Delorenzo
958 Madison Ave.
New York, NY 10021
212/249-7575

Diva Showroom
8801 Beverly Blvd.
Los Angeles, CA 90048
310/278-3191

The Knoll Group
105 Wooster St.
New York, NY 10012
212/343-4000
8687 Melrose Ave., #B203
Los Angeles, CA 90069
310/289-5827
3970 NE 2nd Ave.
Miami, FL 33137
305/446-0211

Luminaire
2331 Ponce de Leon Blvd.
Coral Gables, FL 33146
305/448-7367

Modern Age
102 Wooster St.
New York, NY 10012
212/966-0669

Modern Living
8775 Beverly Blvd.
Los Angeles, CA 90046
310/657-8775

Modernism
1622 Ponce de Leon Blvd.
Coral Gables, FL 33146
305/442-8743

Peter Roberts Antiques, Inc.
American Arts and Crafts
134 Spring St.
New York, NY 10012
212/226-4777

Saladino Furniture Inc.
200 Lexington Ave.
New York, NY 10016
212/838-0500

FLOORS

American Terrazzo and Tile
1915 N.W. Miami Ct.
Miami, FL 33136
305/667-8612

Farnese Gallery
8460 Melrose Pl.
Los Angeles, CA 90069
323/655-1819

La France
2008 S. Sepulveda Blvd.
Los Angeles, CA 90025

310/652-6881
550 15th St., Suite 2
San Francisco, CA 94103
415/861-2977

Rhomboid Sax
8904 Beverly Blvd.
Los Angeles, CA 90048
310/550-0170

Ann Sacks
8483 Melrose Ave.
Los Angeles, CA 90069
323/658-8884

Stone Source
215 Park Ave. South, Suite 700
New York, NY 10003
212/979-6400

CARPETS AND RUGS

Doris Leslie Blau
724 5th Ave.
New York, NY 10019
212/586-5511

Y&B Bolour
321 S. Robertson Blvd.
Los Angeles, CA 90048
310/274-6719

Emser International
8431 Santa Monica Blvd.
Los Angeles, CA 90069
323/650-2000

F.J. Hakimian
136 E. 57th St.
New York, NY 10022
212/371-6900

Patterson, Flynn, & Martin
979 Third Ave.
New York, NY 10022
212/688-7700

Rosecore Carpet Co., Inc.
979 Third Ave.
New York, NY 10022
212/421-7272

Stark Carpets
979 Third Ave.
New York, NY 10022
212/752-9000
8687 Melrose Ave., #B629
Los Angeles, CA 90069
310/657-8275

Topalian Trading Company
281 Fifth Ave.
New York, NY 10016
212/684-0735

V'soske
155 E. 56th St.
New York, NY 10022
212/688-1150

HARDWARE

Beardmore
17 Pall Mall
London SW1Y 5LU
United Kingdom
44-171-670-1000

The Brass Center
248 E. 58th St.
New York, NY 10022
212/421-0090

Czeche & Speake
39C Jermyn St.
London SW1Y 6DN
United Kingdom
44-171-439-0216

Details
8625 1/2 Melrose Ave.
Los Angeles, CA 90069
310/659-1550

P.E. Guerin
23 Jane St.
New York, NY 10014
212/243-5270

LIGHTING

Marvin Alexander Inc.
315 E. 62nd St.
New York, NY 10021
212/838-2320

Atrium
Center Point
22-24 St. Giles High St.
London WC2H 8LN
United Kingdom
44-171-379-7288

Chrystian Aubusson Inc.
315 E. 62nd St.
New York, NY 10021
212/755-2432

Alexandre Biaggi
40 Rue de Seine
Paris 75006
France
33-1-44-07-34-73

Mrs. M.E. Crick's
166 Kensington Church St.
London W8
United Kingdom
44-171-229-1338

Delorenzo
958 Madison Ave.
New York, NY 10021
212/249-7575

Paul Ferrante, Inc.
8464 Melrose Pl.
Los Angeles, CA 90069
323/653-4142

Nesle Inc.
151 E. 57th St.
New York, NY 10022
212/755-0515

Therian & Co., Inc.
716 N. La Cienega Blvd.
Los Angeles, CA 90069
310/657-4615

LANDSCAPES

Abat Jour
232 E. 59th St., 6th Fl.
New York, NY 10022
212/753-5455

Ruth Vitow, Inc.
155 E. 56th St.
New York, NY 10021
212/355-6616

CURTAIN FABRICATION AND UPHOLSTERY

A Schneller Sons, Inc.
129 West 29th St.
New York, NY 10001
212/695-9440

Mary Bright
636 Broadway
New York, NY 10012
212/677-1970

Classic Design
3520 Wesley St.
Culver City, CA 90232
310/841-0120

Jacquard
Park House
140 Battersea Park Rd.
London SW11 4NB
United Kingdom
44-171-627-1228

K. Flam Associates, Inc.
805 E. 134th St.
Bronx, NY 10454
718/665-314

Anthony Lawrence
53 W. 23rd St., 5th Fl.
New York, NY 10010
(212) 206-8820

White Workroom
62 White St., 5th Fl.
New York, NY 10013
212/941-5910

CURTAIN HARDWARE

Joseph Biunno Ltd.
129 West 29th St., 2nd Fl.
New York, NY 10001
212/629-5630

FABRICS AND WALL-COVERINGS

Roger Arlington
979 Third Ave.
New York, NY 10022
212/752-5288

Jeffrey Aronoff Inc.
16 West 23rd St.
New York, NY 10010
212/645-3155

GP & J Baker
278-280 Brompton Rd.
London SW3 2AS
United Kingdom
44-171-589-4778

Brunschwig & Fils
979 Third Ave.
New York, NY 10022
212/838-7878
8687 Melrose Ave., #B653
Los Angeles, CA 90069
310/659-9800

Manuel Canovas Inc.
979 Third Ave.
New York, NY 10022
212/752-9588
8687 Melrose Ave., #B647
Los Angeles, CA 90069
310/659-1423
also available through
William Curran & Assoc.
737 Miami Circle
Atlanta, GA 30324
(404) 233-1297
In France:
7 Place Fursternberg
Paris 75006
33-1-43-25-75-98

Manuel Canovas Inc.
125 Rue Plaisanterie
Paris 75116
France
33 1 45 03 72 00

Carlton V Ltd.
979 Third Ave.
New York, NY 10022
212/355-4525

Clarence House
211 E. 58th St.
New York, NY 10022
212/752-2890

8687 Melrose Ave., #B504
Los Angeles, CA 90069
310/652-0200

Classic Revivals Inc.
1 Design Center Place, #534
Boston, MA 02210
617/574-9030

Rose Cumming, Inc.
232 E. 59th St.
New York, NY 10022
212/758-0844

Donghia Showrooms, Inc.
939 Third Ave.
New York, NY 10022
212/935-3713
8687 Melrose Ave., #G196
Los Angeles, CA 90069
310/657-6060
Merchandise Mart #631
Chicago, IL 60654
312/822-0766
1855 Griffin Rd., #A124
Dania, FL 33004
954/920-7077

Galacar & Co.
144 Main St.
Essex, MA 01929
978/768-6118

Yves Gonnet
979 Third Ave.
New York, NY 10022
212/722-2535

Sahco Hesslein
24 Chelsea Garden Market
Chelsea Harbour
London SW10 OXE
United Kingdom
44-171-352-6168

Christopher Hyland Inc.
979 Third Ave., Ste. 1710
New York, NY 10022
212/688-6121

James Gould Textiles
22 Beckfield Ln.
Greenwich, CT 06831
203/629-1440

Lee Jofa
979 Third Ave.
New York, NY 10022
212/688-0444
8687 Melrose Ave., #B678
Los Angeles, CA 90069
310/659-7777

Sam Kasten
P.O. Box 950
Stockbridge, MA 01262
413/298-5502

Kneedler–Fauchere
8687 Melrose Ave., #600
Los Angeles, CA 90069
310/855-1313

Nancy Koltes
900 Broadway, #201
New York, NY 10003
212/995-9050

Lelievre (UK) Ltd
1/19 Chelsea Harbour Design Center
London SW10 OXE
United Kingdom
44-171-352-4798

Mimi London
8687 Melrose Ave., #G168
Los Angeles, CA 90069
310/855-2567

Maryse Boxer at Joseph
26 Sloane St., 2nd Fl.
London SW1 X 7LQ
United Kingdom
44-171-245-9493

Keith McCoy
8710 Melrose Ave.
Los Angeles, CA 90069
310/657-7150

Hodsoll McKenzie
52 Pimlico Rd.
London SW1W 8LP
United Kingdom
44-171-730-2877

Françoise Nunnalle
105 West 55th St.
New York, NY 10019
212/246-4281

Old World Weavers
979 Third Ave.
New York, NY 10022
212/355-7186

Percheron
Unit 6/Chelsea Harbour Design Center
London SW10 OXE
United Kingdom
44-171-349-1590

Prelle
5 Place des Victoires
Paris 75001
France
33-42-36-67-21

Rogers & Goffinon Ltd.
41 Chestnut St.
Greenwich, CT 06830
203/532-8068

Arthur Sanderson & Sons Ltd.
112-120 Brompton Rd.
London SW3 1JJ
United Kingdom
44-171-584-3344

Scalamandre
942 Third Ave.
New York, NY 10022
212/980-3888
8687 Melrose Ave., #B617
Los Angeles, CA 90069
310/657-8154

J. Robert Scott
8737 Melrose Ave.
Los Angeles, CA 90069
310/659-4910

Tassinari & Chatel
26 rue Danielle Casanova
Paris 75002
France
33-42-61-74-08
11 Place Croix-Paquet
Lyon 69001
France
33-78-26-06-18

Zuber et Cie
979 Third Ave.
New York, NY 10022
212/486-9226

PASSAMENTERIE

Houlès
979 Third Ave.
New York, NY 10022
212/935-3900
Houlès Showroom
8584 Melrose Ave.
Los Angeles, CA 90069
310/289-2435

Renaissance Ribbons
P.O. Box 699
Oregon House, CA 95962
530/692-0842

Scalamandre
942 Third Ave.
New York, NY 10022
212/980-3888
8687 Melrose Ave., #B617
Los Angeles, CA 90069
310/657-8154

Tinsel Trading
47 West 38th St.
New York, NY 10018
212/730-1030

V V Rouleaux
54 Sloan Sq.
London SW1W 8AX
United Kingdom
44-171-730-3125

DECORATIVE PAINTING
AND LEAFING

Galice, Inc.
7916 Melrose Ave., Suite 4
Los Angeles, CA 90046
323/935-6900

Grand Illusion Decorative Painting, Inc.
20 W. 20th St., #1009
New York, NY 10011
212/675-2286

Granvelle and Associates
8205 Santa Monica Blvd., #1176
West Hollywood, CA 90046
323/993-3399

Lance Leon
7213 1/2 Santa Monica Blvd.
Los Angeles, CA 90046
323/874-8305

Karin Linder
212/598-0559
by appointment

Perucchetti Associates
RMC House #15
Townmead Rd.
London SW6 2QL
United Kingdom
44-171-371-5497

Sepp Leaf Products, Inc. and Center for the Gilding Arts
381 Park Ave. South, #1301
New York, NY 10016
212/683-2840

COMPOSITION ORNAMENT

J.P. Weaver
941 Airway
Glendale, CA 91201
818/841-5700

THE ARCHITECTS AND DESIGNERS

Bilhuber Incorporated
Jeffrey Bilhuber
330 E. 59th St., 6th Fl.
New York, NY 10022
212/308-4888

Linda Chase Associates, Inc.
482 Town St.
E. Haddam, CT 06423
860/873-9499

Deamer + Phillips
145 Hudson St.
New York, NY 10013
212/925-4564

Victoria Hagan Interiors
654 Madison Ave., Suite 2201
New York, NY 10021
212/888-1178

John F. Saladino, Inc.
200 Lexington Ave.
New York, NY 10016
212/752-2440

Sidnam-Petrone Architects
136 W. 21st St., 6th Fl.
New York, NY 10010
212/366-5500

Tassinari & Chatel
26, rue Danielle Casanova
75002 Paris, France
33-42-61-74-08
11, Place Croix-Paquet
69001 Lyon, France
33-78-26-06-18

Trilogy
620 N. Almont Ave.
Los Angeles, CA 90069
310/276-7880

Zuber et Cie
979 Third Ave.
New York, NY 10022
212/486-9226

PASSAMENTERIE

Jacques Bredat Imports
1800 N. Stanley Ave.
Los Angeles, CA 90046
213/850-5454

Houlès
979 Third Ave.
New York, NY 10022
212/935-3900
8584 Melrose Ave.
Los Angeles, CA 90069
213/652-6171

Dorures Louis Mathieu
rue Reaumur 130
Paris 2, France
33-45-08-47-37

Renaissance Ribbons
PO Box 699
Renaissance, CA 95962
916/692-0842

Scalamandre
950 Third Ave.
New York, NY 10022
212/980-3888
8687 Melrose Ave.
Los Angeles, CA 90069
213/278-2050

Standard Trimming
306 East 61 St.
New York, NY 10021
212/755-3034

Tinsel Trading
47 West 38 St.
New York, NY 10018
212/734-0032

V V Rouleaux
201 New Kings Road
London SW6
071-371-5929

DECORATIVE PAINTING AND LEAFING

Antique Conservation
408 West 14 St.
New York, NY 10014
212/645-8693 by appointment

Galice, Inc.
5424 W. Washington Blvd.
Los Angeles, CA 90016
213/935-6900

Grand Illusion Decorative Painting, Inc.
20 West 20 St., #1009
New York, NY 10011
212/675-2286

Granvelle and Associates
8205 Santa Monica Blvd., #1176
West Hollywood, CA 90046
213/993-3399

Lance Leon
7213 1/2 Santa Monica Blvd.
Los Angeles, CA 90046
213/874-8305

Karin Linder
212/598-0559
by appointment

Carlo Marchiori
Maestro d'Arte
357 Frederick St.
San Francisco, CA 94117

Mauro Perucchetti Associates, Ltd.
RMC House #15
Townmead Road
London SW6 2QL
44-71-371-5497

Sepp Leaf Products, Inc. and Center for
the Gilding Arts
381 Park Ave. South, #1312
New York,, NY 10016
212/683-2840

Larry Young
3223 Ellis St.
Berkeley, CA 94703
510/601-0246

COMPOSITION ORNAMENT

J.P. Weaver
2301 W. Victory Blvd.
Burbank, CA 91506
818/841-5700

THE ARCHITECTS AND DESIGNERS

Bilhuber Incorporated
Jeffrey Bilhuber
19 East 65 St.
New York, NY 10021
212/517-7673

Peter F. Carlson
Carlson Chase Associates, Inc.
3415 Tareco Dr.
Los Angeles, CA 90068
213/969-8423

Linda O. Chase
Carlson Chase Associates, Inc.
3415 Tareco Dr.
213/969-8423

Deamer + Phillips
149 Franklin St.
New York, NY 10013
212/924-4564

Victoria Hagan Interiors
22 East 72 St.
New York, NY 10021
212/472-1290

Richard Lowell Neas
1204 Third Ave.
New York, NY 10021
212/772-1878

John F. Saladino, Inc.
305 East 63 St.
New York. NY 10021
212/752-2440

Sidnam-Petrone Architects
7 West 22 St., 10th Floor
New York, NY 10010
212/989-2624